# The
# ELEGANT
# MAN

# *The* ELEGANT MAN

### RICCARDO VILLAROSA
### &
### GIULIANO ANGELI

## How to Construct the
## Ideal Wardrobe

PHOTOGRAPHY BY FREDI MARCARINI
INTRODUCTION BY RICHARD MARTIN

RANDOM HOUSE 🏠 NEW YORK

# CONTENTS

*The Primary Material*

*The Style*

*The Basic Garments*

# THE WARDROBE
*94 – 165*

*Conservation*

# MAINTENANCE & CARE
*166 – 185*

# PREFACE

*This book cannot teach men elegance, regardless of the title's declaration. One obvious reason is that such a notion is even more elusive than its feminine counterpart. But, more important, the authors have serious doubts that elegance is something that can be learned. One can hope to acquire it with information, persistence, and practice. But the prudent course is to abstain from judging the results. Being well-dressed is possible; in fact, it is an imperative: In today's civilized world the issue is taken quite seriously. That's why it is extremely important to understand the rules of fashion and to know how to organize a wardrobe. Such knowledge is not just the equivalent of a social and economic investment, it is also a source of one's confidence and image, as well as an expression of individuality. How one dresses: No other act is at once so personal and yet so tied to social norms. It is a creative moment, a free act, yet it is conditioned, more or less consciously, by fixed rules, habits, fashions and collective tendencies.*

*Within this dualism one finds a personal image by combining a few elements taken from endless possibilities, even though such codes are somewhat rigid. Nevertheless, within the boundaries of a few typologies the number of variants, secondary and subtle, which can be introduced is enormous: the particulars of a cut, a nuance of color, the number of buttons, the shape of the pockets, not to mention the matching of essential "accessories." (Could we walk without shoes?) In addition to the accessories, the degree to which clothing wears and the way which one looks in them are enough to make something unique.*

*For this reason it is important for a gentleman to take charge of his wardrobe and to serve as his own judge in this highly expressive yet extremely personal area. In other words, he should not have to depend upon the taste and planning of his wife, the whims of his girlfriend, the dictates of his tailor, or the choices offered by the shop in which he normally makes his purchases.*

*A guide such as* The Elegant Man *makes an excellent companion for anyone interested in penetrating the secrets of tailoring. It offers practical help in making informed selections, and in building and drawing upon a wardrobe that will offer the right fashion solutions for whatever season or occasion.*

*The tone is serious but not grave; the content is rich in detail but always stimulating. Moreover,* The Elegant Man *never fails to be technically reliable — regardless of whether it is discussing fabrics, reviewing the structural details of a garment, or recounting the origins and the history surrounding the categories of men's clothing. And all this is carried out with a thoroughness and precision highly unusual for a book not specifically intended for specialists. Nevertheless,* The Elegant Man *has useful things to say even to those who work in the clothing sector.*

*Those who collaborated on* The Elegant Man *hope that its readers take an interest in their wardrobes and in the way they dress, also — and above all — because it gives them pleasure. To learn. Certainly. But as Max Beerbohm said many years ago, it is also important to enjoy "that splendid process, the product of a multitude of considerations, which leads to wearing a suit well and with discretion." He certainly knew what he was talking about.*

# INTRODUCTION

Men have ordained and sustained the subtle art of tailoring— a noble sartorial science—for centuries. The elegant man listens to and follows his inner reason when he dresses; he does not merely "practice" fashion. The certainty and stability of the tailored clothes a man selects cannot help but inspire more confidence than a woman's wardrobe: Her clothes tend to obey the rules of rapidly changing styles. The tailored clothes in a man's closet may be subject to endless modifications but, as this primer of the sartorial science so well demonstrates, always include proven fabrics, tested and familiar styles and constantly effective and effectively expressed details.

The exotic and highly successful "Peacock Revolution" that so radically changed men's attitudes towards clothing in the early 1970s led some to believe that the deliberate choices and systematic values of a well-reasoned wardrobe might never return. But the last quarter of the 20th century has confirmed the lasting potential of a regimen of apparel options that holds countless exciting possibilities. "The apparel oft proclaims the man," said Shakespeare. *The Elegant Man* is the lexicon of that proclamation, a coherent discussion that translates for us the language of textiles, describes the complex detailing of fine-tailored clothes and teaches us the basic elements of a masculine wardrobe. That a man's clothes can speak so forcefully is due in large part to the fact that he has available to him those criteria that are such a determining factor in the creation of his individual personal style.

It is his awareness of the principles described in this canon of male tailored clothing that defines the elegant man. Its authors reassure us that, "like anything else concerning elegance, common sense must be the guide"; that style and grace in men's clothes are not the result of subserviently followed rules but present only when the wearer feels confident and in command of the practical and aesthetic aspects of his dress— aware of both the finite elements of tailoring and of the infinite variations that may be played upon it.

A man's elegance stems from his knowledge of clothes, of how to wear, buy and care for them. It is this awareness that others notice about him: he is no self-aggrandizing dandy but a man whose confidence is perfectly balanced by the beauty and suitability of the clothing he wears. We step back and admire the eloquent nonchalance of one who knows the rules and has successfully and joyfully mastered them.

*Richard Martin*
*Curator of the Costume Institute*
*Metropolitan Museum of Art*

# FABRICS

— *A suit of raw fabric,*

*even creased, worn with colorful socks,*

*shiny black leather shoes and a black-and white-striped*

*linen or silk shirt, a linen or hand-colored*

*neckerchief and a white or yellow wide-brimmed*

*straw hat, on a bright morning, in the country*

*or at the seaside, would be a most elegant outfit.*

— *Filippo De Pisis,*
Adamo o dell'eleganza
(Adam and the Art of Elegance)

# SPINNING & WEAVING

If it's true that a badly cut suit ruins a good piece of cloth, it is just as true that a mediocre fabric can prove fatal to the work of even the best tailors.

It is therefore not surprising that a quality suit is the result of choosing the right materials and evaluating their worth. What follows applies only to natural fibers, which are appropriate for dress suits; synthetic or artificial fibers offer a more practical alternative for clothes designed for work or play.

## Weaving

Fabric is the product of an intertwining of thread or, more precisely, the threads of the warp. These threads are crossed by and interlaced with the weft and form the lengthwise threads in the woven fabric.

Weaving has ancient roots and is considered one of the first signs of civilization. It was practiced throughout the Mediterranean region, although not by the more primitive tribes. In fact, when Julius Caesar invaded Great Britain, he found that the use of the loom was unknown to the native population.

Weaving looms originally ran vertically and then, around 2500 B.C., horizontal looms appeared. But the first looms required continuous manual intervention. Leonardo da Vinci invented a mechanical loom activated by water, but his invention wasn't practical, even if a certain Moller of Danzig built a model of one in the 16th century.

The official title of inventor could not be claimed until 1787, when Edmund Cartwright of England obtained the patent for a mechanical or power-driven loom. From then on, a succession of inventions would bring about even greater technical improvements in the weaving process.

Giovanni il Calabrese and Claudio Degon, weavers from Lyon, obtained fancy designs from their loom; Bouchon, Falcon, Regnier, and Vaucanson introduced modifications to speed up the work, while Joseph Marie Jacquard invented elaborate designs, known as jacquards, by applying to the loom strips of perforated cardboard with the patterns he wanted to obtain. His loom was further improved by another Frenchman, Breton, who is credited with inventing a single control for all the mechanisms of the loom. The lever, which was activated by means of a pedal, was attached to just one spindle.

A practical loom must be mechanically simple, sturdy, and easy to maintain. Naturally, there are a variety of looms for different types of fabrics: silk, cotton, linen, light wools and synthetic fibers, drapes and covers, hemp, jute, and coconut fiber.

How does this device work? The threads of the warp run lengthwise; one part is elevated while the other part remains at the same level or lower. There is a space between the two series of warp threads into which the threads of the filling are inserted. The filling yarn is passed or shot through the shed from one side of the web to the other by means of a device called a shuttle. This shuttle contains a bobbin. Once the shuttle has reached the end of its run, all the elevated threads of the warp are lowered, the other threads raised, and the shuttle then begins its return movement.

Most modern looms are mechanical and thus do not require manual starting; they are also automatic, which means that the empty bobbin is replaced by a full bobbin while the loom is operating. A loom can use only one shuttle when the fabric is the same color; more than one shuttle is necessary

for patterns of different colors. When the interlacing is more complicated, the loom requires a mechanism that individually controls the threads of the warp. It was invented by Jacquard and bears his name.

The spun yarn is obtained from textile fibers whose origins can be animal — such as silk or wool — or vegetable — such as cotton or linen. On the other hand, chemical fibers are divided into artificial (rayon) and synthetic (polyamide and polyester) types.

Cotton fibers are nothing but the lumps that cover the seeds of the plant; wool fibers, however, are derived from the fleece of sheep, and from the undercoat of certain breeds of goats or camels in the case of more precious fibers. Linen fibers are extracted from the stem of the plant, while silk comes from the saliva secreted by the silkworm, which feeds exclusively on mulberry leaves. Fibers are obtained through a variety of procedures, depending upon their origin. They are judged according to length, fineness, and sheen. More length is generally accompanied by a coarser texture and less gloss, although such a fiber is more resistant.

Spinning is a series of actions in which textile fibers are prepared and twisted together to obtain thread. The art of spinning is also very ancient and most certainly preceded weaving. The Chinese believed it was invented by Emperor Yao; the Egyptians by Isis; the Greeks by Athena and the Peruvians by Mama Oello, wife of their first king.

There are many methods of spinning; some of them date back centuries and are still in use. However, the two main techniques are intermittent spinning — with the spindle operated manually or by pulley — and continuous spinning, in which a spindle with flyers is moved by means of manually operated pulleys.

Before the actual spinning takes place, the fibers undergo a series of treatments, from cleaning — which removes much of the impurities — to carding — which separates and straightens the fibers — to combing and coupling.

The quality of spun yarn is determined by the yarn count, which is derived from the relationship between length and weight; the higher the yarn count, the finer the thread.

On the other hand, a fabric is determined by length, weight per yard, number of weft and warp threads per inch, yarn count in the weft and warp, and weave.

Spun yarns and fabrics are treated according to the procedures described in the following pages.

## THE SPINNING CYCLE

### Carding

One of the basic procedures of the spinning cycle, carding unwinds and separates the fibers from each other in order to remove any short, undesirable pieces. The fibers are thus arranged into a single cylindrical form which is gradually thinned during the various stages of spinning and which, in turn, produces the spun yarn.
A woolen (carded) yarn has not been combed. It is produced with short, less uniform fibers that have not been arranged parallel to one another. Consequently, a woolen (carded) textile is produced with carded yarns.

### Combing

This is a procedure that follows carding in which fibers under a certain length are removed. The remaining fibers are laid out parallel to one another while undergoing additional cleaning to eliminate any further impurities. Combing strengthens the fibers and gives them a greater smoothness. However, it is a costly procedure because it generates large amounts of wasted material. Thus it is carried out only on yarns intended for high-quality fabrics.

### Spinning

After a series of preparatory treatments, including combing, the fibers are mechanically spun. The yarn count, i.e., the relationship between the length and the weight, is determined in this phase.

### Twisting

This is performed after the spinning in order to twist together two or more threads. The yarn is single- or multiply, depending upon the number of threads used. The process is carried out by two machines: a doubler, which combines two or more threads, and a twister, which twists the threads after they are combined. A two-ply fabric is stronger than a single-ply one; fabrics made from such yarns are, as a consequence, more durable.

## PHASES OF THE

## WEAVING CYCLE

### Warping

This is a preparatory phase in which the threads that will eventually make up the warp are arranged vertically on the loom.

### Weaving

This is the process in which the threads that form the cloth are interwoven. The threads that run lengthwise, or vertically, are referred to as warp or chain; those that run horizontally are referred to as weft.

## THE FINISHING

## STAGES

### Mending

This process can be performed more successfully with materials of a finer texture that, once inspected, are mended by hand wherever there is a defect in the threads or the interlacement. Mending is carried out in two stages: in the raw stage, i.e., before the material has been finished, and again after the finishing itself.

### Fulling or Milling

This is a felting process in which the fibers of the garment are immersed in special tubs — called milling machines — in order to lift them. The fibers are then beaten and flattened mechanically.

### Drawn Finishing

This is a process reserved for wool fabrics intended for outdoor use. It produces a type of fleece that renders the garment more water resistant; for example, loden or beaver have drawn finishes. The effect is obtained by sliding the fabric under rotating cylinders. These cylinders are coated with metallic teasels that raise the nap of the yarn, thus creating the fleece. Until a few years ago — and even today in a few factories with high-quality standards — nap was raised with vegetable carders

(instead of metallic cylinders), which have a large number of small natural hooks.

## Shearing

This is a cutting operation in which the excess fleece on the surface of the fabric is shaved and brought to a uniform length.

## Calendering

During this process a fabric is rolled under rotating cylinders to make it more compact and shiny.

## Lapping

A series of mechanically operated metallic brushes raise the fibers of the fabric to obtain an effect similar to that of suede. This process, for example, is used to obtain fustian.

## London Shrunk

This process is used to prevent fabrics — especially wool — from shrinking. The fabric is dampened with wet blankets, dried in a special room, and pressed.

## Decatizing

This process is sometimes performed after calendering to reduce the excessive glossiness of a fabric. Steam is used to obtain the desired effect. The same name is given to a series of very important processes that must be performed to ready the material for the actual production and tailoring of the garment. These processes usually entail free steaming or cold-water dampening, which help eliminate the residual stresses from the weaving and finishing stages.

## Rest

For a certain period of time following the manufacturing process, a good quality fabric is left in storage at room temperature and under controlled humidity.

---

### WEAVES

---

## Plain Weave

This is the most simple weave and is obtained by passing the filling threads alternately over and under successive warp threads, producing a checkered surface. In fact, it can be designed as a checkerboard pattern with white and black squares.

## Twill or Four-Harness Weave

This is the most popular method for the weaving of textiles intended for men's clothing. The inner and outer faces of the resulting fabric are equal, with a characteristic diagonal run, and are especially flexible and elastic. Examples of twills are pick-and-pick (called sharkskin in the U.S.) hound's tooth, glen check and others.

## Three-Harness Weave

This is characterized by diagonal lines only on the outside. The filling threads are woven over and under two or more warp yarns, producing the diagonal pattern.

## Satin Weave

This is distinguished by the fact that the interlacement of the threads does not create diagonal lines but a series of points spaced at regular intervals. The warp effect can be seen on one side of the fabric because the fibers are virtually all warp threads, while the weft can be seen on the other side. The most common satin weaves have 5 and 8 warp and weft yarns in each full weave repeat. The interlacing of each warp thread with the weft thread is repeated at intervals of 5 and 8 wefts.

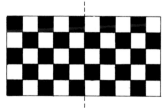

*Plain Weave*

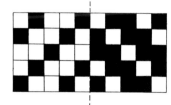

*Three-Harness Weave*

*Satin Weave*

# WOOL

Wool is a natural fiber produced by sheep for protection against harsh climates. A fiber of wool is made up of three concentric layers. The external layer, or cuticle, consists of a protein substance, keratin, which is similar to that of hair, horns, nails, feathers, and fur. Keratin is composed of minute overlapping scales. The intermediate layer is formed by spindle-shaped cells whose properties determine the physical characteristics of the wool. The internal layer, or medulla, consists of air-filled cells; the medulla is absent in fine or medium wool. The diameter of the yarn is measured in microns, the length in millimeters, and depends on the breed of sheep, its age, feeding, and the conditions under which it was raised.

The characteristics that distinguish wool include its luster, fineness, waviness, softness, and elasticity. Waviness is more pronounced in finer wools.

Raw wool is classified according to its origin, treatment, and uses. Annual world production of wool is over 3.3 million tons, which roughly corresponds to 14 ounces per person and represents only 5% of the textile fibers consumed worldwide. If only wool existed, more than nine-tenths of the world's population would be without clothes.

The largest producers of wool are Australia, the former U.S.S.R., New Zealand, Argentina, South Africa, and Uruguay, followed by England, the United States, and Italy.

It is not true that the major producers of wool are also the biggest processors of wool. For example, the Italians process more wool than anyone else, yet they produce a mere 3,479,000 spindles a year, followed by Japan, England, Germany, and France.

Australia produces 750,000 tons of unspun wool, which far surpasses their internal consumption demands. Australian wool is obtained primarily from the Merino breed of sheep, which are of Spanish origin and were imported from South Africa near the end of the eighteenth century by a certain Captain MacArthur. It is an especially valued wool, fine and very crimped, and is used almost exclusively for clothing. One interesting characteristic of Merino sheep is their ability to provide — at shearing — approximately 22 pounds of wool, as compared to an average of 4 pounds by the common breed of sheep found in virtually every country in the world. On the other hand, the standard varieties of sheep are also a source of meat and milk. These medium-wool breeds produce a rather ordinary and somewhat bristly grade of wool like that, for example, of Sardinian sheep. Wool from Sardinian sheep has been used for mattresses, capes, and overcoats. Its use was encouraged by Mussolini as a way of promoting an Italian-produced wool.

Lastly, there are crossbreeds, which originated from the pairing of Merinos with local breeds and which today are used primarily as a source of meat. They provide a medium-length wool with few curls; it is generally used for blankets and carpets.

Further distinctions can be made between sheared wool and wool from the hide or skin; the former is obtained by shearing the live animal, the latter is taken from the hide of the carcass. Shearing is done once or twice a year. Since it is generally carried out after the cold winter months, the time varies from country to country. It can be done by machine or, as in Italy, by skilled persons who can shear approximately 350 head of sheep a day.

If the wool has just been removed from the sheep, it is called "greasy wool." It contains impurities mixed into the fleece. It is known as "jumped and washed" when the wool

comes from animals that have been sheared after having been washed; or else it is "scoured," if it has been mechanically washed after the shearing. Scoured wool is completely free of impurities and is ready to be processed. There is also "mother's wool," which, as the name implies, comes from the shearing of a mother that has already been sheared many times before. And then there's "lamb's wool," which comes from the first shearing of a lamb and has very wavy fibers. This wool is less resistant, but it is very soft and is therefore quite valuable. For example, it is used for sweaters of the lamb's wool type. Last but not least, an additional distinction must be made between combed wool, which is very long, and carded wool, which is shorter, though this is generally an old-fashioned distinction because nowadays short wool can also be combed.

Beyond the capacity to keep us warm, the properties of wool are varied and remarkable. For one thing, it is water-absorbent, and can absorb humidity up to 33% of its weight without giving the sensation of being wet. For this reason wool clothing is useful in humid climates, or in cases of strong perspiration, because the wool will act protectively by absorbing sweat and humidity and returning it to the external environment in a continuous process of transpiration.

Wool is also water-resistant, and thanks to the waxy and greasy material coating its fibers, it does not absorb liquids or stain. What's more, given its limited amount of static electricity, wool does not attract dust, and because of its insulating capabilities, it protects against heat and cold. It is no accident that the Bedouins of the desert cover themselves with a woolen shawl to protect themselves from the burning sun; in fact, air remains trapped between the interstices of the fibers, thus guaranteeing thermal insulation.

Rarely flammable, wool does not support fire nor does it melt when near sources of heat. Burnt sections of a woolen carpet are easily removed; with synthetic carpets the burnt fibers melt together and cannot be eliminated.

In addition, wool resists folding, but it is also very flexible. Such properties make wool a highly valued material for clothing. Creases on a woolen garment due to crumpling or improper care are easily removed by ironing. Heat and especially the humidity from ironing cause a temporary separation of the chemical bonds in the sulfur and hydrogen of the wool: the fibers lose their consistency and can be easily reshaped. Yet once the effects of the steam have dissipated, the new folds and creases become a permanent part of the garment.

Another quality of wool is, therefore, its resiliency, in other words, its capacity to shed unsightly or unwelcome creases, although its elasticity makes wool especially resistant to wear and tear. This explains, for example, the durability of certain ancient carpets, even of those that for long periods of time had covered the floors of frequently crossed hallways or rooms.

One of the most common defects of soft wool is certainly that of pilling, which is the formation and accumulation of small pill-like balls of fiber on the surface of woolen garments. It is a clear sign of wear and can only be slowed by constant and energetic brushing.

To solve the problem of wool's natural tendency to felt, many research institutes have perfected a shrinkage–control treatment. This process enables manufacturers to produce wool clothing that can be safely washed without fear of shrinking, felting, or deforming the shape of the garment.

## BARLEYCORN

**Weave:** barleycorn is based on a twill weave. The yarn is normally carded. The name refers more to the design than to the type of fabric; it is, in fact, a type of design obtained by the contrast between the warp and the weft, which form a design similar to the shape of a triangle.
**Weight:** from 11 to 13 ounces.
**Use:** suits and jackets.
**Characteristics:** It is an ideal pattern for sports jackets made of lamb's wool and cashmere.

## BEDFORD CORD

An ideal fabric, it is used primarily for solid-color sports pants.
**Weave:** Bedford with worsted yarns.
**Weight:** 14 to 16 ounces.
**Use:** mainly pants.
**Characteristics:** It does not crease; it's very resistant and is especially suitable for sports like hunting and horseback riding.

## BIRD'S EYE

**Weave:** specific, with two light and two dark threads; the yarn is worsted.
**Weight:** 10 to 16 ounces.
**Use:** suits.
**Characteristics:** It is a fabric with small, dark and light round dots resembling the eye of a bird. It is a semi-formal pattern often used in business environments as an alternative to pick-and-pick suits.

## CAVALRY TWILL

Its name derives from the fact that it is also largely used for military uniforms.
**Weave:** twill weave with worsted yarns.
**Weight:** 13 ounces.
**Use:** Due to its elasticity, it is suitable for sports clothing and especially for horse-back riding.
**Characteristics:** It is elastic but must be closely woven. It does not have particular disadvantages and is suitable for durable pants. A different type of cavalry twill, with a wider effect, is called "Tricotine," because it resembles tricot knits.

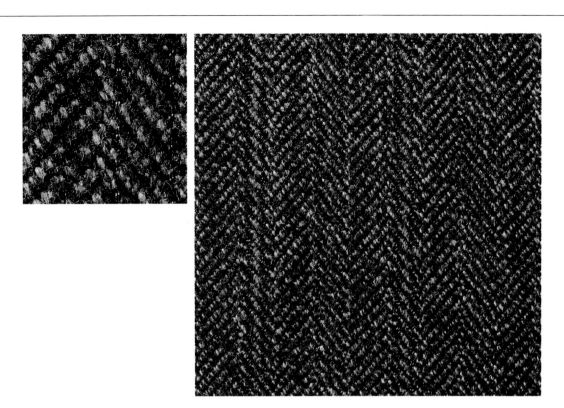

## CHEVIOT

It was originally produced with wool from a breed of Scottish sheep called Cheviot.
**Weave:** A fishbone pattern on a four-harness twill, it is intersected with a bright color silk decoration; the yarn is carded.
**Weight:** over 18 ounces.
**Use:** sports suits or dress pants.
**Characteristics:** Among the classic types of fabrics, it is one of the heaviest; it is coarse and is obtained from carded yarn. It is a fairly elastic fabric and does not crease easily.

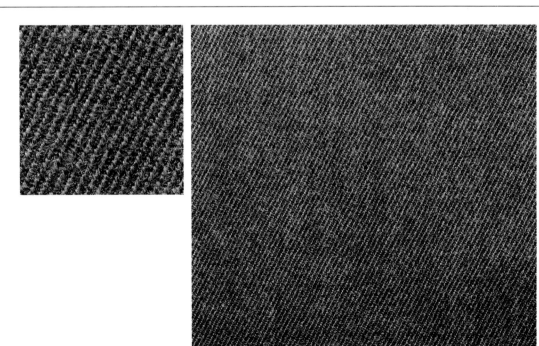

## COVERCOAT

**Weave:** mainly twill weave with a diagonal effect; the worsted yarn used for this material has a contrast twist effect; in other words, it is obtained by the twisting together of two different-colored threads.
**Weight:** 13 to 16 ounces.
**Use:** pants and overcoats.
**Characteristics:** It should feel smooth and closely woven, as well as having a certain elasticity. A very resistant material, it cannot be easily worn out.

## CREPE

**Weave:** This can be a special type of weave called crepe, or it can be a plain weave or even a twill weave; the yarn is worsted.
**Weight:** 7 to 11 ounces.
**Use:** jackets and men's suits. It was once used mainly for women's clothing.
**Characteristics:** It has a mat effect obtained with a high-twist yarn known as crepe-twist. This is why different types of weaves made of the same yarn are also known as wool crepes. The fabric is dry, airy, and fits loosely, making it suitable for summer wear. It does not crease much, but if the fabric is not of the best quality, it can be coarse to the touch.

## CROSSBRED

The name derives from the fact that this cloth is made with wool from crossbred sheep.
**Weave:** twill weave. It is produced with contrast-twist worsted yarn and with two or more plies.
**Weight:** 18 ounces and more.
**Use:** It is typical of the English sports suit, the suit to be used during the weekend, but no proper Englishman would wear it while conducting business in London.
**Characteristics:** It is very resistant but is considered too heavy and is no longer fashionable.

## FAILLE

It is quite popular in the Middle East, where it is used for suits with a Western cut.

**Weave:** satin weave with the weft threads thicker than the warp threads.

**Weight:** 12 to 13 ounces.

**Use:** dress suits.

**Characteristics:** Made of worsted yarn with a mat face and a shiny back, it is also widely used in women's clothing. It is highly resistant. Garments made with this material always have a neat appearance and immediately recover their shape even after a long day of wear. It has a tendency to become shiny.

## FLANNEL

Fabrics known as chalk stripe are always made of flannel.

**Weave:** usually a twill weave. It is milled and made of carded yarn.

**Weight:** 10 to 13 ounces.

**Use:** suits and pants.

**Characteristics:** Flannel can be woolen (carded) or worsted. The latter type is lighter, not as soft, and has a more visible but more resistant weave. Garments of this fabric require a certain amount of "rest" after having been worn. Flannel tends to peel in the areas subject to the most friction; this is why it's better to have two pairs of pants for every jacket of this material.

## GABARDINE

**Weave:** twill weave, sometimes three-harness weave. It is characterized by vertical twill lines obtained with more warp threads than weft threads. It is tightly woven to make it almost water resistant. The yarn is combed.

**Weight:** 8 to 11 ounces.

**Use:** suits and pants.

**Characteristics:** It is a rather delicate fabric. When buying a gabardine garment, it is a good idea to be sure of its quality, elasticity, and resistance to avoid possible shrinkage or distortions after the initial dry cleaning.

**See also:** cotton gabardine.

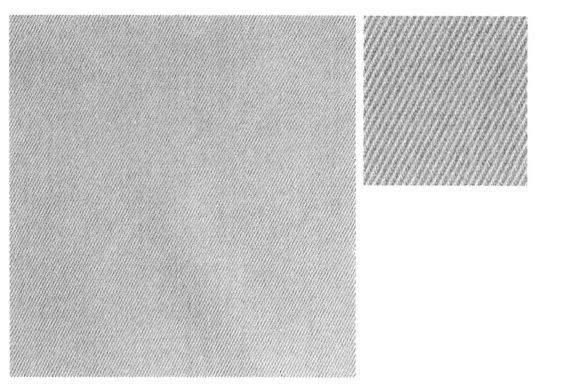 

## GRANITE (Granite Effect)

**Weave:** granite weave. It is woven with worsted yarn and has a grainy surface derived from the particular kind of weave from which it gets its name.

**Weight:** 11 to 13 ounces.

**Use:** suits and jackets. The barathea version of this fabric is used mainly for dinner suits.

**Characteristics:** It is a strong fabric that should never weigh less than the abovementioned amount. Although resistant, it has a tendency to become glossy very quickly.

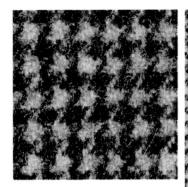

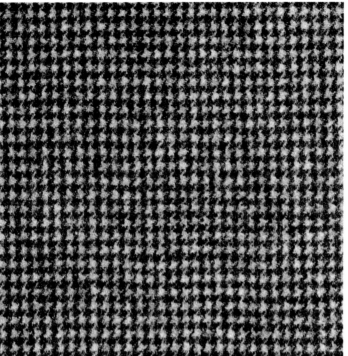

## HOUND'S TOOTH

**Weave:** twill weave. The effect is obtained by intertwining four light threads with four dark threads to create a checkered pattern. It's produced with either worsted or woolen yarn. (Also known as four-and-four check.)
**Weight:** 7 to 16 ounces.
**Use:** jackets and suits.
**Characteristics:** This kind of material does not exhibit any particular type of problem. In fact, the simple and highly regular design can hide possible defects in the yarn.

## LIGHTWEIGHT WORSTED SUITING

**Weave:** twill weave. This is a cloth with a silky hand obtained from very fine worsted yarns. (Also known as foulard.)
**Weight:** 7 to 11 ounces.
**Use:** suits
**Characteristics:** It is a very resistant fabric for spring and fall, but is now widely used all year round.

## LODEN

**Weave:** twill weave. This fabric is obtained with carded yarn. Loden generally is made of coarse wool or, in better qualities, of wool and mohair, and its characteristic drawn finish makes it almost waterproof. It is usually milled on the reverse side.

**Weight:** 13 to 18 ounces.

**Use:** sports jackets, cloaks and sometimes coats.

**Characteristics:** The nap must be short, dense, and closely woven; if the nap is too long, it is not a true loden. A coarse fabric and not very suitable for indoor wear, loden is traditionally worn in the Tyrol, where it is still used by hunters and shepherds who appreciate its water-resistant properties.

## MELTON

This fabric has been used since ancient times and is named after Melton Mowbray, a town in Leicestershire.

**Weave:** mainly plain or twill weave. It is a fabric made from carded wool that has undergone heavy milling.

**Weight:** 16 ounces.

**Use:** military uniforms, mountain clothing, and pea coats.

**Characteristics:** It is not easily maintained because of a tendency to attract dust and impurities from the air. It therefore requires frequent brushing. If it's too light, it will not keep its shape.

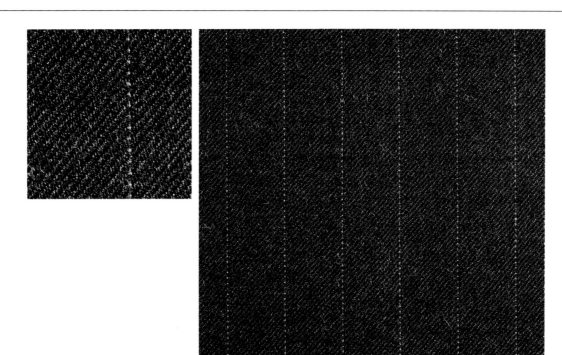

## MILLED WORSTED SUITING

**Weave:** mainly twill weave with worsted yarns. (Also known as foulé.)
**Weight:** 10 to 14 ounces.
**Use:** It is generally rendered in different kinds of designs, including pinstripes and herringbone.
**Characteristics:** It is a worsted fabric that has undergone a milled finish and is very similar to a worsted flannel; it sheds easily, and therefore it is advisable to avoid designs with a strong color contrast.

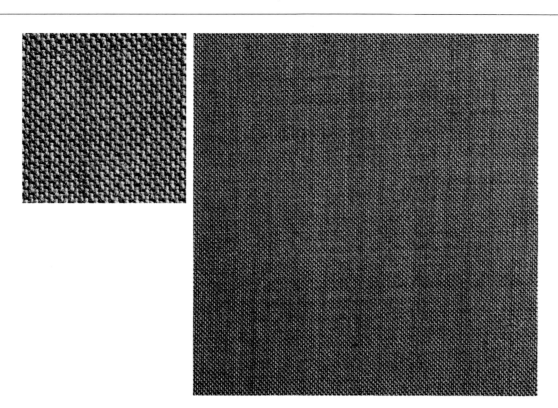

## PICK-AND-PICK

**Weave:** twill weave. It is a fabric obtained from worsted yarn with a one-and-one dark and light design. (Also known in the U.S.A. as sharkskin.)
**Weight:** 7 to 14 ounces. Pick-and-pick used to weigh 10 to 16 ounces and was the favorite fabric of businessmen. In the last few years, a trend originating in the United States has contributed to a reduction in the weight of this fabric to make it more practical.
**Use:** suits and pants.
**Characteristics:** Quality pick-and-pick must be manufactured with fine and regular yarn. Low grade pick-and-pick is immediately recognized by its irregular texture.

## SAXONY

Its name derives from the heirs to the English throne who, from the days of Edward VII, often wore garments made of this fabric.

**Weave:** twill weave. A milled cloth obtained from carded yarns.

**Weight:** 13 to 16 ounces.

**Use:** jackets, suits and pants.

**Characteristics:** Saxony, so-called because it was originally woven with wools from Saxony, should be soft to the touch, with very little nap. It is normally in a glen check design. Garments made of this material, and those made of flannel, pose problems because they must rest and thus cannot be worn over long periods of time.

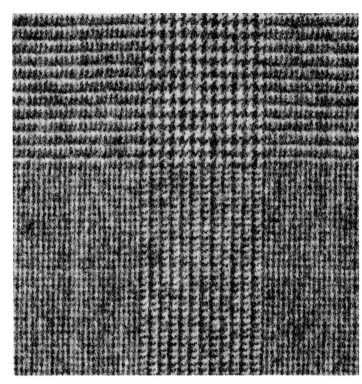

## SUNSHOT

**Weave:** three-harness weave with combed yarn.

**Weight:** 10 to 13 ounces.

**Use:** suits, especially spring and summer garments.

**Characteristics:** It is almost an iridescent cloth obtained with combed yarn. It is very similar to gabardine but with changing effects due to the different colors of the warp threads.

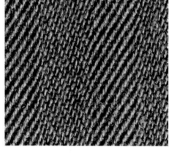

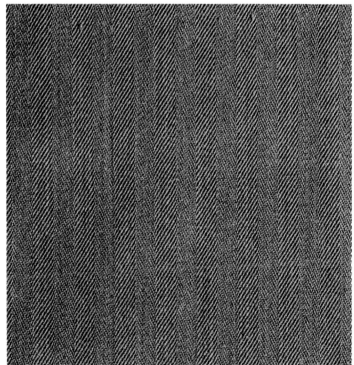

## TARTAN

Originally the colors of tartan served to distinguish the thirty-three clans of the Scottish Highlands.

**Weave:** twill weave. It is a fabric with checks of different colors. In ancient times, it was made only with carded yarns, whereas nowadays it is used also with worsted yarns.

**Weight:** 7 to 18 ounces.

**Use:** jackets, golf pants, and naturally, the famous kilts.

**Characteristics:** It is a slightly elastic fabric with good insulation qualities. It has a tendency to shed and felt.

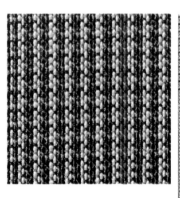

## TROPICAL

**Weave:** plain weave. It is a worsted fabric with relatively high-twisted two-ply yarn. It makes a lightweight, airy, yet sturdy fabric for summer suits and jackets. An important version uses a mohair wool blend in the weft, thus rendering the fabric more lustrous and resilient. It is often used for dinner suits.

**Weight:** 7 to 10 ounces.

**Use:** summer suits and suits for hot or tropical climates.

**Characteristics:** A variety of tropical is called "fresco" and is made of three-ply yarn. It is no longer popular because of its higher weight.

## TWEED

The name derives from the Scottish word "tweel," an English twill, which means "to cross." Subsequently, the name evolved and took the name of the Tweed River, which separates England from Scotland. There are different varieties of tweeds that generally take the name of the area of their origins.

**Weave:** twill weave with a diagonal effect; the yarn is carded, using the local wool.

**Weight:** 11 to 18 ounces.

**Use:** jackets and vests.

**Characteristics:** It is a fabric that is very easy to imitate. Tweed is prickly and very coarse. It can last for a couple of generations but the areas of major wear must be repaired with patches of leather. Due to its coarseness, tweed is not appropriate for the tailoring of pants.

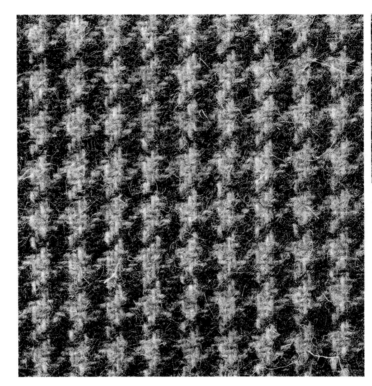

## DONEGAL TWEED

Its name derives from the Irish city where it was originally woven.

**Weave:** plain weave with woolen knobs; the yarn is carded.

**Weight:** 11 to 18 ounces.

**Use:** jackets and country suits.

**Characteristics:** Colored woolen knobs contrast with the warp and weft yarns to create a typical effect. It is one of the most common variations of tweed and is often used for caps and knickerbockers.

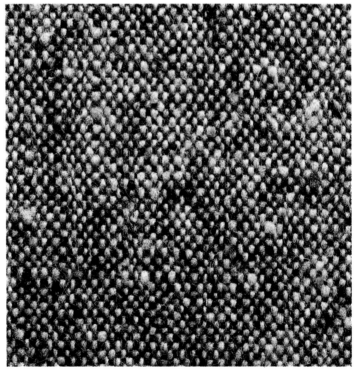

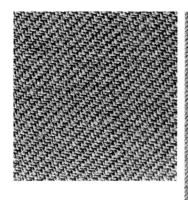

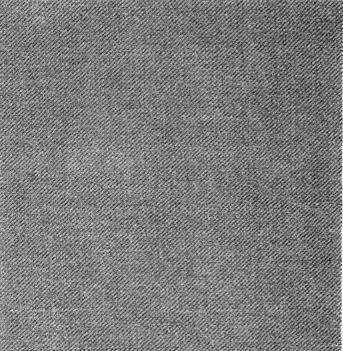

## TWILL

**Weave:** twill weave. The fabric is produced with combed yarn and has a diagonal effect. (Also known as serge.)
**Weight:** 10 to 13 ounces.
**Use:** suits and the classic blue blazer.
**Characteristics:** It is not very elastic and thus keeps its form, but it has a tendency to become glossy after repeated wearing.

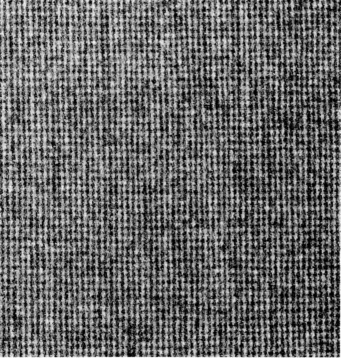

## TWO-AND-TWO

**Weave:** twill weave. The color effects are obtained by the intertwining of two light and two dark threads.
**Weight:** 7 to 14 ounces.
**Use:** jackets, suits and pants.
**Characteristics:** It does not pose any particular problem.

# PRECIOUS FIBERS

The camel coat, the vicuna jacket, or the cashmere suit are the height of male elegance. They are also the softest and warmest garments on the market.

Produced from the highest quality materials, some of which have been known since ancient times, the use of these fibers in Western clothing is fairly recent, going back only as far as the Twenties. The English were the first to use these materials. In fact, for a long time the English held a monopoly over the most elegant and valuable fabrics for men. Initially, camel's hair was the only material used, especially for coats, while cashmere had a more varied use.

The Thirties witnessed an increase in the popularity of these fabrics, though mostly among a limited group of wealthy individuals who could afford to pay high prices. Those years were characterized by significant industrial development and by a more intense economic and commercial relationship with the countries that provided these raw materials. In addition, people began to pay greater attention to fashion and clothing in general.

Refined yet comfortable, elegant and costly, these textiles possessed all the qualities that would make them popular among the newly rich Americans. Not surprisingly, they were bought mostly by these same Americans. The images of the Prohibition era are typical: the gangster who sports a pinstriped suit, a camel's hair overcoat tied at the waist, and a pair of suede shoes.

Precious fibers originate from the extraordinary fleece of different species of animals of various sizes and shapes. All of them, however, possess the characteristics necessary to survive in regions with unusually cold climates. Some are goats, some are camelidae, others are Angora goats, and some are even rabbits.

There are various types of camelidae. Originally from North America, they migrated southward during the glacial period and are now found in the wild or in the pastures of the Andean Highlands. The hunting and consequent exploitation of their hair are strictly controlled by the Peruvian government, which has encouraged the domestic breeding of the animals as a means of obtaining the fibers in a more bloodless fashion. The camel, on the other hand, migrated to Asia in ancient times and lives mostly in the region stretching from Mongolia to the Persian Gulf.

While the exploitation of the hair of some animals is a recent custom, the opposite is true for other species. For example, mohair, sheared from Angora goats, was used in Biblical times to weave the ornamental curtains of the Hebrew tabernacles. Cashmere, however, was used for shawls during the time of the Mongol Empire, while priests and emperors of the Andean peoples wore cloaks of vicuna. Since it was necessary to kill the animals to obtain their valuable fibers, hunting was restricted, even in ancient times, to once every four years.

In most cases the fiber is taken from the plush undercoat of the animals and is known as either borra or duvet. It is not taken from the outer coat of the fleece because these fibers are too stiff and coarse. The hair of the undercoat grows abundantly during the winter months; it is fluffy, very soft, and very similar to silk. Some of these fibers have such a beautiful natural color that they are almost never dyed. In some cases, such as with camel or vicuna, the names of these natural colors have been taken from the names of the animals themselves.

Naturally, all fabrics produced from precious fibers are very costly.

## ALPACA

It belongs to the camel family and is very similar to the llama, though a little smaller. It is bred in flocks on the Andean Highlands. The average yield for one animal is about seven to eight pounds. The fleece is much like that of the Angora goat, a fairly ordinary outer coat but a downy undercoat.
The extremely valuable undercoat has a diameter of 14 microns.
**Weave:** twill weave with a drawn finish.
**Weight:** 11 to 18 ounces.
**Use:** jackets and coats.
**Characteristics:** Softness and luster.

## ANGORA

It is believed that the Angora rabbit originated from a genetic change among wild rabbits in France during the first half of the 18th century. The breeding of this particular kind of rabbit is especially intense in China, where its white, silky coat is sheared every three months. An average of 10 ounces of fiber is obtained at each shearing.
**Weave:** twill weave.
**Weight:** 10 to 14 ounces.
**Use:** jackets and coats.
**Characteristics:** Lustrous, soft and warm. It is generally mixed with wool because it is very delicate.

## CARDED CASHMERE

It is obtained from goats bred in certain areas of Tibet, Mongolia (where the most valuable cashmere originates), and Iran (where the fiber is less valuable). Colors include white, brown, gray, and red.

**Weave:** twill weave.

**Weight:** 10 to 13 ounces.

**Use:** jackets and coats.

**Characteristics:** It is a very soft and resistant fabric, usually milled. Although the fibers of goat's wool bind together when milled, this is not true of camel and cashmere. The fibers can also be combed, which makes the yarn stronger and almost as durable as wool.

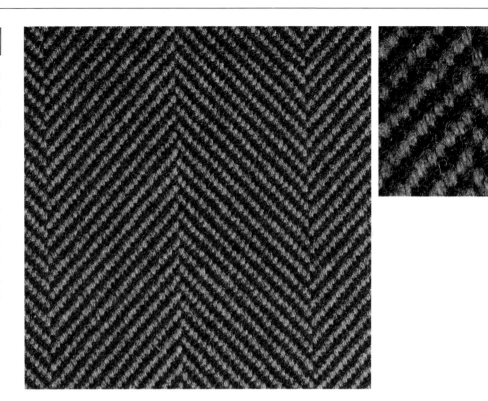

## WORSTED CASHMERE

**Weave:** twill weave.

**Weight:** 8 to 10 ounces.

**Use:** suits and jackets.

**Characteristics:** The fabric is woven from the best part of the fiber. This is because the combed yarn cannot be spun with defective or imperfect fiber. This yarn yields extremely light materials that are nevertheless more resistant than carded cashmere. Normally, worsted cashmere does not suffer from "pilling" (the creation of little balls of fuzz on the surface of the material), but it is more expensive than carded cashmere.

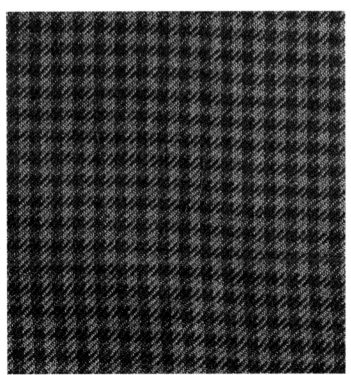

## CAMEL HAIR

Hair taken from the outer coat of a Bactrian camel is coarse and can be as long as 15 inches with a diameter of 20 to 120 microns. Hair taken from the undercoat, however, is very fine and soft, has great thermal properties and is 1 to 5 inches long. It usually has a reddish or light-brown color. The hair of a dromedary, on the other hand, is even coarser and thinner because it lives in the hotter climates of the Middle East.

**Weave:** twill weave with a drawn finish.

**Weight:** 11 to 18 ounces.

**Use:** coats and jackets. Usually, it is produced in its natural colors or is dyed blue.

**Characteristics:** It is very warm and soft but less delicate than a cashmere.

## LLAMA

It belongs to the camel family and lives in the Andean Highlands at an altitude above 13,200 feet. The fleece comes in four colors: white, reddish brown, gray, or black. The outer coat is thick and ordinary, while the undercoat is shiny and warm.

**Weave:** twill weave.

**Weight:** 10 to 14 ounces.

**Use:** jackets.

**Characteristics:** It is light and lustrous but not very soft. The fibers to be woven are usually taken from a llama that is less than one year old.

## MOHAIR

It is produced from the hair of the Angora goat, a breed that has existed for 3,000 years and that was once bred mainly in the center of Anatolia. Today, the best farms are in South Africa and Texas. By far the most valuable breed, it has a milky-colored fleece, although different varieties can be black, brown and rose-colored. The hair is less curly than sheep hair and is therefore shinier.

**Weave:** Normally plain weave.

**Weight:** 7 to 11 ounces.

**Use:** summer suits, especially the well-known "mohair tropical." During the weaving process, the mohair is put into the weft, usually with a worsted wool warp.

**Characteristics:** Very resilient, lustrous, and durable. It rarely creases.

## VICUNA

It is the smallest member of the camel family. A wild animal that lives high in the Andes, it is very difficult to capture. The animal must be killed to obtain its fleece. The fiber of the extremely valuable undercoat has a diameter of 14 microns.

**Weave:** It is generally a twill weave.

**Weight:** 10 to 14 ounces.

**Use:** jackets and light overcoats.

**Characteristics:** Extremely soft and warm.

# LINEN

Linen was probably the first fabric used by man following his emergence from a prehistoric era in which he used only animal skins to cover himself. In fact, evidence of linen use dating back more than 10,000 years has been found in the Swiss lakes region in what seems to have been the center of an ancient civilization. Remains of linen cloths dating back to the Bronze Age have also been found in Ireland. The Egyptians, however, were undoubtedly the first civilization to put these wild plants under cultivation for subsequent use in the production of fabrics. As soon as the Egyptians realized its value, they began cultivating flax according to the seasons — sowing around the middle of November and harvesting in March.

Linen has been connected to religious rituals for centuries. In ancient Greece, the priests of Isis wore linen fabrics. In Roman times, the tunics of the vestal virgins and the purple stripe on the togas of the senators were made of linen. Ovid and Juvenal referred to Roman priests as "linen wearers." The mummies of the Egyptian pharaohs were wrapped in strips of more than 300 yards of the finest linens available. During the Middle Ages, all ecclesiastical garments were made of linen, as was the Holy Shroud.

Flax refers to any one of the 22 varieties of plants belonging to the genus *Linum*. This family also includes more than 200 species, but only the *linum usitatissimum* variety is widely cultivated for its fiber, which is extracted from the stem of the plant. The stem itself ranges from 28 to 40 inches in height, with a light-blue, pink, or white flower of five petals. The light-blue variety is finer and more valuable, while the pink and white varieties are more resistant but less valuable.

Linen varies according to its place of origin: Italian linens from Po Valley have a yellow-brown to reddish color; linen from Naples is gold colored and has a thick flat fiber; Russian linen is gray and shiny; Belgian linen is very shiny and long, while the Dutch variety is also very long but stronger and coarser. Finally, Irish linen is light, silvery, very soft, and easy to spin.

Flax must be soaked in order to extract its fiber. This involves the decomposition of the sticky parts that bind the fibers together. The next step consists of "scutching" the flax, which frees the fibers from their wooden residues. Women used to beat the flax on the floor of their homes. Today, a scutcher — or scutching machine — automatically performs the task of separating the short fibers and the residues, and regroups them into hanks of fibrous bundles. Two-thirds of the flax processed by the machine is scutched, which means that it is ready to be spun into linen, while one-third is waste. Spinning is followed by weaving and then by a series of finishing treatments, such as bleaching, dyeing, printing, and calendering, all of which give linen its distinctive mark of nobility. Interestingly, bleaching used to be done by leaving the material on dew-covered lawns; today it is done by artificial means.

The general method of spinning and weaving has been the same for centuries, though this does not mean that innovations have not taken place. One of the most important innovations occurred in 1811, with the invention of the first mechanical spinner. In response to a competition proclaimed by Napoleon, a French engineer, Philippe de Girard, built a spinning device with twelve spindles.

Linen supplied a great part of the world's demand for fabrics until the mid-1880s, when it was supplanted by cheaper cottons.

## FANCY LINEN

**Weave:** usually twill weave.
**Weight:** 8 to 10 ounces.
**Use:** jackets.
**Characteristics:** It is often woven in such a way as to produce the "shantung" effect (see silk), or that obtained by alternating thick and fine threads. In many cases it is also used in combination with silk and other fibers.

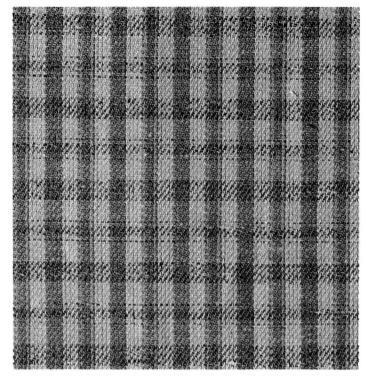

## IRISH LINEN

Irish linen has traditionally been the most widely used for men's suits, particularly in Italy, where it is especially valued as a material for summer suits.
**Weave:** plain weave.
**Weight:** 8 to 13 ounces.
**Characteristics:** It always comes in solid colors; it is very closely woven and tends not to crease as much as other linens. Its compact texture derives from the type of weaving and also from the structure of the fiber, which is very long and uniform.

## ITALIAN LINEN

**Weave:** plain weave.
**Weight:** 10 ounces.
**Use:** jackets, summer suits, pants.
**Characteristics:** Its weave is less uniform and its threads are softer than Irish linen. It is often yarn-dyed, a process that makes it possible to obtain a more delicate shading than that of Irish linen, which is normally piece-dyed. The fabric is lighter and softer than Irish linen and is thus more suitable for summer suits, even if it does crease more easily.

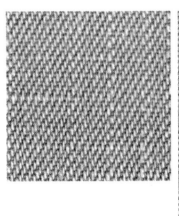

## LINEN GABARDINE

**Weave:** three-harness twill weave.
**Weight:** 9 to 11 ounces.
**Characteristics:** It may be considered the gabardine of linen. It is a less traditional cloth than the plain weave, though it is slightly heavier but softer and more resistant to creasing.

# COTTON

Cotton fabrics satisfy 47% of the world demand for textiles. If linen, silk, wool, hemp, and all the various synthetic fibers were added together, they would not be equal to the worldwide production of cotton. Perhaps it is for this reason that cotton is sometimes referred to as "the other half of heaven."

It is said that cotton is as ancient as the world. In Arabia, and in the northeastern parts of the African continent, cotton has been under cultivation for thousands of years. In a Tehaucan Valley cave near Mexico City, an archeologist found a lump of cotton dating back more than 8,000 years. A 5,000-year-old ball of cotton fiber, representing the first evidence of the use of cotton, was found during a dig at Mohenjo Daro in Pakistan.

The word cotton derives from the Arabic "qutn," which means "part of the conquered countries," and is a reference to the conquests of Alexander the Great.

The Saracens were the first to introduce cotton in Europe when they invaded Sicily. As a result, many cotton textiles bear the name of the Asian cities where they were originally produced.

Cottons are classified according to their yarn count, which is a number that corresponds to the relationship between the length and weight of the fiber.

The fiber's length determines the quality of the cotton: the longer the fiber, the glossier, more resistant and valuable is the cotton. The length of the fiber, i.e., its cut, can measure from less than one inch to more than an inch and a half. The best cottons are Egyptian (especially from the south), Sudanese, Peruvian, and the famous Sea Island from the British West Indies. This last group of cottons includes a variety known as Superfine of St. Vincent — whose fibers can reach a length of 50 or even 60 millimeters. This cotton is originally from South Carolina, and is now cultivated in the islands of Antigua, Montserrat, Nevis, St. Kitts, Barbados, and St. Vincent. Production is very limited and extremely valuable.

In 1930, the *Times* of London and other influential newspapers published a declaration by the Prince of Wales in which he revealed that he was a "steady wearer," meaning that he favored West Indian Sea Island cotton.

Cotton is a durable fiber; it is the only one that actually becomes stronger when wet, which means it can be washed repeatedly because it is not damaged by humidity. Moreover, it tolerates alkaline detergents and resists high temperatures up to the boiling point. For example, all surgical gowns and other garments requiring sterilization are made of cotton. It also has other useful properties. A cotton fiber is not electrostatic and thus does not disturb the wearer; it absorbs perspiration and will not irritate the skin or produce allergies; it can be ironed at high temperatures; it doesn't soil or felt, and can be easily dyed.

Cotton has few defects but some are worth mentioning: It is not particularly elastic, has poor thermal qualities, and creases easily. However, there are also cotton fabrics that shrink and those that require frequent washing. Problems that may arise with a shirt of carded Indian cotton certainly do not appear in shirts of mercerized cotton. In fact, the latter is produced with the finest cotton. It is combed and twisted, which guarantees a stronger, more resistant fabric. However, some of cotton's imperfections can be overcome with special treatments, or by mixing cotton with other fibers. Mercerizing is one possibility. The cotton is treated with alkaline substances to increase its strength.

## CORDUROY

Its name derives from the French "cour du roi," or "court of the king," where it was used for the hunting outfits of the servants. It was known as the velvet of the poor because it was made with cotton and not silk, which was used to make genuine velvet.

**Weave:** plain or twill weave.

**Weight:** 6 to 11 ounces.

**Use:** pants and sport suits.

**Characteristics:** It is the warmest cotton material because the ridges of the corduroy form an insulating cushion of air. A good-quality velvet can be identified by the compactness of the weaving on the reverse side. Like all cotton material, corduroy, when wet, will easily disperse body heat.

## DENIM

The name derives from the city of Nîmes in France, where this fabric was first produced. The term jeans comes from the corruption of the word Genoa. In fact, Genoese sailors, who were called "genes," used to wear pants similar to those worn by American gold prospectors of the Old West. Hence the name caught on in America.

**Weave:** twill weave. The weft threads are not colored, while the warp threads are colored with indigo blue, which comes from a vegetable dye.

**Weight:** 10 to 15 ounces.

**Use:** work garments, but mostly jeans.

**Characteristics:** It is a very resistant fabric. It discolors when washed but the discolored and beaten look has become very fashionable.

## DRILL

First used by the British for their colonial uniforms, it usually has a khaki or blue color.

**Weave:** twill weave with diagonal striping and a compact or tight texture. It is normally a carded fabric.

**Weight:** 10 ounces.

**Use:** military uniforms, work clothing, suits.

**Characteristics:** It is a resistant and durable fabric. The name drill is associated with robust fabrics used for uniforms and similar garments.

## FUSTIAN

A classic fabric once used mainly for warm weather working or hunting garments, fustian has gradually been replaced by lighter versions, especially those with a brushed gabardine, which gives almost the same effect.

**Weave:** satin weave. The fabric undergoes a brushing treatment that raises part of the fiber, giving it a suede effect.

**Weight:** 11 to 16 ounces.

**Use:** pants and sports suits.

**Characteristics:** Genuine fustian is a very stiff fabric and, like denim, becomes softer and more pliable with wear.

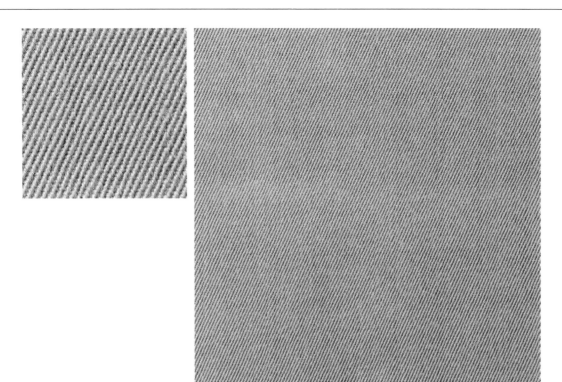

## GABARDINE

**Weave:** Four– or three–harness twill. The fabric has a diagonal effect.
**Weight:** 8 to 13 ounces.
**Use:** pants, summer and spring suits.
**Characteristics:** Good-quality gabardine can be identified by the uniformity of its ridges: The thinner the ridges, the higher the quality. In order to obtain a changing color effect, the weft threads are a different color from the warp threads.
**See also:** gabardine wool.

## GAUZE

A lesser-known fabric, gauze was used in colonial uniforms intended for tropical regions.
**Weave:** gauze, which is a variation of the plain weave, with the warp interlocking two by two by means of a specially prepared loom.
**Weight:** 5 to 8 ounces.
**Use:** jackets, shirts; frequently used for curtains.
**Characteristics:** It is a light fabric whose structure is similar to that used for polo shirts. It is elastic and porous.

## MADRAS

The name is taken from the Indian city of Madras, an important textile center. Genuine madras is made in India on manually operated looms. Individual pieces are usually quite short because the warp is often stretched 66 feet between two trees.

**Weave:** plain weave.

**Weight:** 3 to 6 ounces.

**Use:** Only the heavier type is used for jackets and pants, or even light furnishings. Other types are used for shirts and pants.

**Characteristics:** The fabric has a tendency to discolor because of the vegetable dyes, but this effect, called bleeding madras is valued by experts.

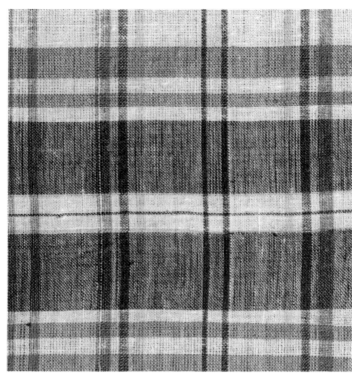

## POPLIN

The name comes from the Italian "papalina" (papal) because it was developed in Avignon, which temporarily served as the seat of the popes during the Great Schism.

**Weave:** plain weave. It is a mercerized cotton fabric with a slight horizontal effect in the direction of the warp.

**Weight:** 4 to 7 ounces.

**Use:** generally for shirts; its heavier version can also be used for summer suits and pants.

**Characteristics:** It is a very light fabric that wrinkles easily.

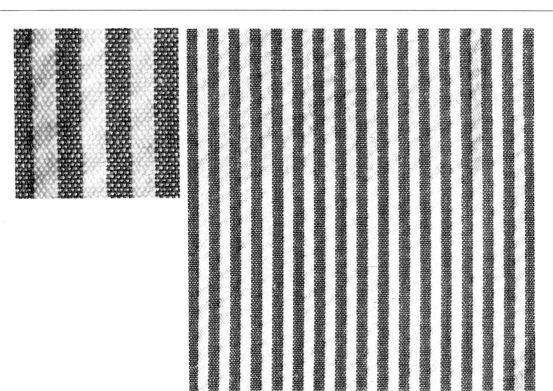

## SEERSUCKER

In America this fabric is made of 75% polyester to give it a wavier effect. Original seersucker was produced in India, where the cotton was woven along with silk that, shrinking differently from cotton, would create its characteristic wavy effect.

**Weave:** plain weave. The base threads are stretched while the weft threads are looser in order to give the impression of alternate lines with a crinkled effect.

**Weight:** 5 to 8 ounces.

**Use:** shirts, jackets, Bermuda shorts, and sports garments in general.

## VELVET

The name derives from the Latin "vellus," which means fleece. This type of velvet was, until a century ago, almost exclusively made of silk. It was brought from the Orient to Europe in the 13th century. In the following century, Venice became one of the major production centers of velvet. For the most part they were velvets with designs, as well as multicolored velvets called "garden velvet."

**Weave:** a plain or twill weave with an additional number of threads in the warp and the weft. Plain velvets are obtained by cutting the supplementary threads of the warp, in which case called velure.

**Weight:** 6 to 11 ounces.

**Use:** jackets.

**Characteristics:** It does not crease easily and drapes well.

# SILK

"Silk is the fabric you have to wear if you want to reach God," according to an ancient Chinese saying. The noblest, the softest, the finest among natural fibers, cool during the summer and warm during the winter, silk is a very thin and shiny filament. It is made from two silk flosses with a triangular section tied at one end, which the silkworm wraps around itself in different layers to form a cocoon known as tissue paper. The silkworm remains inside the cocoon during the chrysalis and butterfly stages. The name silk is generally given to a filament as long as 600 to 900 meters which is produced from the cocoon of the *Bombyx mori*, which feeds on mulberry leaves. The filament created by other kinds of lepidoptera that breed in the wild in Japan, China, India, Africa, and America is called tussah silk, and is darker and coarser.

Sericulture probably began in 2600 B.C. in China, which even today accounts for two-thirds of all the raw filaments produced worldwide. This is due to China's thousands of years of experience and its continued production of silk during the 1950s—when artificial fibers, which the Chinese were unable to produce, were glutting the world market. Moreover, the breeding of silkworms is so labor intensive that, at present, only the Chinese can afford to do it. Today, more than 10 million Chinese are involved in the breeding of the 300 varieties of silkworms.

Silk was known to the Greeks and Romans in the first century B.C. and they imported it in the form of extremely valuable clothing. Various authors — among them Seneca, Horace and Pliny — mentioned silk fabrics as the most refined and luxurious garments, noting that they were used mainly by wealthy courtesans. Silk was considered too effeminate for men and its use was prohibited under the reign of Tiberius.

However, silk has a great historical value. In fact, its movement along the silk routes, which covered enormous distances, helped create the commercial and cultural ties between the Orient and the West.

Justinian of Byzantium introduced sericulture into the Mediterranean Basin in 1552. He charged two merchants (who would later disguise themselves as monks), with the task of stealing the secrets of raising silkworms. Spain was the first country to develop a silk industry, followed by France, England, Germany, and Holland. In Italy, the golden age of silk was the sixteenth century: Venice, Florence, and Milan were the most important centers. The local artisans would create splendid patterned fabrics, which would then be used to make the garments for Italian and foreign courts. Silk processing involves a number of different stages. The cocoons, once dried for preservation, are sifted according to their thickness, then manually sorted according to their qualities and defects, and then passed to the spinning mill to undergo treatment.

There are a variety of treatments. Steeping softens the external layer of the cocoon and is carried out in tubs filled with steam-heated water; brushing, executed with special machines that tie together the ends of the silk filaments; and silk reeling, which groups a certain number of silk filaments according to their count, thus forming a raw silk thread which is then twisted, washed, and wound into skeins.

Fabrics produced with silk are divided into different types according to the thickness of the thread or count, their degree of twist, and the type of weave. There are four varieties of fabrics: taffetas, twill, satin and jacquard.

The resistance of the fabric depends on the type of fiber. Organzine, for example, is very resistant.

## FAILLE AND SATIN WEAVE

**Weave:** satin weave. It is a fabric with an opaque color on the front side but with a shiny back.
**Weight:** 8 to 13 ounces.
**Use:** dinner jackets. Once very popular, it is now limited almost exclusively to jackets. It is used mostly for women's clothing. The part with the satin-weave effect is used for the lapels of tuxedos.
**Characteristics:** It is shinier than wool and more uniform than shantung. It is a particularly delicate fabric.

## SHANTUNG

The name derives from a province in northern China that is a famous center of sericulture.
**Weave:** plain weave. The fabric is coarse, with identifying knots that are irregular. These knots are the result of two silkworms spinning the same cocoon. It is actually a defect that, because of its rarity, has become an asset.
**Weight:** 8 to 10 ounces.
**Use:** suits and jackets. The classic combination is a white shantung jacket with black pants.
**Characteristics:** This fabric does not crease; it is resistant and flexible. It is not as delicate as other silk fabrics. Poor quality shantung is recognizable by its artificial irregularities created from silk wastes that easily peel and cause holes.

## SILK AND WOOL TWILL

**Weave:** plain weave.
**Weight:** 6 to 13 ounces.
**Use:** suits and jackets.
**Characteristics:** It is sometimes used for suits that have a shiny effect. In this case, they have a dark woolen background, and little dots of silk. This version is heavier than silk plain weave, and is often combined with wool and used for sports jackets to provide a raw and rustic effect. These jackets are very durable. The resistance varies according to the type of silk used: It is very good if the thread is organzine, fairly good if the thread is obtained with combed silk waste.

## SILK PLAINWEAVE

**Weave:** plain weave.
**Weight:** about 7 ounces.
**Use:** jackets.
**Characteristics:** It is glossier than wool but more uniform than shantung. It is a light fabric especially suited for summer. In the more closely woven and therefore heavier version, it is known as silk poplin.

# CUT & TAILORING

*— In suits as in legislation,*

*man does not proceed by chance, he is always guided*

*by the mysterious acts of his mind. In every fashion,*

*in every form of dress, the Architectural Idea*

*is ever-present. The body and the suit*

*represent the place and the material on which*

*— and with which — one must construct*

*the splendid edifice of the entire Personality.*

*— Thomas Carlyle,*
Sartor Resartus

# THE CUT

It is better to be the master of you own fate than to be a slave to it. In a sense, this is also true of clothing, where choosing according to your own taste and physical requirements is preferable to being a slave to fashion or a hapless victim of your tailor's sudden inspirations. Which means it is probably a good idea to avoid men's handbags, bell-bottom pants, white turtleneck sweaters like those worn under dinner jackets in the '60s, or jackets with enough shoulder padding to satisfy NFL safety requirements. And this list is by no means inclusive.

Even if you seek shelter in classic materials and styles, be aware that what you have chosen is influenced not only by the tastes of your designer but by the fashion traditions of your country as well.

It is worth noting to those who dress in western-style jackets and pants that cuts and tailoring are divided into four or five great schools. Each has a direct influence on a tailor's work. Even when trying to create a suit with a personal style, a tailor is likely to produce a finished product bearing the unmistakable influence of one of these schools.

The English school heads the list, followed by the American, Italian, and French.

The "school" of a suit depends on how the shoulder is shaped. It may be padded or natural, with varying degrees of fullness. Or it may be sharply or broadly angled, narrow and high, or low and sloping. In addition, it may be influenced by a series of "strategic" decisions regarding the so-called ring of air, or the suit's capacity to cling or adhere to the body, for which a jacket can be waisted or straight, long or short. These elements can be mixed and used in a variety of combinations to create a jacket that conforms to a rigorously classical cut.

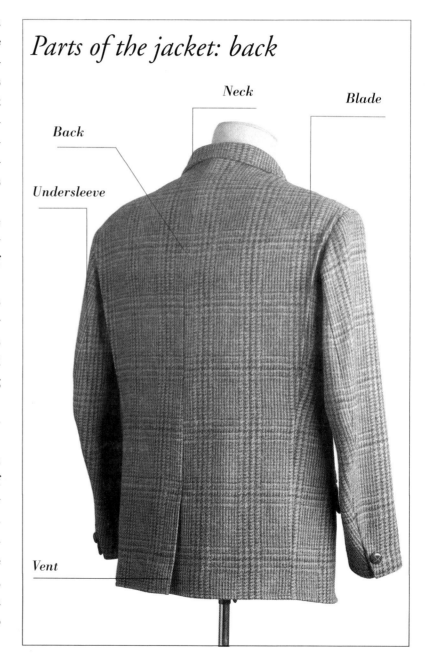

*Parts of the jacket: back*

Neck

Blade

Back

Undersleeve

Vent

# *Parts of the jacket: front*

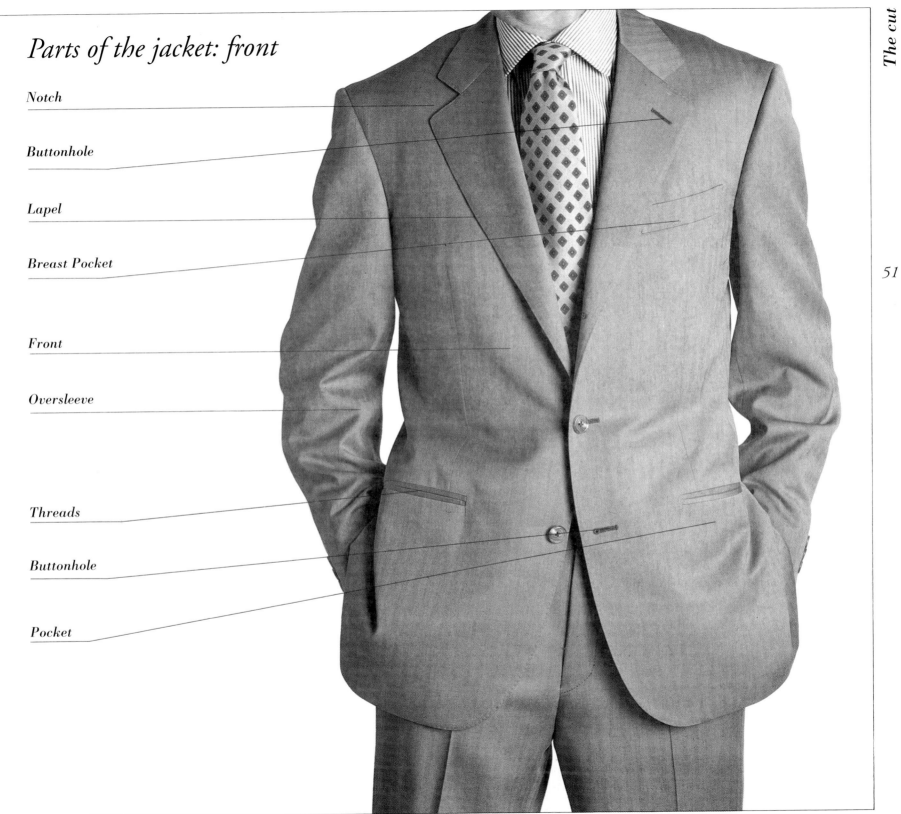

Notch

Buttonhole

Lapel

Breast Pocket

Front

Oversleeve

Threads

Buttonhole

Pocket

52

## The English School

For decades, if not centuries, the English suit was synonymous with elegance, so much so that all over the world it is still possible to see people dressed in different interpretations of the English style, ranging from tweed to pinstripes. As a matter of fact, the English style is more popular abroad than it is in England, where only an aging landowner or a steadfast client of a Savile Row tailor will continue to uphold the tradition.

The key to this universal appreciation can probably be found in the extreme soberness of the cut, along with the careful attention to detail. It is best understood by observing the Changing of the Guard at Buckingham Palace. Officers and soldiers of the guard wear jackets and overcoats whose cut and styling are as fine and distinguished as those of the best tailoring establishments in the world.

The English jacket tends to adhere to the lines of the body and is marked at the waist. The shoulders are soft, have little padding, and are not particularly large. The line of the suit is soft, with the fabric well adapted to the movement of the body, even around the armholes, which are usually cut quite high. The two side vents are fairly high, even in dress suits, which, in Italy for example, are usually tailored without vents.

A single-breasted jacket has two or three buttons, and most suits of this type come with a vest. The double-breasted jacket, whether alone or in a suit, is more popular in England than in America. The trousers usually have two pleats while the pockets are placed along the seams.

One of the characteristics of English jackets—which is shared by all garments of good tailoring—can be seen in the blade, meaning the fold on the back of the shoulder attachment. This detail, which requires a certain measure of tailoring skill, provides more comfort and greater freedom of movement.

## The American School

Contrary to popular foreign stereotypes, Americans are quite capable of dressing elegantly, even in settings that do not require sportswear, which happens to be the area in which American quality and design set the standards for the rest of the world. The basis of American fashion is the "natural shoulder." The shoulder is soft, slopes evenly, and has little or no padding, which further flattens the edge of the shoulder. Jackets almost always have three buttons, with only the center button fastened. The lapel tends to roll onto the center button, thus hiding the top button. The epitome of the "natural shoulder" trend was reached with the "sack coat," so-called because its very straight form resembles a sack. It was introduced by Brooks Brothers, the famous clothing house of New York, and has become one of their trademarks. For nearly half a century, the sack coat, with its limited padding, has been the "uniform" of the East Coast establishment. The strongholds of the sack coat are the areas of Boston and New York.

Comfort has always been the categorical imperative of American clothing. The sack coat offers the advantage of great comfort with its own particular brand of elegance. The sack coat always has three buttons, but its armholes are wider than the English version, thus providing more comfort and adaptability to different physiques. It is no coincidence that this characteristic has had great success among industrial manufacturers of men's clothing. The pockets of the jacket always have flaps, and the back has only one vent.

The pants are always without pleats, and the fit down the leg is relatively tight. They usually have short cuffs to avoid having them rest on the shoes. The pants pockets are another sign of the comfort-first imperative. They do not open along the seam, but run diagonally in a configuration that makes it easier to reach inside them.

The fabrics most often used for this type of garment are glen checks, pinstriped fabrics, wool and dacron tropicals, tweeds and shetland.

In addition to its success on campuses, the sack coat is popular among the Madison Avenue advertising establishment and with members of the liberal arts professions: teachers, journalists, editors. There is a soft-shoulder version for business-

men, which is characterized by a slightly padded, wider shoulder, though it remains soft, and has a more waisted cut. In this version, the jacket has two buttons and the pants are often without pleats. This American cut is likely to come with a vest to form the well-known three-piece suit. Double-breasted models are not as popular. This type of American cut represents a middle ground in men's style between a classical European cut and the traditional sack coat.

A third cut dominates men's suits from the Midwest to the California coast. The result of Hollywood influences, it is colorful and lively.

Once known as the hourglass cut, it is characterized by a high, wide, and padded shoulder, with a well-marked waist and a long and wide lower part. The two vents in the back are very high; they open to reveal the behind when the wearer is walking.

One style of dress that certainly fits in with the West Coast's exuberance is none other than the zoot suit, a version of which was a favorite among American blacks, especially in the Harlem of the '40s. It was very popular in the areas of Los Angeles that were influenced by their proximity to the motion picture studios. This makes sense because the suit certainly does attract attention. It comes with enormous shoulders and extra-large pants with an incredibly high waist. The style began just after the outbreak of World War II, and was greatly discouraged by the authorities because its production required a huge

amount of material that, in the government's view, could best be used to outfit the troops.

Among other things, the hourglass cut is characterized by wide lapels and, like the zoot suit, it helps create the impression of a dynamic and athletic form. It is, however, decidedly less comfortable than the sack coat, though certainly more flashy.

## The Italian School

The Italian school was dominated by tailors from southern Italy. Their traditions are continued by sartorial houses in Rome and Milan founded by tailors, or families of tailors, coming from the south.

From the end of the last century until the first part of the twentieth, the center of Italian men's fashion was Naples, which in turn was influenced significantly by the English school. In fact, for nearly a century, the Kingdom of Two Sicilies, and Sicily in particular, was considered something like an official colony of the British Empire. It is no accident that in Italy a lightly padded shoulder with a shirtlike attachment is called a Neapolitan shoulder. It has seams pressed on the inside to create the effect of a soft and very low shoulder. The concept of the natural shoulder in Italy is, however, limited to a few sartorial schools, of which Caraceni is the most famous.

In Italy, the shoulder is usually quite high, padded, and sags a bit. In America, it is known as the wedge shoulder. Like jackets

of the continental style, the Italian jacket clings a bit more tightly to the body and has a rather narrow armhole.

In the past, the Italian style tended to veer towards certain extremes, such as small and extremely tight jackets, or to suits that would pull in every direction the moment something was put into the jacket pocket or if a hand reached into one of the pants pockets. An example of this tendency was the competition held in San Remo in which tailors would compete in creating a jacket with the least amount of material. The idea was not just to save materials, but to show off their ability to stitch together a suit with the tightest fit possible, regardless of comfort.

The jackets generally have pockets without flaps and are ventless in the back. In Italy, single or double vents are often limited to sports jackets.

The pants have diagonally cut pockets and a low waist—even lower than those made in America. These characteristics developed because the Italians were among the first to abandon pants with suspenders, which require a high waist. And pants that require belts do not fall as much, provided that the waist rests securely on the hips. Suspenders probably fell out of favor because of the relatively hot climate on the peninsula, which gave impetus to the shedding of hats and jackets on informal summer occasions. Without a jacket and vest, an exposed pair of suspenders is not the height of fashion elegance. The classic Italian

line is extremely difficult and complicated and requires great tailoring skills to produce the desired effects. If not cut properly, the resulting suit can be very uncomfortable.

Grafted onto these characteristics were innovations by that movement of designers or stylists headed by Giorgio Armani, which radically altered the image of the classic Italian suit. Armani has attracted to his school a group of tailors specialized in the crafting of custom-tailored suits. Armani can be credited with a revision in clothing style that, over time, has led to the production of jackets with a looser, more casual fit and appearance. For this new style, to which all the major Italian designers would later contribute, an extensive search for primary fabrics was carried out. Lighter fabrics were preferred for the production of jackets with a lighter lining and less padding, which resulted in looser and fuller garments. It is no accident that Super 100's, the extremely light worsted fabric that made these new creations possible, was developed in Italy. This made-in-Italy fashion movement of the '90s culminated in a style of jacket characterized by large and rounded shoulders with a front pitch. Such characteristics in the cut had already been experimented with in the United States during the late 1930s, and were popularized by Clark Gable and Cary Grant. In those days the effect was different, due to a lack of light fabrics, even though research into producing such fabrics was underway in America. Wool crepe figured prominently among the materials that contributed to the modification of the Italian shoulder line. This is largely due to the characteristics of the twist of its threads and the type of weave, which produce a loose effect that fits in well with the interpretation of the new designers. This new approach, with its lower armhole, is quite suitable for the mass production of ready-to-wear lines. At the same time, the Italian school was able to maintain a cut in which the jacket is tapered and follows the contours of the body. Close attention to detail and finishing have contributed to the outstanding international reputation of made-in-Italy fashions.

## The French School

The French school derives from the style begun in the '60s by Pierre Cardin, who proposed a jacket with high shoulders and a visible little roll at the sleeve's head. This type of jacket—which had previously been created by Roman tailors—was flared and very long. It is a reinterpretation of an informal horseback-riding jacket that was very popular in England in the first half of the century. This jacket, in its turn, originates from a kind of sporty frock coat.

Cardin's jackets had very high lateral vents, while the pants were bell-bottomed and without pleats. Some of these elements can still be found in the basic structure of French men's clothing.

## The German School

The suits of the German school have always been designed for comfort and durability. The shoulder of the jacket is low and natural, with the seam running diagonally along the back of the shoulder rather than along its ridge. The breast is prominent, to provide enough room on the inside for pockets deep enough to hold wallets, notebooks, pens, etc. The crotch and the waist are low. The fabric is often quite strong and can reach nearly 19 ounces in weight. This helps give the suit an aspect much like that of a suit of armor.

This German style has virtually disappeared among the upper classes but survives among the lower bourgeoisie and in the East European countries.

*English School*            *American School*            *Italian School*

# THE JACKET

Within the boundaries of a particular school, a jacket can vary depending upon a series of accessories, the cut of the lapel, or the number of buttons. Speaking of buttons, keep in mind that with single-breasted, two- or three-button jackets, fasten only the one in the middle, never the lowest. However, with certain jackets of a particular cut, the two top buttons can be fastened. A typical three-button jacket with all three buttons securely fastened evokes the image of a country bumpkin coming to the market on Sunday.

Hunting jackets with three or four buttons are normally the ones that are completely fastened. Double-breasted jackets are generally worn with one button fastened; usually the upper, but it might also be the lower one, according to taste.

# Dinner Jackets

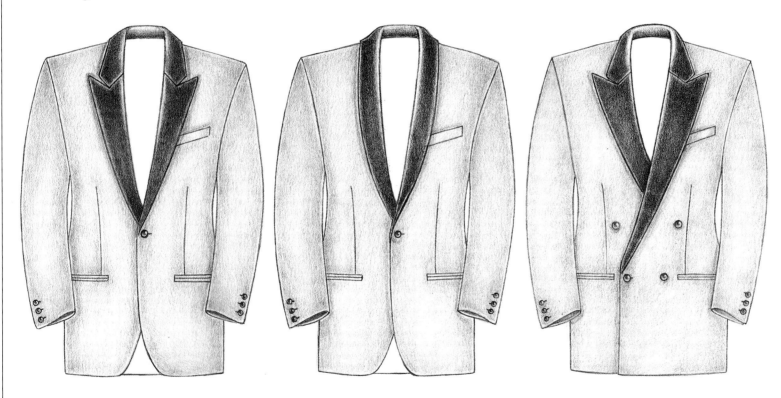

**Single-breasted with peaked lapel**
*Usually black or dark blue for winter, white for summer, the dinner jacket is the formal suit par excellence. Shown above is one of the four variations of the jacket: single-breasted with a peaked lapel.*

**Single-breasted with shawl collar**
*The single-breasted version with a shawl collar is less suited for those who have problems with their shape. Besom pockets are used in every version of this jacket.*

**Double-breasted**
*The double-breasted dinner jacket has either a shawl collar or raised lapels—like that shown above. The jacket has four buttons; the pockets are cut to the height of the lower buttons.*

# Waisted Jackets

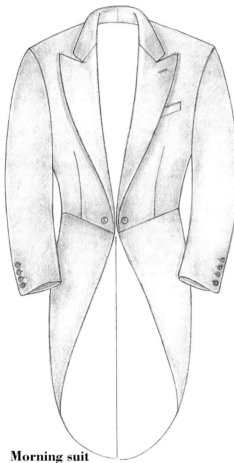

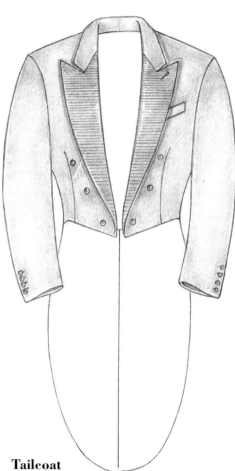

**Morning suit**
*The morning suit is still the most popular of the waisted coats. It is characterized by a tail that partially covers the legs. It is always buttoned and worn with a vest.*

**Tailcoat**
*It is the oldest garment; its shape and cut have remained virtually unchanged since the 18th century. It is worn with a white piqué vest and is left unbuttoned.*

**Spencer**
*The spencer or mess jacket is usually worn in the evening at the officers' mess. Appropriate in summer at formal dinners in place of a white dinner jacket. It is not buttoned.*

## Double-breasted Jackets

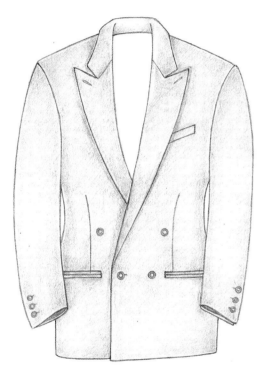 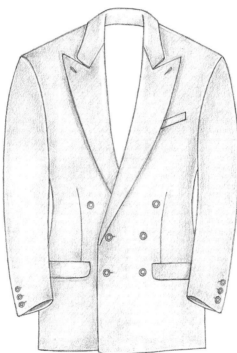 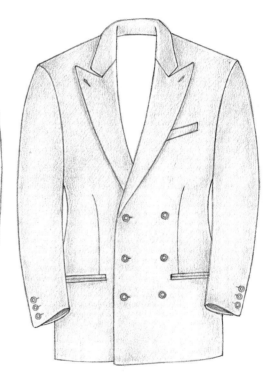

**Two buttons**
*It is a relatively new model. A single button is always fastened. There are always two or four buttons on the jacket for effect.*

**Four buttons**
*The classic blazer. Often only one of the two buttons are fastened. But which button should be left open? Fashion experts do not agree. Generally, someone with a wide waist should leave the lower button unfastened.*

**Six buttons**
*Normally used almost exclusively for naval uniforms. The version favored by the English navy has eight buttons. Rarely used outside naval circles, it can, however, be seen at the yacht club.*

# Single-breasted Jackets

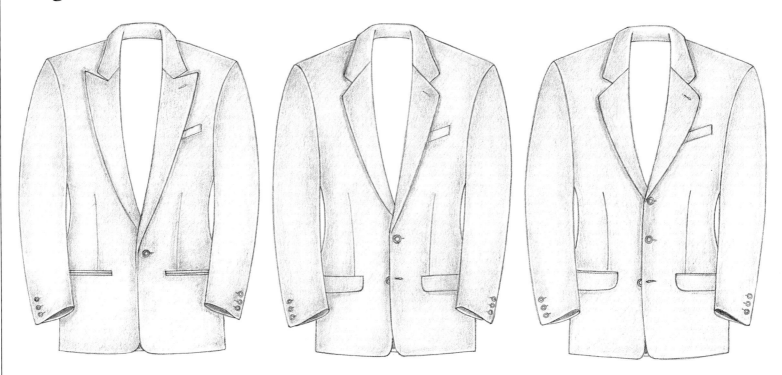

**One button**
*This version is used mainly for single-breasted dinner jackets for summer or winter. For other occasions the jacket with one button is considered less conventional, even if it was once favored by stylists.*

**Two buttons**
*A two-button jacket was developed especially in the United States and was once characteristic of the sack suit and sports jacket models. Today it is also used for business suits. Fasten only the highest button.*

**Three buttons**
*The highest button and its corresponding buttonhole are slightly hidden by the lapel. Generally, the highest buttonhole is fashioned inside out. It is a sign of quality to have a buttonhole finished on both sides.*

# Sports Jackets

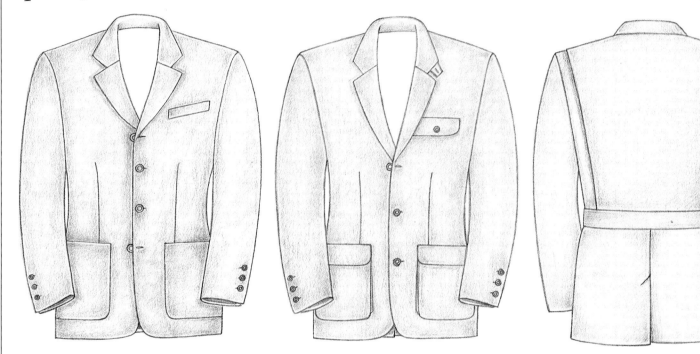

### Four buttons
*A four-button jacket is worn almost exclusively on sporting occasions, usually for horseback riding. It generally has stitched pockets and double vents in the rear. The lapels are noticeably shorter than those with two or three buttons.*

### Golf or hunting jackets
*It is the classic sports jacket, usually with three or four buttons and patch pockets. The back has a half-belt and two lateral folds corresponding to the armholes to provide the arms with maximum freedom of movement.*

### The back of golf or hunting jackets
*Sports jackets are often characterized by a half-belt, vent, and lateral folds to provide maximum freedom of movement, all very useful in the situations that require this type of jacket.*

# Sports Jackets

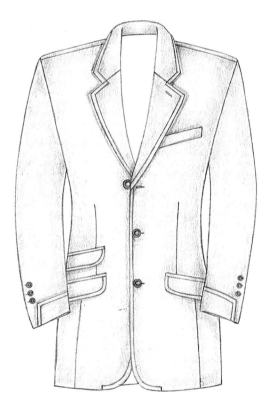
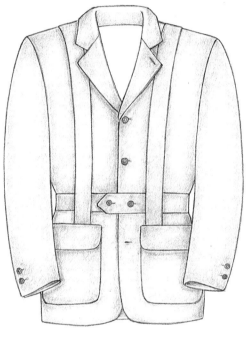
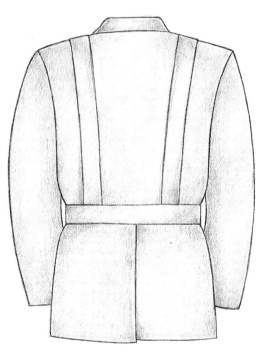

**Riding**
*It is characterized by greater length and flair on the bottom and has a central vent in the back. The buttoning is high, with three or four buttons. The regular pockets and the waist pocket are flapped and diagonally cut. It is made of red cloth, in covercoat or tweed.*

**Norfolk**
*It is a hunting jacket sometimes used instead of a three-button tweed jacket. It is characterized by four buttons, a belt or half-belt, with folded and flapped pockets and a suspender effect running along the shoulders and back.*

**The back of the Norfolk**
*The back of the Norfolk is characterized by a deep vent, a belt stitched at the waist; the suspenders can also be stitched up to the waist.*

# *Various Jackets*

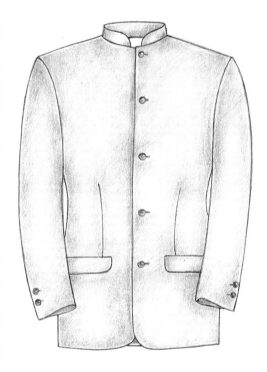 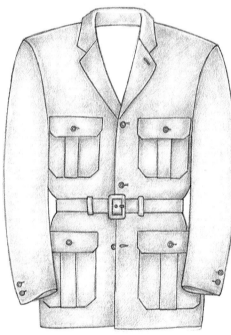 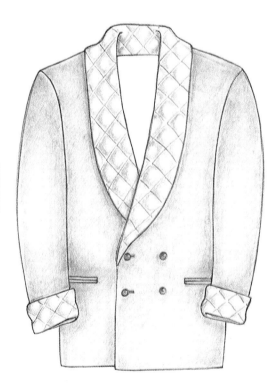

**Closed-Neck or Nehru jacket**
*This takes its name from that of the first prime minister of independent India. Nehru wore this jacket, which was in keeping with the native style of the Indian subcontinent. It was fashionable in the '60s, but nowadays is used mainly for servants' uniforms.*

**Safari jacket of military origin**
*These jackets are made of cotton drill and have four bellow–patch pockets. The jackets often have a belt in the waist.*

**Smoking jacket**
*It is usually made of velour, with satin lapels, sometimes embroidered, and slightly quilted. Some are without buttons and can be fastened with a belt.*

# *Lapels*

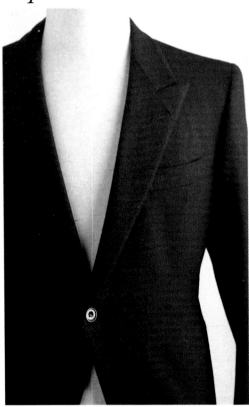 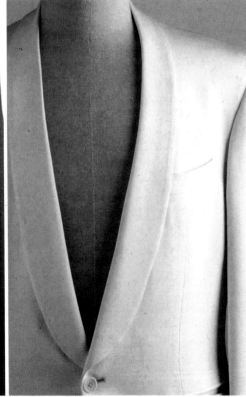 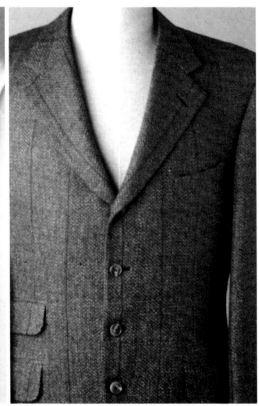

**Peaked for a single-breasted jacket**
*The straight and peaked lapel for a single-breasted jacket is mainly used in the morning-coat version. It is sometimes used for normal single-breasted jackets, usually the two-button model.*

**Shawl collar**
*Characteristic of a single-breasted dinner jacket, either summer or winter. It lacks a notch, which refers to the cut that separates the actual lapel from the collar.*

**Short**
*This type of lapel is found almost exclusively on sports jackets, usually those for hunting that have four or more buttons. These are the only jackets whose buttons are, as a rule, all fastened.*

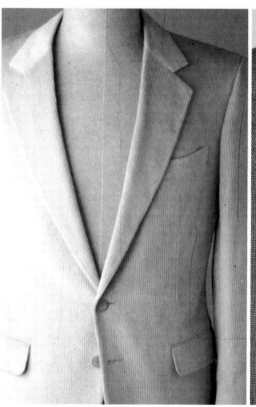 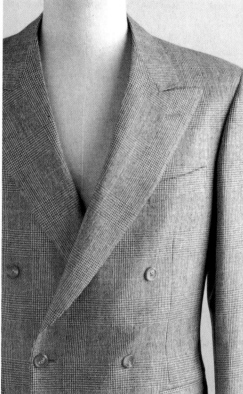 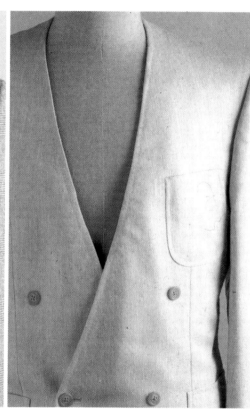

**For a single-breasted jacket**
*Lapels of single-breasted jackets are straight or slightly curved. The classic lapel is neither too wide nor too narrow. Ideally, its finishing line should reach halfway to the shoulder.*

**For a double-breasted jacket**
*Double-breasted jackets are characterized by peaked lapels connected to the collar; they do not form a notch. Experts are divided over whether a lapel on a double-breasted jacket should be with or without a hole for flowers.*

**Without lapels**
*This version was popular in the '60's, especially with double-breasted jackets. Today it can still be used for semi–formal occasions at the seaside.*

## Pockets

The most important pockets of a jacket are those on the sides; the two borders are normally trimmed with a besom, unless it is a sports jacket with flaps that, in effect, replace the higher of the two besoms. Flaps that help prevent objects from accidentally falling out of the pocket can be stitched onto the pocket itself. In this case it is covered by a besom. When the flap is inserted, it disappears from view.

A normal flap is shaped in the form of a trapezoid, which is larger at the bottom. It has a tendency to crease when something is inserted into the pocket. On the other hand, rectangular flaps, by tradition, are not permitted. For reasons of comfort, certain sports and riding jackets have slanted side pockets. It is possible to open something like a "pocket within a pocket" inside the lining of the right side pocket to be used for carrying a lighter or change. That which the English refer to as a "ticket pocket" can be used for train tickets or other small foldable items. These pockets are invariably placed above the right pocket in many types of sports jackets.

There is also a pocket on the left breast that is used exclusively for handkerchiefs, and was once used for glasses as well. It is the only one characterized by a braid or a band on the upper edge.

Pockets on sports jackets can also be patched; they are easier to make, but they hold less. To avoid such an inconvenience, certain types of hunting or safari jackets come with patch pockets that have deep gussets.

Two pockets open inside the upper part of the jacket lining: one on the right for wallets or notebooks and one on the left for the tailor's signature or the label of the house that produced the jacket. There is also a pocket in the lower left portion that can be used for packs of cigarettes.

Certain tailored jackets have a right inside pocket with a double opening at the top and the bottom to hold particularly large personal documents or plane tickets.

## Buttonholes and Buttons

As previously noted, the highest button on a single-breasted jacket with three buttons should be trimmed on both sides, particularly if the lapel is pressed in such a way that its tip reaches the middle button. There is a passive button next to each active button on double-breasted jackets. It was taken from the designs of military uniforms in which the passive buttons would act as spare buttons.

Double-breasted jackets have a pair of decorative buttons that, for purposes of symmetry, are sewn onto the jacket. They are a reminder of the time when double-breasted jackets were exclusively military jackets and were buttoned only up to the shoulder.

Buttons on the sleeve represent yet another example of military style influencing civilian dress. In reality, buttons on the jacket sleeves were already used in the 18th century to fasten the ends of the sleeves, which were rolled up and thus buttoned.

At the beginning of the 19th century, however, it became fashionable to add puffed sleeves to men's jackets. As the name implies, these sleeves were puffed at the top and became progressively narrower as they ran closer to the wrist. A cut was made at the wrist so that the sleeves could be slipped on without difficulty; each cut was closed by buttons. This fashion soon disappeared as well, and jackets without buttons were not seen again until the end of the century. It seems that buttons first reappeared on the jacket sleeves of English navy uniforms as a way to discourage the men from wiping their mouths and noses on their sleeves.

Today, there are usually four buttons on English-style jackets, three on Italian jackets, and one or two on those of the American school.

Custom-made jackets usually have unbuttonable buttonholes on the sleeves, even though they do not serve any purpose. They are, however, considered a sign of elegance. Some people unbutton the sleeve, especially of sports jackets, to show this refinement. Others leave it fastened, and are happy to keep the knowledge to themselves.

Ready-to-wear clothing has fake buttonholes on the sleeves to facilitate the alteration of the sleeves according to the clients' measurements.

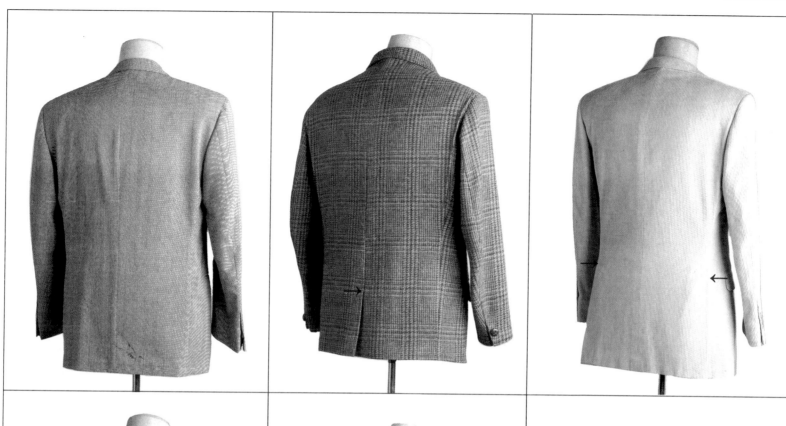

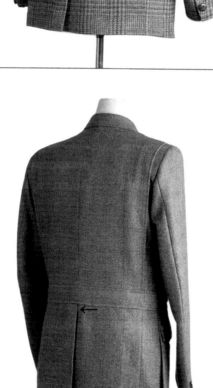

Clockwise from top left:

**Ventless jacket**
*This version is normally found on double-breasted jackets or on the city model.*

**Jacket with low vent**
*Generally found on sports suits.*

**Jacket with two vents**
*This version can be used for almost every occasion.*

**Jacket with a vent, half-belt and folds on the shoulder**
*This version is used mainly for hunting jackets.*

**Jacket with a high vent**
*Found mostly in the United States and France, it is a practical solution for those with large backsides.*

# THE PANTS

Like jackets, pants can also be classified according to the particular styles of cut adopted by the various schools that produce pants. Apart from the size of the leg, pants can vary according to whether the waist is high or low, or if the cut provides for suspenders.

Certain types of pants can be supported either by a belt or suspenders. Some Americans like to use them together, calling it a form of double insurance; if one fails, there is always recourse to the other.

It is worth noting that the greatest change in the cut of pants —at least since culottes fell into disfavor—has undoubtedly been the general disappearance of suspenders. Until the 1930s, most men's pants were supported by suspenders that, particularly in sports pants, were extremely comfortable and made breathing easier since they didn't maintain a stranglehold around one's waist. They were high-waisted pants, and seemed aesthetically unpleasing to the eye, even if they did not serve to hide a vest.

The end or the decline in the use of suspenders was related to the progressive abandoning of the vest, which in turn came about because of the steady increase in the availability of central heating, and because it simply took less time to loop a belt than to attach suspenders.

Pants requiring only a belt generally have a lower waist, otherwise they would have a tendency to fall, unless cut in a particular way. In fact, blue jeans, which were the first truly popular pants with a belt, came with a waist so low that it actually rested on the hips.

For most of their history pants have been tight at the bottom —from the German breeches described by Tacitus, to the ski pants of today. Such pants follow naturally the contours of the leg and tend to compliment the figure, with short peo-

ple being the principal beneficiaries of this type of cut. Pants with wider bottoms are a relatively recent innovation and can be divided into three or four broad categories. The first to appear on the scene were navy pants, which should not be confused with bell-bottoms. Navy pants developed as a result of a sailor's need to climb ratlines or perform other complicated maneuvers. These pants were usually made of cloth or cotton and had a buttoned flap. They were the same size from the waist to the feet, or sometimes they widened from the waist down; usually, they almost completely covered the foot, leaving only the tip of the shoe exposed. When ironed the pleat must be on the side and not, as in the case with normal pants, on the front. Oxford bags were considered the civilian version of navy pants. These were very large pants that were worn for a short period in the 1920s by Oxford students. Such pants appeared to have reached more than 24 inches in width. They quickly disappeared from the fashion scene but returned briefly in America as the pants to be worn with the zoot suit of the 1940s. Nevertheless, they did help push fashion toward a wider cut for pants that, since the end of the First World War, had remained rather narrow at the bottom.

The so-called straight pants were also popular during this period. Their major characteristic was uniformity of width, from 10 to 12 inches along the entire length of the leg. Bell-bottoms, on the other hand, were an outgrowth of the '60s and the hippie movement. They were derived from pants flared at the bottom and were developed by Pierre Cardin in reaction to the narrow shoulder, which was fashionable in that period. The effect of bell-bottoms, other than their ability to collect dirt from the ground, is to shorten the leg significantly, giving the impression that it has been hidden

under the knee, which is precisely where the bell at the bottom begins to open.

It is possible to find evidence that pants were used in sports a long time ago and were then subsequently forgotten. An extremely tight-bottomed pair of ski pants, for example, with an elastic tape that runs under the foot to keep them stretched, is very similar to a type of pants worn in the last century. These too were characterized by an elastic band or strap into which the foot was placed. This style was quite practical for horseback riding in an age in which the horse was the principle means of transportation and one had always to be ready to pass from the living room to the saddle and vice versa.

Knee pants, which are similar to the fashionable culottes of the 18th century, continue to be worn today and are divided into two types: those for hiking or hunting, which are not particularly wide, and the knickerbockers or plus fours, which are much wider and fuller, the material forming a pleat reaching halfway down the calf. They are particularly comfortable for sports that require a lot of walking, such as hiking or golf.

The exigencies of sports have also led to short pants. With the exception of Bermudas, these pants are relatively tight and extend down to the knees. In some countries they are also used on semiformal occasions. The classical pair of flared shorts were called empire builders. Worn during the first half of this century by English colonial soldiers, they were extremely comfortable but were eventually replaced by shorter and tighter shorts that are today worn throughout the territories of the Commonwealth.

Before concluding, it is worth dwelling a moment on the subject of pleats. The ironed-in pleat or fold was virtually unknown until the 20th century, probably because it served no useful function, as a gentleman's pants were kept stretched by the elastic straps under the feet. It is also just as likely that no one gave the idea any thought. There is some evidence of them in paintings and photographs of people like Vittorio Emanuele II, the Italian king, or the generals of the Civil War, who, incidentally, sat for pictures with terribly creased pants. Considering that at one time pants used to be rather tight, it would have been impossible for the pleat to be permanent. It was only at the beginning of the century, when pants became larger, that the pleat became useful and gave pants a neat and orderly aspect. Tradition maintains that the pleat was invented by the Prince of Wales, but this is not true.

# *Long Pants*

**Wide pants**
*They are characterized by a rather pronounced and unvarying width. They give the impression of being very wide at the bottom.*

**Classical pants**
*The width is unvarying, but narrower than the above version. Blue jeans belong to this category because of their tightness along the leg.*

**Narrow-bottomed pants**
*Normal tightness in the crotch, narrowing gradually at the bottom.*

**Bell-bottomed pants**
*There are different categories of bell-bottomed pants. The most common version are those worn by sailors, which gradually widen from the crotch toward the bottom. Then there are the so-called elephant leg pants, which are narrow at the knee and then become decidedly wider. Finally, there are the so-called Oxford bags, which begin to widen at the crotch.*

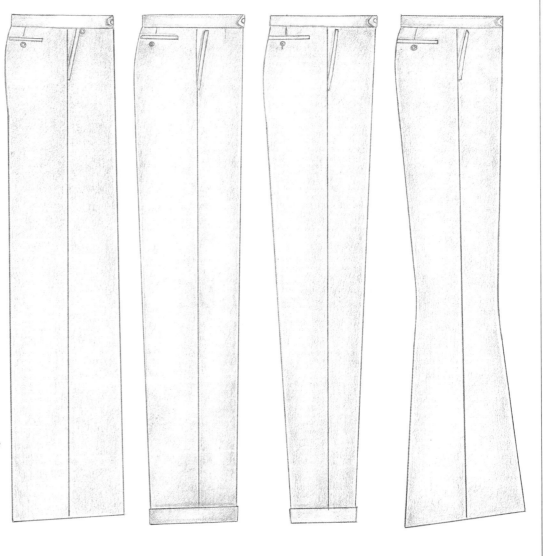

## Special Lengths

**Jodhpurs**
*Named in honor of the Indian city where they first appeared, today they are used almost exclusively for riding.*

## Knee Pants

**Knickerbockers: plus twos**
*Generally used for hunting, the fabric extends downward to approximately two inches under the fastening.*

**Knickerbockers: plus fours**
*The fabric extends to approximately four inches under the fastening. Very comfortable, they are often worn to play golf.*

## Above the Knee

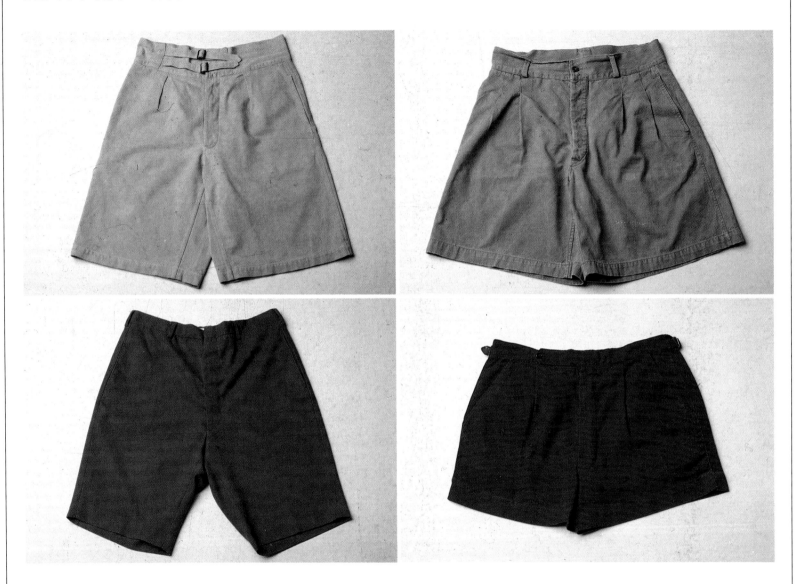

Short pants are divided into three main categories: flared, Bermuda shorts, and shorts. The first group, which today have virtually disappeared, originated with the military and were used by English colonial forces in India. Also known as empire builders, they are sturdy enough to provide good protection, yet are very comfortable, since they allow a measure of air to circulate freely. Bermuda shorts, whose name comes from the islands, are tubed. The later extend only a few inches below the groin. Two types of flared short pants with varying lengths can be seen in the photos at the top; those on the left reach down to the knee. Below left: A pair of Bermudas. Right: A pair of shorts.

## Pleats

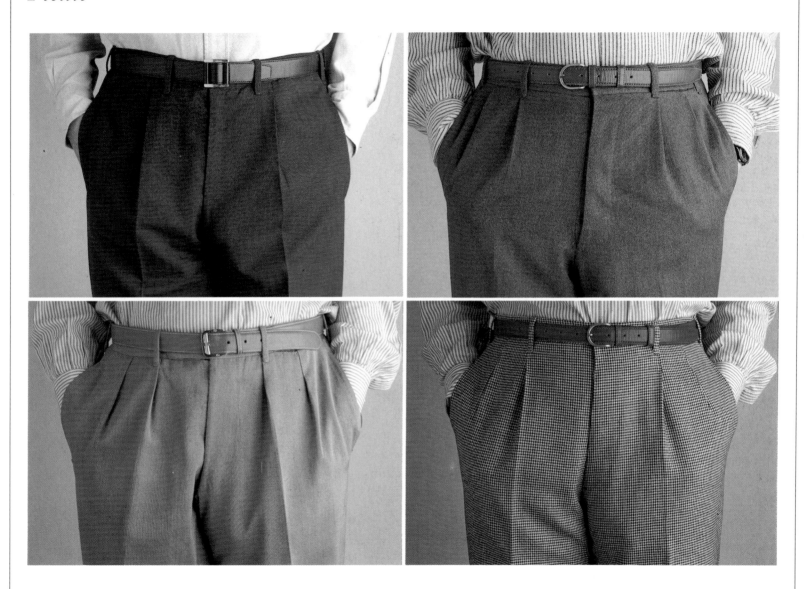

Pleats anchor the line of the pants and allow them to fall better when hands are put into the pockets. Pants can have either a single or double pleat. Top left: Pants with a single pleat.

Below left: Pants with a double pleat. The most common types are on the right. Sports pants usually do not have pleats. Sometimes they have stitched pleats, either single or double. They

can be inside or outside, as illustrated in the two photos on the right.

## Length and Cuffs

Pants can come with or without cuffs. One legend suggests that the use of cuffs was yet another in the unending series of inventions attributed to the Prince of Wales, later Edward VIII. It was said that the future king turned up the ends of his pants while on a hike in the country so as not to muddy them—a practice that was quickly followed by his companions. In reality, this expediency had already been adopted, more or less consciously, by many country squires, including Edward's grandfather, Edward VII, who did so long before Edward was born.

Without question cuffs look better on pants that are a bit narrower at the bottom, allowing the pants to drape elegantly over the shoes. In general, cuffs are approximately an inch and a half high; some prefer them even higher. Shorter cuffs are rightly to be avoided.

Americans prefer the length of their pants to be just above the shoe, slightly exposing the sock. Generally, however, it is more elegant if the pants rest lightly on the shoe. Some people wear their pants tailored a bit longer in the back, regardless of whether or not they have cuffs.

## Pockets

Side pockets are the most important pockets on pants; the classical English cut has them opening along the seam, while in Italy and America the preference is for a more comfortable slanted cut.

For certain sports models, pockets open almost parallel to the belt and are called "frontier pockets." These pockets are characterized by a curvature at the two extremities. Blue jeans contain an endless number of pockets and subpockets, depending upon the design of the producers, although the classic model has five pockets.

On the right or the left side (for those who are left-handed) of the waist, pants can sometimes have a small pocket covered by a flap.

There are always two back pockets, although sometimes only one on sports pants. The openings of the back pockets are always finished with besoms and should usually be closed by fastening a button with a buttonhole or loop.

## Pleats

American pants, and some sports pants, are tailored without pleats for aesthetic reasons or to save fabric. Besides having an aesthetic advantage, pleats allow the pants to give better when a hand or wallet is inserted into one of the pockets. Moreover, it should be noted that when one is sitting, hips and buttocks have a tendency to spread and thus need space. There can be one or two pairs of pleats, but two are the most common and per-haps the most accepted style.

Pleats can be folded inside or outside. Those folded inside give the pants a more slender appearance and are therefore more suited for persons with robust figures.

## Buttons, Buttonholes, and Straps

The first question is: Should the fly be closed by a zipper or with buttons? Purists maintain that a fly fastened by buttons stretches better when one sits and is therefore much more secure than a zipper. The zipper used to have problems of a mechanical nature.

On the other hand, the zipper has its staunch supporters, even among the clientele of famous tailors; they claim that zippers provide a cleaner or more uniform effect, which is indispensable in pants made of a light fabric.

Side tabs that button twice at the waist for tightness can be replaced by a back strap, which is used especially with high-waisted pants and those with vents in the back for suspenders. A few examples of these models are shown on the following page.

When suspenders are necessary, it is better to wear the type attached by buttons rather than those attached by clips. If the pants are designed to be worn with suspenders, it is always best to have a small vent on the back of the waistband.

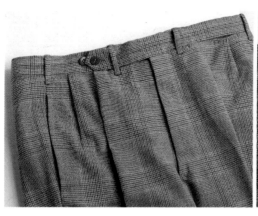

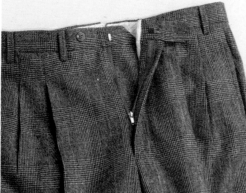

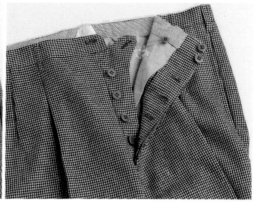

### Strap
*Some pants come with a strap that follows the waist and can be fastened to the one or two buttons attached to the other side of the waist. Two buttons make it easier to adjust the waist and are therefore recommended.*

### Zipper
*The zipper is the most common type of fastener, especially in ready-to-wear suits. For some time it was also used in custom-tailored suits, usually at the request of the clients, who preferred the more rapid closing action of the zipper.*

### Buttons
*Today buttons are used almost exclusively by tailors. Clearly, buttons take longer to fasten, but purists claim that the fly stretches better when one sits. Above right: Note the three buttons which provide a perfect closing of the waist.*

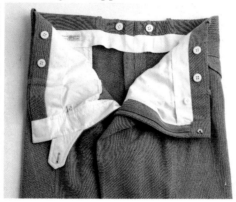

### Side tab
*The side tab is used mainly on sports pants, which often do not provide loops for a belt. Once connected with elastic ribbons, side tabs make it easier to adjust the waist.*

### Buttons for suspenders
*They are indispensable for those who prefer to wear traditional suspenders which, unlike the newer versions, do not have clips. The thread with which they are attached to the waist should be very strong.*

### Back strap
*The adjustable back strap was once very common with suspender-supported pants characterized by a rear vent.*

# THE VEST

The waistcoat or vest—in varying forms—has been an accessory of men's clothing for over three hundred years. Vests are still an indispensable accessory for lending a more authoritative air to suits. Nevertheless, over the last few decades they have given way to the kind of sweaters that were previously worn, at least until 1914, by fishermen and farmers. Vests became outdated with the advent of central heating.

Beginning with Edward VIII, all subsequent English kings wore vests with six buttons. They were tailored in a way that did not permit the last button to be fastened. Apparently the subtlety of this refinement was lost on everyone but a handful of high-fashion connoisseurs. In fact, one manufacturer of tailored clothing was forced to halt production of such vests because his clients complained about not being able to fasten the lowest button.

In general, only a small portion of the vest, corresponding to its highest button, should be visible just above the collar of the jacket. Vests with a higher cut tend to "suffocate" the tie and are an aesthetic disaster.

The vest must always cover the belt if worn with pants that do not require suspenders. The classic vest has a strap on the back to allow for loosening or tightening according to specific needs. The back of the vest is made of satin, or of the same material as the lining of the suit. With informal or sports suits, on the other hand, it can be a good idea to wear a vest of material different from that of the suit.

There is no consensus on whether a vest can be worn under a double-breasted jacket. It does not appear to be in harmony with present tastes, though it was considered elegant in the past. Vests may be considered practical in cold climates, but only with low-buttoned jackets. Vests for dinner jackets and morning coats can have a variety of shapes and fits; morning-coat vests with shawl collars are usually double-breasted. Tail-coat vests are always single-breasted with shawl collars, these being made of white cotton piqué, like the bow tie.

The sash or cummerbund is worn with single-breasted dinner jackets. It is reminiscent of formal military clothing and serves the purpose of hiding the suspenders while affording ample protection from harsh winter climates.

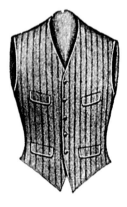
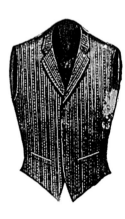

# Types of vests

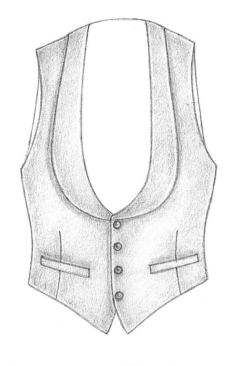

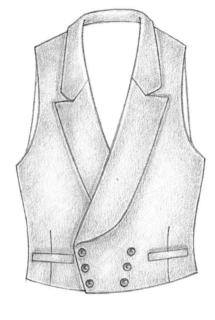

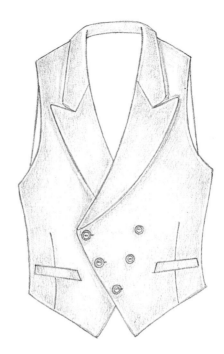

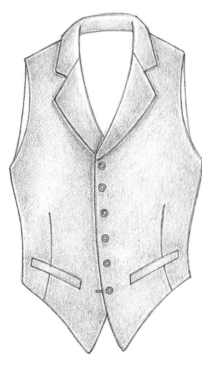

Vests for formal suits do not follow any particular convention, but can vary according to occasion or individual taste. In general, those worn with dinner jackets have shawl collars (see design above left), while those worn with tailcoats and morning coats (above center and above right) are double-breasted.
Below left: The classic six-button vest with four pockets, suitable for any occasion.
Below right: A sports vest with lapels, usually made from a heavy fabric for protection in cold weather.

# THE FITTING

It is a good idea to have at least a rudimentary understanding of the preliminary phase of tailoring, in which measurements are taken. Such knowledge helps the buyer to explain his particular needs or preferences to a tailor or salesperson right from the start.

Tailors divide physical types into four or five categories and cut their suits according to these broad divisions. Thus, for example, if you are a bit overweight and have poor posture, it is useless to stand with shoulders back and stomach in just to impress your tailor—unless, of course, you have decided to change your life-style by joining the local health club. Obviously, a sunken chest and curved back, require a jacket with a bit more length in the back, while the opposite is called for in a subject with a rounder shape in the front.

For some mysterious reason, tailors divide in half a fundamental measurement—the circumference. In other words, if the circumference of your chest is 40 inches, a tailor will record that half of your chest is 20 inches, which will then determine the cut. The other key measurements for the jackets are the external circumference of the chest, a measurement that also includes the arms; the circumference of the waist, the hips, individual height, the measurement from shoulder to shoulder, and the length of the arm.

The best way to take measurements, although the tailor or salesperson will probably suggest it, is without a jacket and with heels together. Belts and pants buttons should be unfastened when the measurement of the waist is being taken. If the tailor does not measure your arms, it is a good idea to remind him, because sometimes there is a difference in length between the left and right arm. It is very important to wear a perfectly tailored shirt on these occasions because the tailor or salesperson will measure the sleeve length in a way that will extend the cuff by approximately one half inch.

The measurements for pants, taken with legs slightly apart, consist of the length of the inside and outside of the leg. It is wise to indicate if you have any specific preferences or requirements regarding the length of the rise, i.e., the piece that includes the waist and the seat: The longer the rise, the higher the waistline, but this will be at the expense of the trimness of the pants.

It is worth noting that a suit within the same general category of size can fit more or less tightly according to the style of that particular line. Certain ready-to-wear lines of clothing are characterized by what is called a drop, which refers to the difference between the circumference of the chest and the circumference of the waist. The resulting measurement indicates the width of the waist of the pants and, to some degree, the tightness of the garment. A person with a wide chest, broad shoulders, and slim waist will have a drop as high as four or five inches. On the other hand, someone with normal shoulders and a heavier to obese figure will have a drop that goes from two inches to none. In ready-to-wear lines, heights are usually approximated. This is done in the following manner: short—under a height of 68 inches; medium—from 68 to approximately 72 inches; long—above 72 inches.

Taking exact measurements is a rather difficult art, one that is acquired only with experience and after a few unfortunate errors. To reduce the possibility of mistakes, some companies are capable of furnishing industrially produced made-to-measure suits in client sizes thanks to samples of suits first sold in selected shops. Clients are invited to try on the size that best fits them. The salesperson then takes more precise measurements to calculate which additional

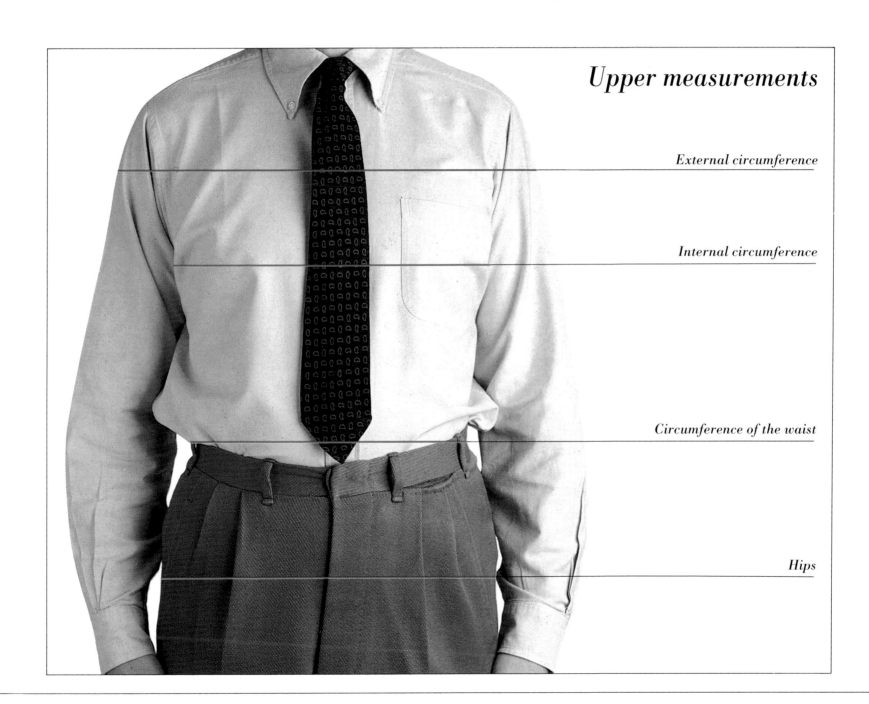

## Upper measurements

External circumference

Internal circumference

Circumference of the waist

Hips

modifications have to be made. The measurements are then communicated to the factory, where they are fed into a computer, which in turn sends the data to a machine that automatically cuts the pieces of the garment to specification. Suits obtained in this way generally fit the client perfectly, thus eliminating the need even to try them on.

The measurement stage coincides with the choosing of materials and the style of the suit. It is during this phase that decisions are made according to specific physical characteristics.

The fabric, for example, can play a crucial role in rendering a figure more slender or robust. Dark and thinly striped materials help create the impression of slimness. If the stripes are not thin, however, they will create exactly the opposite effect. Light or checkered materials with emphatic designs create an impression of weight and should therefore be avoided by those with heavier figures.

Thin people will benefit from double-breasted jackets; those who are overweight will not.

Short people should avoid long jackets; a sense of height can be obtained by asking the tailor to shape a higher waist on the jacket, or by having the pockets moved a bit higher up. Lowering the pockets will usually produce the opposite effect. Last but not least, widening the lapels is an option best suited to taller people.

Flannels and carded fabrics have a marked tendency to shed and wear out rapidly in the areas which are subject to the most friction. This is especially true in the area of the thighs just under the crotch, particularly for those who are overweight. Such individuals would do best to choose worsted, clear-cut fabrics.

In addition to these considerations, it should be remembered

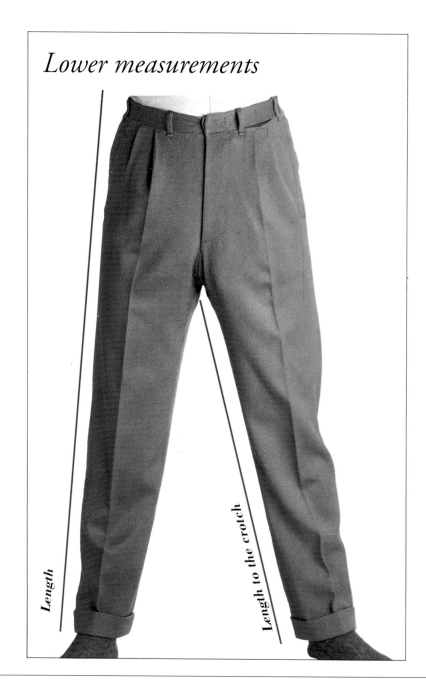

*Lower measurements*

*Length*

*Length to the crotch*

that, when it comes to dressing well, slim people have an easier time of it than do "robust" people, as tailors euphemistically refer to the fat among (or upon) us. On the other hand, however, it should not be assumed that fat people have to completely give up light suits—as well as chocolate pound cakes. If it is true that dark fabrics or materials tend to create a slimmer appearance, it is also true that tight suits that stretch in many places must absolutely be avoided. Nothing makes a man look heavier than a jacket that cannot be buttoned because it is too tight; or, for that matter, a pair of pants that cannot be buttoned without the wearer first taking a very deep breath.

Some clients insist on asking their tailors to eliminate the pleats, believing that they create a bulkier appearance. In reality, pleats ensure that the material will not stretch when the wearer is sitting. They also prevent the pockets from opening, and they impede the formation of unsightly creases around the hips.

In addition to the choice of dark or light colors, other important considerations consist of evaluating how well the selected fabric drapes the body, and whether or not the suit provides the wearer with a certain ease of movement.

In other words, literally—and figuratively—speaking, a fat person looks better in a senatorial toga than in a wet suit. To better understand how a tailor prepares your suit, it is worth knowing to which physical category you belong. These categories are determined according to the slope and angle of the shoulders, stomach prominence, and the curvature of the back. They are identified in the next pages.

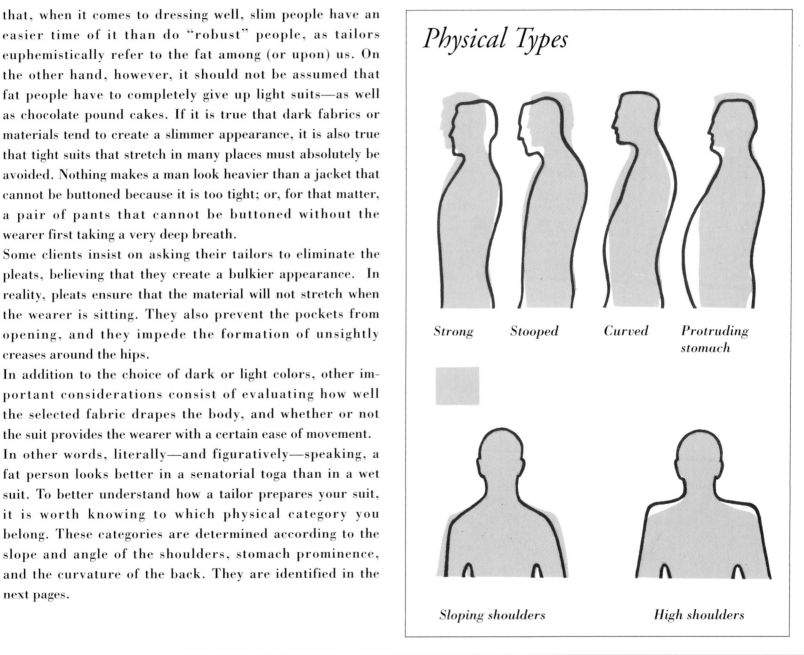

## Physical Types

*Strong*     *Stooped*     *Curved*     *Protruding stomach*

*Sloping shoulders*          *High shoulders*

# Causes of some common defects in jackets

**Detaching collar and jacket too short**

*A curved back requires a jacket with more length in the back, since a standard jacket will be too short in the back. The collar will have a tendency to fit too loosely at the back of the neck, while the front of the jacket will move towards the back.*

**High neck and creases around the waist**

*If an individual has a slouching posture, the back part of the collar will fit too snugly around the neck, raising the collar too high. As a result, the jacket does not fall freely*

*and forms unsightly creases originating at the armhole.*

*This defect, however, is easily eliminated. To render it visible to the tailor, simply take the fabric, as indicated in the above design, and mark it with pins.*

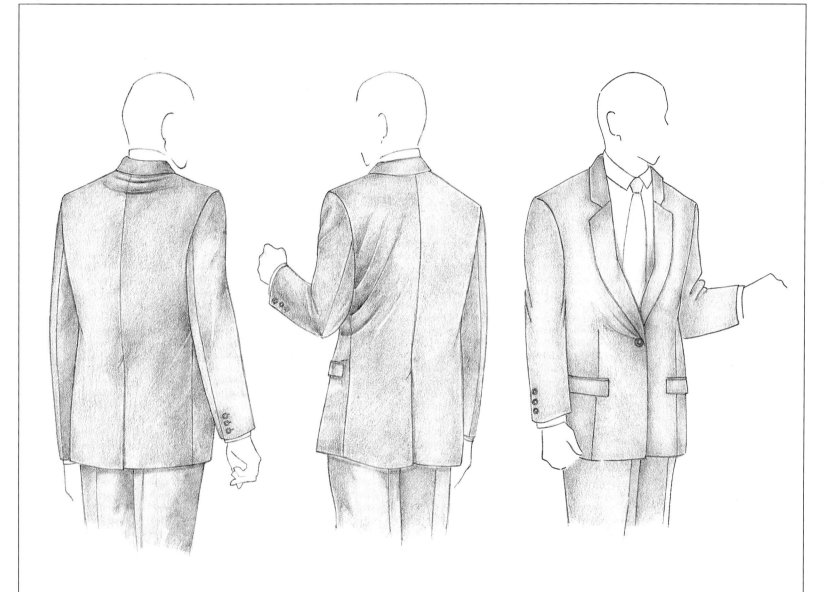

**Creases under the collar**
*An athletic build with high shoulders pushes the collar up, giving the impression of someone with a short neck. Parallel creases will form in the back, on the upper part of the jacket. If the jacket is unbuttoned, the front tends to open on the hips.*

**Creases under the armpits**
*Sloping shoulders generate creases that spread out from the armpits. Semi-circular creases will appear in the front of the jacket and spread to the back.*

**Arched lapels**
*If the person is broad-chested and the jacket is buttoned, the lapels tend to bend in the front or on the side, thus not resting properly on the chest. This noticeably damages the overall look of the garment.*

# Causes of a few common defects in pants

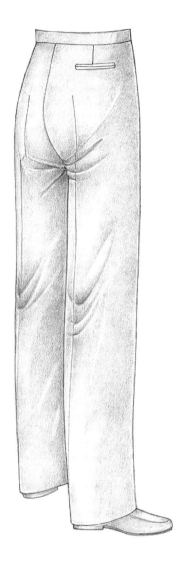 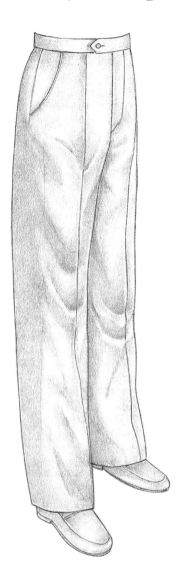 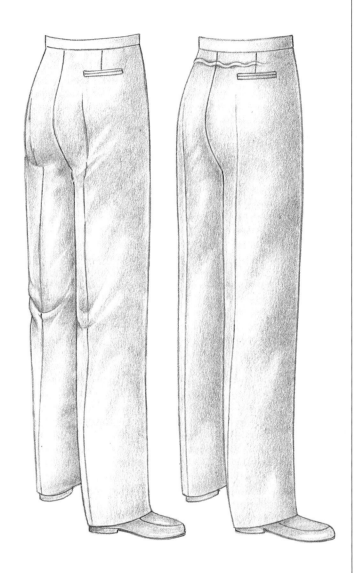

**Creases on the back around the crotch**
*They are sometimes present even on proper-fitting pants. They will show on the back going towards the crotch and are caused by a particular shape of the hip. It is solved by simply widening the crotch.*

**Creases on the front of the pants**
*Pants of individuals who stand with their hips pushed forward will have excess material in the front part. This will cause creases to form in the area that extends from the crotch to the knee.*

**Creases on the rear of the pants**
*Pants of individuals who slouch will have excess fabric on the back. This will cause creases to form from the crotch to the end of the thigh. A fold can also form under the belt.*

## Optical Effects

Fabric and cut can play a crucial role in rendering a figure more slender or robust. Dark and narrow-striped materials help create the impression of slimness.

The stripes should not be too wide, otherwise they will follow the rounded curve of the bust, thereby accentuating its dimensions.

Light or checkered materials with emphatic designs create an impression of weight and should therefore be avoided by those with more robust figures; the opposite holds for those who are a bit thin.

Slim people will benefit from double-breasted jackets; those who are overweight will not; heavier people are advised to wear only single-breasted jackets.

Short people should avoid long jackets, which tend to shorten the legs, while a sense of height can be obtained by asking the tailor to shape a higher waist on the jacket. Another way of giving the impression of height is to have the pockets moved a bit higher up. Lowering the pockets will usually produce the opposite effect.

Shorter people should avoid jackets with wide lapels, which can be slightly fuller for taller individuals.

**Vertical stripes tend to give the impression of slimness.**

**Horizontal stripes create an impression of broadness.**

**The different directions of the stripes give the appearance of two distinct rectangles which, in reality, are two identical squares.**

**The parallel segments appear to converge because they are intersected by oblique parallels.**

**The right rectangle, crossed by a vertical line, appears narrower than the left one.**

# CREATING THE SUIT

Once all the measurements have been taken, the tailor sketches the models on paper. This will guide him when cutting the fabric. These models are jealously guarded and frequently modified when the measurements of the clients change. The paper models facilitate the proper cutting of the material as well as ensuring that the most is obtained from the least amount of fabric.

Some industrial manufacturers use sophisticated electronic equipment, which provide for the drawing of models on a video screen based on data entered by the user. They take into consideration all the modifications necessary to obtain the best fit for the individual customer. When the best posi-

tioning of the model has been obtained, the cloth is placed on the cutting board, where a machine controlled by the computer does the cutting.

Thanks to the computer's flexibility, some manufacturing industries are now capable of offering their clients custom-made clothing in a great variety of cuts and models. At this point work begins on the cut material, which will be transformed into finished jackets and pants. Creating a jacket is more complicated than creating pants. Pants are relatively simple; in fact, they are so much easier to produce that in Italy, for example, they are often given out to workers who specialize in the making of this garment.

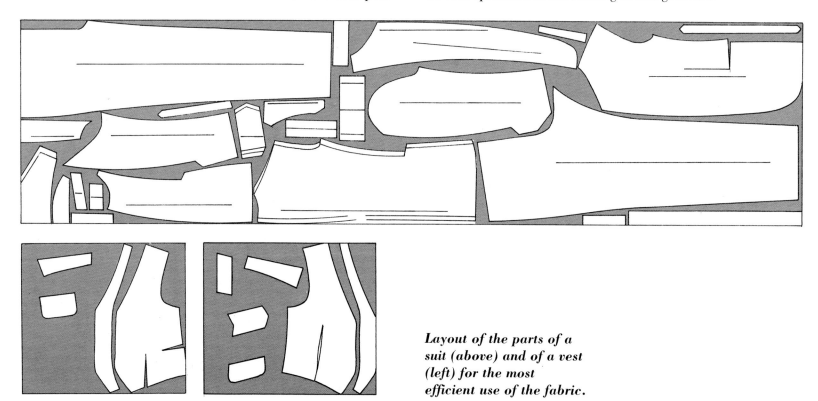

*Layout of the parts of a suit (above) and of a vest (left) for the most efficient use of the fabric.*

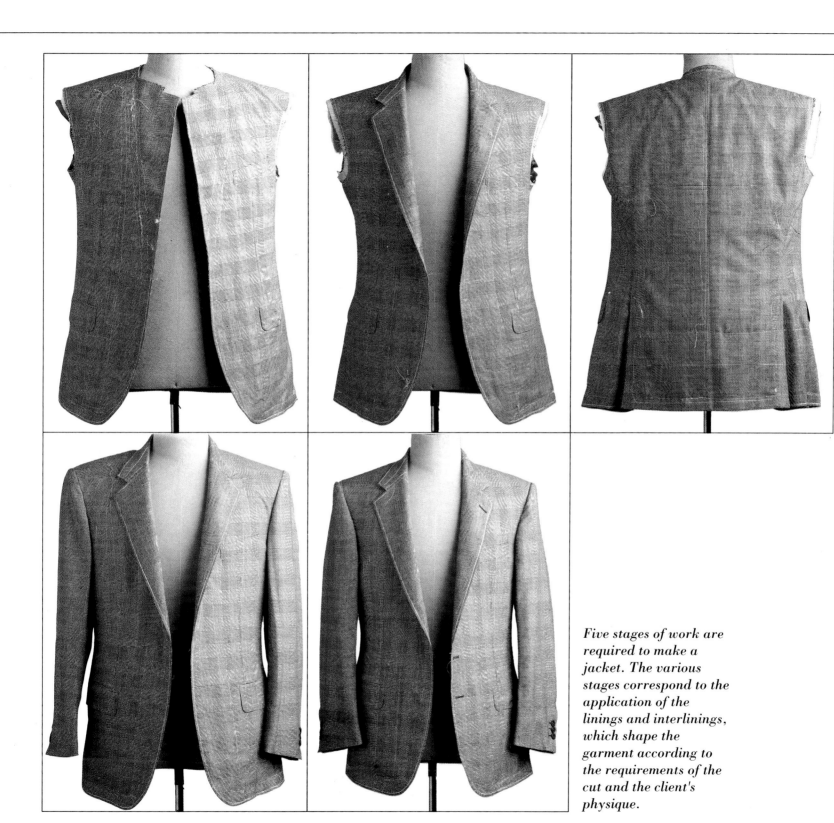

*Five stages of work are required to make a jacket. The various stages correspond to the application of the linings and interlinings, which shape the garment according to the requirements of the cut and the client's physique.*

## Linings and Interlinings

One of the most delicate stages in the making of a jacket is the insertion of the linings and the interlinings, which refer to the various canvases and pads that, used in varying degrees, support the jacket. Generally, thicker interlinings and paddings more easily hide defects in the sewing or cutting, though such jackets will be heavier and more uncomfortable. It is for this reason that an unlined jacket, with very little interlining, is considered the most difficult to produce and provides evidence of a tailor's skills, or lack of them.

The most important element of the interlining is made of canvas or hemp. It is a hand-sewn fabric, a bit rough and raw looking, and serves as the support element of the jacket. The best canvas is light and elastic, especially in the weft, and is made exclusively of natural fabrics—wool, cotton, goat hair, hemp—in various percentages depending upon the desired characteristics.

The supporting canvas is in the back. Before being applied, however, it undergoes a series of elaborations which complete the structure. In fact, while one piece is always placed in the lower part, the higher part can be made of two or more layers; the shoulders are completed by some strips of haircloth—which is obtained from a cotton fabric and horsehair—to ensure that the shoulder will maintain its forward shape for as long as the life of the garment.

A very light cotton flannel is applied to various strategic points between the cloth and the fabric to help maintain the jacket's shape, softness, and regularity. A piece of melton wool is attached under the collar to give it greater adhesion; however, it should not be too rigid, otherwise the collar will not maintain its form or its flexibility.

A small shoulder pad is added to the shoulder. It is usually made of cotton and canvas, and provides shape and adherence to the shoulder. Its thickness is determined by the desired shoulder line, keeping in mind that too much padding in the shoulder can be uncomfortable and is certainly not an indication of quality.

All these elements are brought together through basting, a process of sewing that uses large stitches to form a whole that is known as the plastron.

Before being applied to the fabric, the plastron should be made as resistant as possible to shrinking, stretching, and disfigurement, whether from water, humidity, or heat in general. In fact, any type of adverse reaction among the component parts of the interlinings and the fabric could manifest itself in unsightly swelling, leading to the loss of the desired form. For this reason the plastron is soaked in cold water for a few hours and left to dry naturally.

Another technique used to avoid an adverse reaction between the interlinings and the fabric involves resting the fabric for at least a day before attaching it to the weave.

The preceding descriptions are valid for both a good tailoring house as well as a high-quality industrial manufacturer—the latter being responsible for having brought the traditional interlinings from the high weights and rigidity of the past to lighter and more elastic solutions, even if such solutions are very traditional. Instead of containing mostly canvas, low-quality industrially manufactured suits often have interlinings of mixed synthetic thermo-adhesives which do not have to be sewn to the fabric to keep them attached. These garments are called front fused. When new, they provide a more uniform appearance than garments made by more traditional procedures. Although they have a more perfect form, such garments are less flexible, and over time and repeated dry cleaning they can lose their shape and bubble, meaning they can detach from the supporting fabric.

The lining is among the most important parts of the interlinings. This is because its flexibility determines the aspect of the garment. In the past, pure silk was considered the height of quality, but today this notion

**On the next page.** *The parts of the interlinings: yarns, tapes, ribbons, linings, canvases, padding plastron, flannelette; all required to make a complete jacket.*

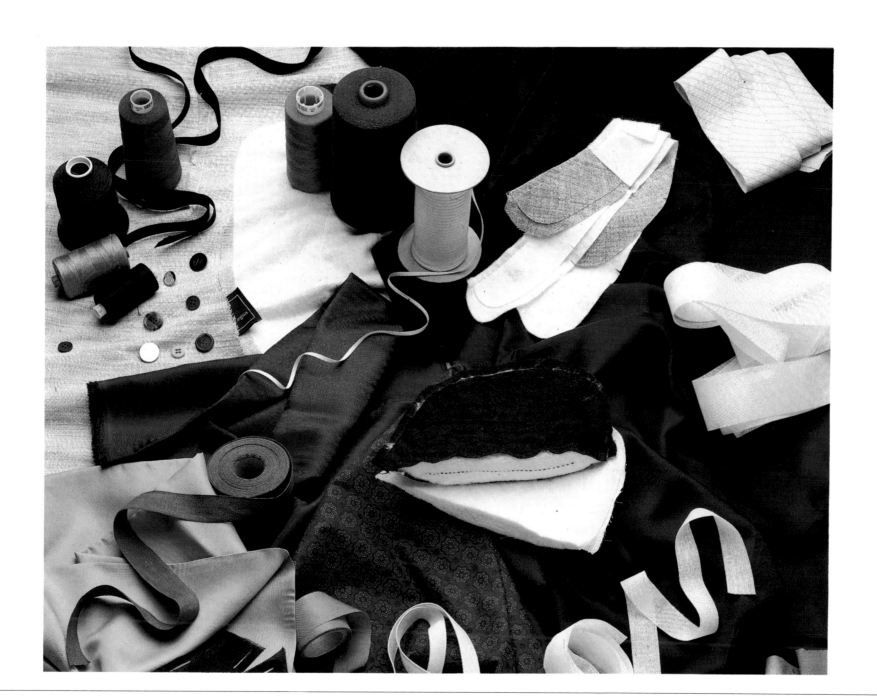

has virtually disappeared, even among tailoring houses.

One might find only a lower grade of light satin in evening garments of very high quality. Apart from these rare cases, the linings are made of light and resistant fabrics in artificial fibers, and less often in synthetic fibers reserved for sports and specialized garments.

Among the artificial fibers, Bemberg offers the highest quality in style, brightness, and resistance. In general, lining is divided between chest lining and sleeve lining. While that of the chest is usually a shade darker than the fabric, sleeve lining traditionally has a white or ecru base. The only exception to this rule are garments in dark and summer fabrics (tropical wool and others) for which a clear-based lining would be transparent from the outside. These models use the same lining as that used for the chest.

## Sewing and Pressing

Nowadays much of the sewing, even for custom-tailored suits, is carried out by machine. However, the more hand-sewn seams on a suit, the more valuable it is. This is because hand sewing, if done properly, enhances the fit of the garment. For the same reason, high-quality garments must be sewn with a cotton thread that matches the color of the cloth. In general it is important that the following parts are hand sewn: the finishings, the internal felling, the armhole, the sleeve

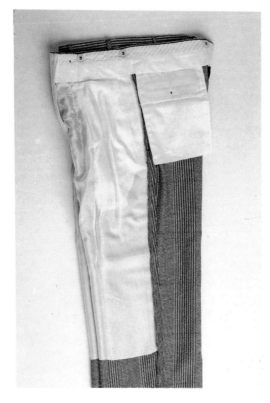

*Pants lining normally reaches the knee.*

vent, the collar and the undercollar, and the lower corners of the lining. Hand sewing of lapels to the canvas to obtain a perfect roll is a sign of quality. Hand stitching on the external borders of the jacket represents another example of quality.

The tapes also represent an important part in the making of the garment. These are strips of cotton cloth of various lengths and widths that, depending upon their function, are cut crosswise (if they have to be elastic), or straight (if they are meant to be rigid). They are placed at the crucial points of the work, and the form of the garment is derived from them. They help the fabric to follow curves, such as those that are found on the collar or the armholes. They also help keep the fabric together.

Pressing is another important part of the preparation. It entails different types of intermediate procedures, each one of which helps give a particular form to the detail of a jacket.

The ironing work in a tailor's shop is all done by hand, while industrial producers mostly rely on machines in a first phase, when it is important to give shape to the garment. This is followed by handwork, which provides a finished appearance to all the parts of the garment.

As previously mentioned, the making of trousers is simpler—insofar as the sewing is virtually straight, it can be done by machine. Pants also require less internal work. They generally have a reinforced band around the waist. It consists of a more-or-less elastic support and a lining made of the same cotton fabric used for the pockets.

A further protection, corresponding to the crotch, is added for aesthetic reasons, and to reduce contact with the stitching. The reinforcing lining is also important. This is a special tape with a raised border that is placed in a slightly protruding manner at the bottom of the pants.

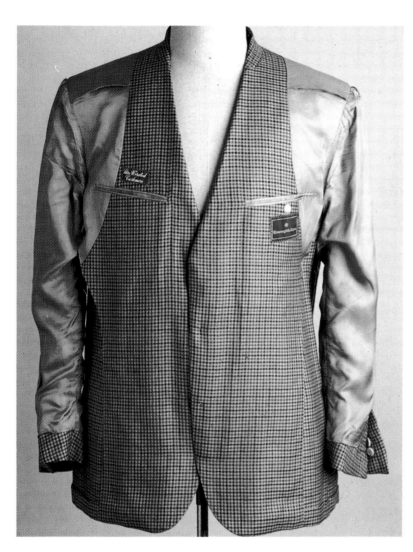

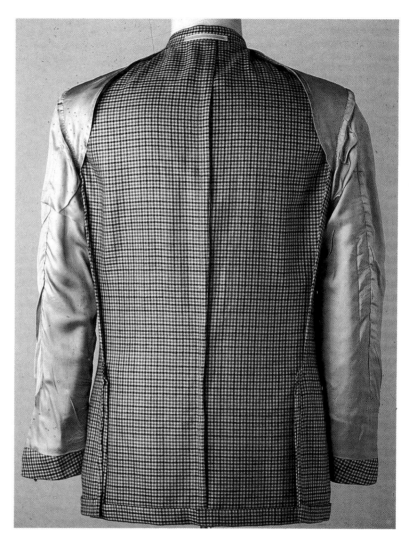

*The front part of a lined jacket.*
*The lining is applied only to the*
*shoulder and sleeves.*

*The back part of the same jacket.*
*This lined version is especially*
*appropriate for summer or*
*in-between season suits.*

The inside lining is also very important in this case because it helps reduce contact between the skin and the front part of the pants, in other words, the part subject to the greatest amount of friction. This lining normally extends below the knee. With white or very light trousers, a complete lining is applied to avoid unsightly transparencies.

## The Finished Suit

If the suit is industrially manufactured, it will be inspected very carefully during the entire manufacturing cycle, worn, and allowed to rest in an environment with a controlled temperature and humidity.

If the suit is hand-tailored, three fitting sessions should be enough to produce a finished garment.

In the last century it was not unusual for people to undergo up to a dozen fittings; of course people had more time, and tailors were probably less skilled. If you are not satisfied with the results after the third fitting, and the problems cannot be remedied with minor alterations, you might consider changing tailors.

It is a good policy to establish a working relationship with a tailor and to a lesser extent with the salesperson, without forgetting, however, that they are at your service. The final decision must be yours; good tailors limit themselves to offering advice within, of course, the range of the cuts with which they are familiar. It is pointless to expect a tailor known for his

Italian-style shoulders to make a natural shoulder with no padding.

If everything has been clearly established from the outset, it will be easier to create an impeccable suit with your tailor, or to choose a suit with a salesperson.

## The Quality of the Suit

Custom-tailored or ready-to-wear? That is the question. Each of these methods has its advantages and disadvantages.

In general, the tailor shapes the suit to fit the client within the bounds of the tailor's style or specific cut. The ready-to-wear suit, however, in a certain sense fits the client to its production line.

A tailor will require more fittings, while ready-to-wear, even the so-called made-to-measure, need less, with the exception of a few final adjustments.

Nevertheless, before visiting a tailor or entering a shop, it is wise to make a series of evaluations.

In the first place, the use of a tailor does not automatically guarantee that the result will be an impeccable suit. Often a tailor is capable of making a suit only by following his particular line, which might conflict with the client's needs. Before visiting a particular tailor, even a famous one, it is advisable to examine the type of work previously carried out for friends or acquaintances. In short, if you like the clothes of your friend, by all means go see his tailor.

One way of judging a tailor might be to

evaluate how the tailor himself dresses. In reality, even very good tailors often dress in a somewhat questionable way. Clearly, however, it is possible to receive from a tailor the type of personalization that is more difficult to obtain with industrially manufactured garments.

On the other hand, ready-to-wear suits can be convenient, especially for the individual whose physique conforms to the parameters of the standard cut.

If one prefers a ready-to-wear suit, the question becomes: What distinguishes a suit of high quality?

One of the classic rules of thumb is price. If it is low, be careful; it is likely that the producer has taken some shortcuts. On the other hand, a high price does not necessarily ensure good quality. Sometimes costs reach considerable levels only because there are fixed expenditures involving publicity and royalties.

Another indication of a suit's quality is the fabric, which can be evaluated along with a series of details that include the finishing of the buttonholes, the lining, and the buttons, which are more expensive if made of horn.

A jacket made with traditional interlinings is unquestionably of a higher quality than a front-fused jacket, that is, a jacket made with thermo-adhesive linings.

How can one determine if a jacket is front-fused? One possibility is to ask the salespeople; if they are honest, they will tell you the truth.

The interlinings are a fundamental

part of the jacket. The more a jacket is padded, the easier it is to shape it to the client, even if the quality is inferior, as it will result in a heavier and less comfortable garment. A custom-tailored suit is likely to be more comfortable. The cloth of the garment, for example, has a shoulder pad which provides a better distribution of weight.

The lining is also important in determining the value of a garment. A tailor first completes the garment and then applies the lining by hand. In ready-to-wear suits of high quality, the lining is placed on the separate pieces of the garment and is completed as the suit itself is put together.

In ready-to-wear suits of a lower quality, the lining is applied during the first phases of the production and the jacket is virtually constructed on the lining. The result is thus more irregular than in the other two cases.

Another way to determine quality is to examine the thickness of the seams and the mountings. Greater thickness means lower quality. In custom-tailored and high-quality ready-to-wear suits, any superfluous material remaining after the sewing is hand-cut with scissors and then pressed with an iron.

Tapes are yet another sign of quality, since they serve to shape and model the jacket. Tape on the waist, for example, is a precaution against the jacket's tendency to lose its shape with repeated wear. It is also attached to the armholes or along the line of the lapels.

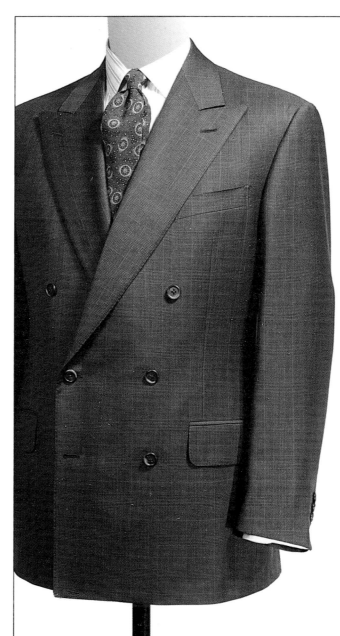

*The major characteristics that identify a quality suit are as follows:*
*– It should not be front-fused, meaning that it should be made without thermo-adhesive interlinings, which tend to stiffen in the front.*
*– The finishing of the buttonholes.*
*– Buttons of horn.*
*– Lining, preferably Bemberg, applied by hand to the finished suit (in the case of a custom-tailored garment) or attached to the separate pieces and finished as the suit itself is completed (high quality ready-to-wear suits).*
*– Thickness of the seams: The thicker the seams the lower the quality.*

# THE WARDROBE

- *A pair of pajamas is not a tailcoat;*

*one should not confuse the two.*

- *Giovanni Ansaldo*
  The True Gentleman

Following the pages dedicated to fabrics, sartorial techniques, and the fitting, we come finally to the finished suit, or more precisely, the suits.

There are many ways to present the various categories of suits. We have chosen those suits that we think are essential for the creation of an ideal wardrobe. We have divided our selections into two main categories.

In the basic types, we have grouped the most common suits, which include two-piece, three-piece, or sports jackets and trousers. Next comes the section "Specific Occasions," which includes dress or more formal suits, followed by those models that, having been created for particular occasions, are now worn much more frequently.

Naturally, "specific" suits—morning coats, dinner jackets, tailcoats—follow precise rules and structurally fixed principles. There have been repeated attempts to modify the traditional styles, given the innate desire among many to go against prevailing tastes. Tampering with elegance is dangerous. And perhaps for this reason, the basic parameters of these suits have held firm against the fearless wanderings of vanity for more than a century.

Suits and accessories are illustrated in two ways: through photographs of noted personalities from yesterday and today who have been unanimously acclaimed to represent the height of fashion elegance—individuals endowed with truly recognizable style; or with photographs of manikins or individuals who graciously offered their services. Our choice, however, should be seen merely as an orientation, a point of departure to give impetus to the creation or completion of a true wardrobe.

This process is anything but simple and, unfortunately, it is usually rather expensive. This means it should be carried out with care and in stages; a wardrobe is not completed in a day or even in a year.

To avoid errors—which inexorably translates into the buying of an outfit that is worn once and then relegated to an obscure corner of the closet—it is advisable to begin at the most basic level, meaning attire that can be used for more than just one occasion.

But this does not mean, for example, that a dinner jacket is less important than a two-piece suit, which is worn more often; it depends on the individual's needs and objectives. "You do not have an evening suit? My goodness! It's indispensable! You see, in Paris, it is better to have an evening suit than a bed." This advice, from a friend who had "arrived," was given to Bel-Ami, Maupassant's famous character who sets out to win a place in opulent, turn-of-the-century Paris. Today, things are different...or are they? Nevertheless, people choose clothing according to their life-styles, enriching their wardrobes over time with new contributions and acquisitions which are not always obtained from shops or tailoring houses. Often, in fact, unique clothing is inherited, and more than one wardrobe has been filled with valuable items garnered from the modest shelves of a used-clothing merchant.

Finally, there are accessories. We have selected only a few: the most common, and perhaps the most secure, to go with a variety of suits. But there are many different accessories with an endless range of possibilities; very often that extra touch of class is given by a particularly successful combination, by an object of high quality, consciously worn, but also with the certain casualness that real elegance requires. In the captions accompanying the illustrations, we have tried to take into account every rule, insofar as it exists.

# THE BASIC TYPES

Today, two-piece suits, usually single-breasted, consist of a jacket and pants made from the same fabric. It is the result of a sartorial evolution that began almost three centuries ago. In effect, it is the classic configuration of a city suit and is generally of gray flannel or pick-and-pick. It has a neutral connotation and can be worn just about anywhere, even for evening occasions that are not too formal.

However, a summer suit tends to have an inherently less formal connotation than its winter equivalent. For example, a suit of tropical fabric or gray Super 100's will seem more casual than flannel or a faille equivalent. A complete summer suit in a solid classic color can be made from the so-called light wool, or from linen, although linen has a tendency to crease more than wool. However, many people consider this a value rather than a defect.

A two-piece suit, which at first glance appears to offer little in the way of creativity and personalized flourishes, actually holds out a series of interpretive possibilities. One can work on pockets, vents, lapels, trouser length, or even determine whether the jacket should be single- or double-breasted. □

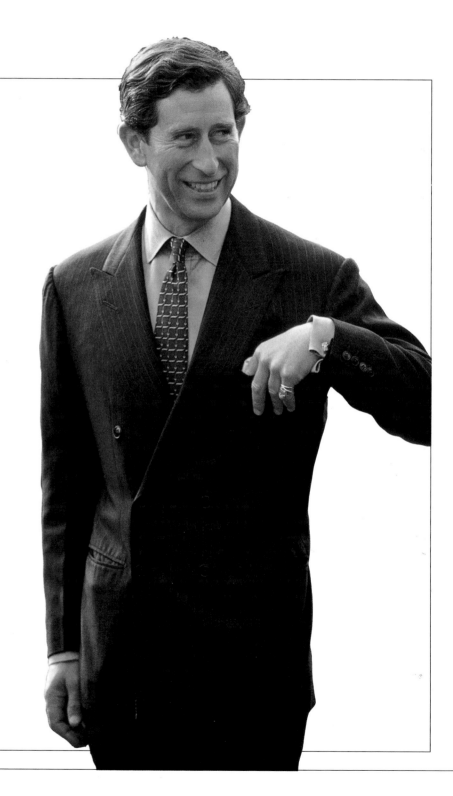

• A double-breasted two-piece suit in a relatively lightweight chalk-stripe fabric, appropriate for in-between seasons. It is a versatile ensemble, one that can be worn in the office, in the evening, or at a ceremony.

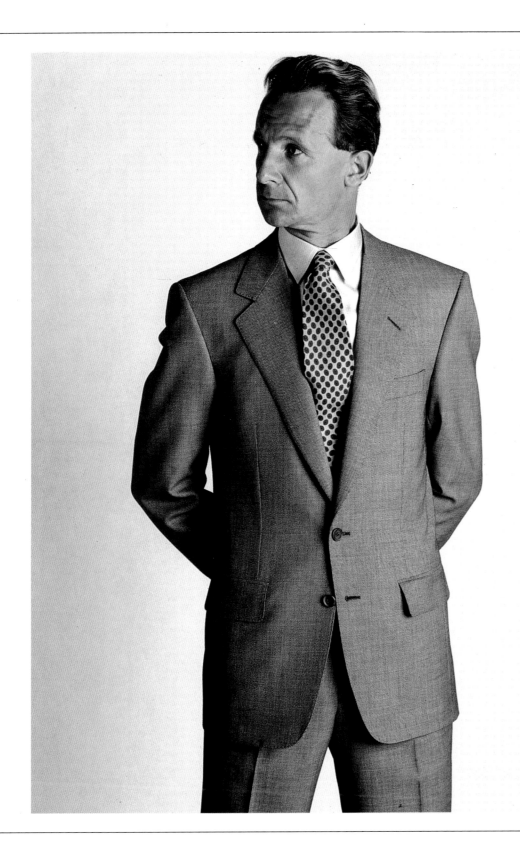

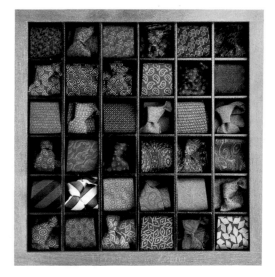

• A medium-weight bird's eye two-button two-piece suit appropriate for in-between seasons. It can be worn in a variety of situations, but preferably during the day. The flaps can be hidden inside the pocket.

• An assortment of silk ties. The most traditional designs are paisley, stripes, and polka dots in various sizes. Today's ties have a support lining, once made from the material of the tie itself but folded seven times to create the same effect. Note the design illustrated below.

## TWO-PIECE SUITS

### NAVY

Navy suits are peculiar; taxidrivers or officials such as bank directors wear them. It is a bit of a uniform, and like all uniforms, the difference is in the cut and the way it is worn. In a certain sense, the navy suit is in a period of transition. Until a few years ago it was rather popular and was worn in the office as an alternative to pick-and-pick. Today, apart from bankers and financiers, who work in an environment where formality is the rule, its use is declining, and it is more likely to be worn in place of a morning coat on formal occasions during the day. It can also be worn in the evening for certain important situations in which a dinner jacket is not explicitly required. A navy suit does not necessarily have to be monotone, and one is free to experiment within the range of the same color shades. Choices can vary from a herringbone fabric to heavy cloth and to the fresh colors of a linen or cotton navy suit. Some people have made a cult out of the navy suit, and have closets filled exclusively with suits of this color. Charles Revson, head of Revlon, is one such person. He has a collection of more than two hundred navy suits. □

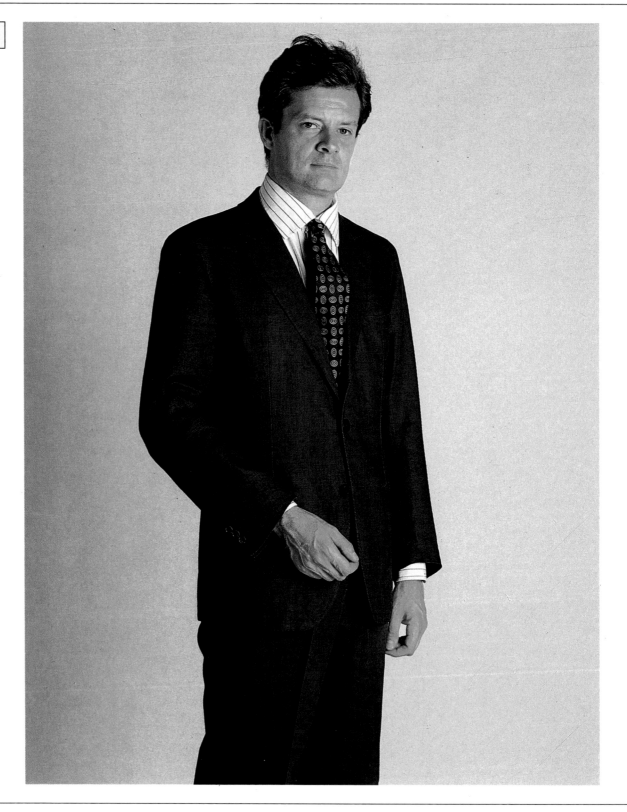

• Cotton pieces for shirts. The navy suit is one of the most adaptable. The tone is dictated by the accessories, in particular by an accurate choice of shirt and tie. At a funeral, for example, a white shirt and black tie are mandatory; in an evening setting a striped shirt is appropriate, while in the office one could select a blue or moderate-colored shirt.

• *Below:* A silver tie bar is a particularly useful accessory for a two-piece suit, which does not have a vest to keep a tie in place.

• *Opposite page:* A linen navy two-piece summer suit with a three-button front. Linen can be easily washed, which gives the material a notable softness and a more elegant effect.

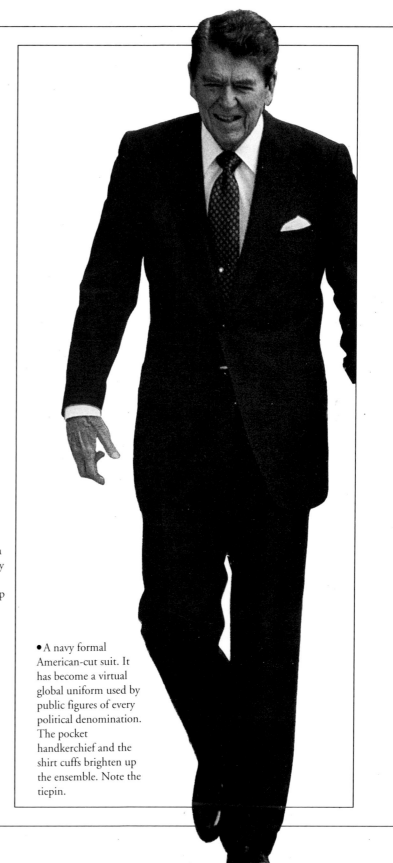

• A navy formal American-cut suit. It has become a virtual global uniform used by public figures of every political denomination. The pocket handkerchief and the shirt cuffs brighten up the ensemble. Note the tiepin.

## GABARDINE

A gabardine suit is in certain respects similar to glen check. Just as the latter can be worn in the city—on informal occasions—so too can the gabardine suit.

Although cotton gabardine is produced, the classic and best-known type is wool gabardine, which is characterized by a certain freshness, although it is relatively heavy. It started to become popular, particularly in the United States of the 1930s, where it was appreciated for the elegance of its fit, which was due to its weight and softness.

Like many fabrics that reached the United States, gabardine was developed in England, where it was produced to satisfy the requirements of colonial dress. The most popular colors were—and still are—navy, gray, and various shades of beige and green. The gabardine suit is a great classic for in-between seasons in addition to summer.

The word gabardine comes from the term used to designate a pilgrimage, usually to the Holy Land and refers to the caftan made of that material that Jews were forced to wear during the Middle Ages. □

• *Left:* A figure from the early 1900s in a white gabardine tennis outfit. At one time this fabric was often used for sportswear.

• *Above:* Straw hats are a useful accessory on bright afternoons. A Panama, with its unmistakable styling, is another classic hat for those steamy summer months.

• *Right:* Lightweight Oxford shirts in two tones of blue. They are often worn with gabardine suits.

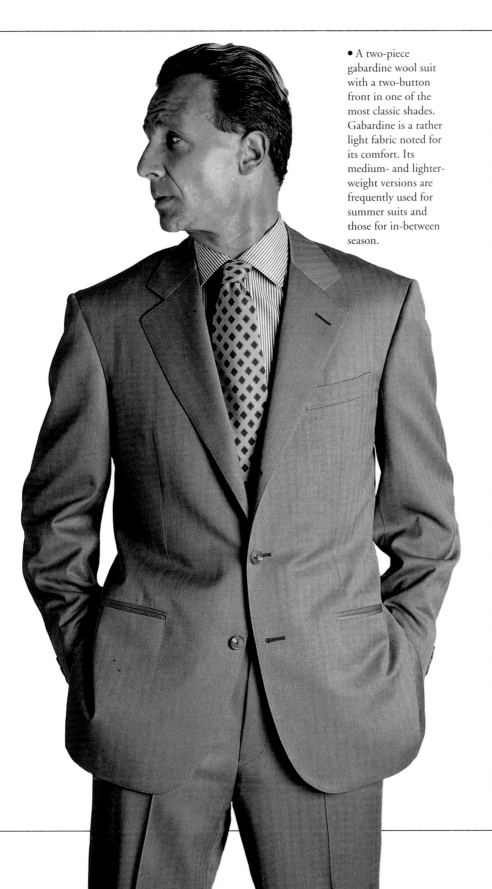

• A two-piece gabardine wool suit with a two-button front in one of the most classic shades. Gabardine is a rather light fabric noted for its comfort. Its medium- and lighter-weight versions are frequently used for summer suits and those for in-between season.

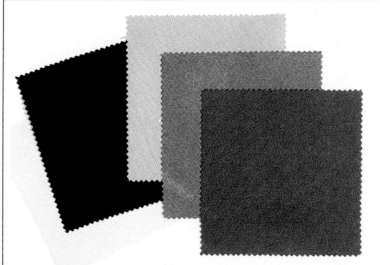

• The three classic shades of gabardine, an ideal fabric for two- or three-button two-piece suits. The same material, in dark blue, assumes a more elegant tone and can be worn as an alternative to a dinner jacket on semi-formal evenings. Gabardine was once found among woolen fabrics but today it comes in cotton as well, although this latter version tends to crease more easily.

• Regimental ties. In England they are generally worn by officials and members of clubs and sporting circles. Someone who wears a regimental tie to a club of which he is not a member is not well received. Thus it is more widely popular outside of Britain. A regimental tie goes well with gabardine, which is always in a solid shade.

### TWO-PIECE SUITS

### GLEN CHECK

A glen check suit is appropriate for the city (as long as it is not worn for work in financial institutions) and the country. In both cases, the style is that of a sporty but formal look.

The English name for this fabric—characterized by a crossing of two-and-two with hound's tooth—is Glen Urquahart, which comes form a Scottish clan that used it to make plaid patterns. It was popularized by the Prince of Wales, later Edward VIII, in the mid-1920s. It is also known as glen plaid or glen check.

Glen check fabric is a yarn that usually consists of black and white threads, although it sometimes has intersections of rush brown or green fibers. There are also versions in beige and other colors. This material was also used to make suits intended exclusively for country wear, especially during the second half of the last century. It is thus not true that this fabric was "invented" by Edward VIII, particularly since his grandfather, Edward VII, was often pictured on country hikes or in a hunting party wearing a Glen Urquahart outfit with a full ulster overcoat of the same material. A glen check jacket can be either single- or double-breasted. □

• *Opposite page:* A three-button glen check suit. The center model is buttoned; the one above remains covered by a lapel. Ironing lapels that have been cut for three-button suits will create an effect like that of the suite in the photograph.
A perfect and still valid example of a traveling ensemble. Note the somewhat excessive attention to accessories: collar pin (notwithstanding the buttons that hold down the tips of the collar); tiepin; pocket handkerchief (different from the tie) and a pinky ring.

• *Right:* A two-button glen check suit with only the top button fastened, as is the custom. The glen check was once worn only in sporting situations. Today it can also be seen around town.

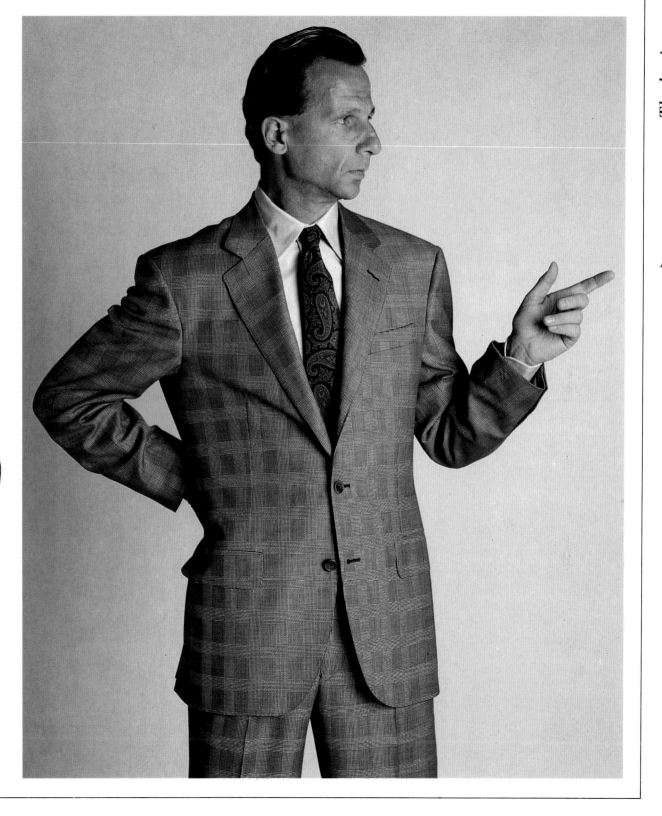

• A walking cane of varnished bamboo is an accessory that needs to be reinvented. It should not be consigned exclusively to the physically impaired. In addition to conferring a sense of dignity to one's bearing, it can be useful in a variety of situations.

## TWO-PIECE SUITS

• The upper part of the lapel must be peaked on a double-breasted glen check jacket. Contrary to the fabric shown below, fabrics used for suits of the 1930s and '40s were made of heavier weights. The attachment of the sleeve to the shoulder is perfect.

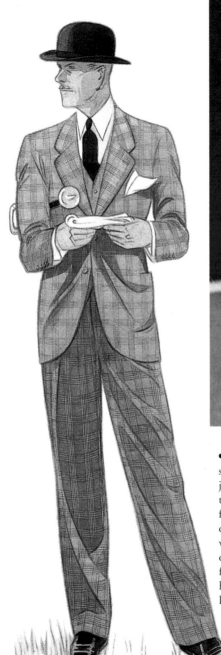

• Figure from the Thirties in a glen check three-piece single-breasted suit. This fabric is also ideal for three-piece models. Note the trousers' relatively wide bottoms and the absence of cuffs.

• Nuances on the sleeve of a glen check jacket. When applying the finishings to this fabric, the symmetry of the squares becomes very important; in other words, the finishings must be in harmony with the lines of the pattern.

• *Opposite:* Two-piece suit elegantly worn for afternoon occasions in the city. Hat and umbrella complete the ensemble.

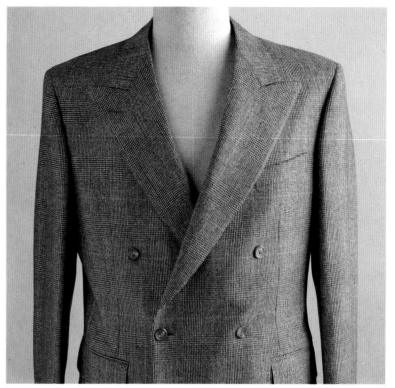

• *Below:* Pair of traditional silk umbrellas with reed and malacca handles. They elegantly accompany a glen check suit for formal occasions.

• *Above:* Double-breasted glen check jacket with blue stripes. It is a modern version, lighter in weight, of the classic Saxony.

## TWO-PIECE SUITS

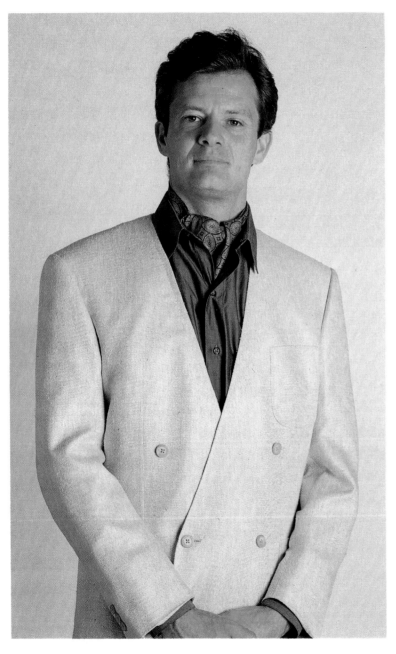

• Brown sports shoes with a toe-cap can be impeccably worn with light suits. This classic Oxford model, with its characteristic decorations, is perfect for rainy days.

• *Below:* Wooden shoetrees are indispensable for maintaining a shoe's form over long periods of time. Another good rule for preserving footwear: Do not wear the same pair of shoes two days in a row.

• A double-breasted jacket without lapels. This was popular summer attire during the Sixties; the cut discourages the use of a traditional tie in favor of a scarf under a colored shirt. The fabric is usually an Italian linen, replaced by shantung silk on more elegant occasions.

• *Right:* A three-button suit in Irish linen. Linen tends to crease, but this characteristic is thought to enhance the look rather than detract from it. Note the patch pockets, which are found especially on summer versions. Linen suits are often unlined which makes it easier to wash them.

• *Above:* A safari jacket used during the Boer War. This type of garment, characterized by deep patch pockets, has inspired many different types of sports coats.

## TWO-PIECE SUITS

• *Below:* A wide-striped double-breasted suit. These lines are generally associated with the gangster images of the 1930s. Pay strict attention when choosing the fabric or else have a slender figure, otherwise you may provoke unflattering associations with certain infamous personalities.

• *Right:* A striped double-breasted suit with a six-button front. This type of fabric, with its more subtle lines, has a very formal look and can be worn in the evening. Contrary to popular custom, which suggests fastening only one button, here the jacket is completely closed.

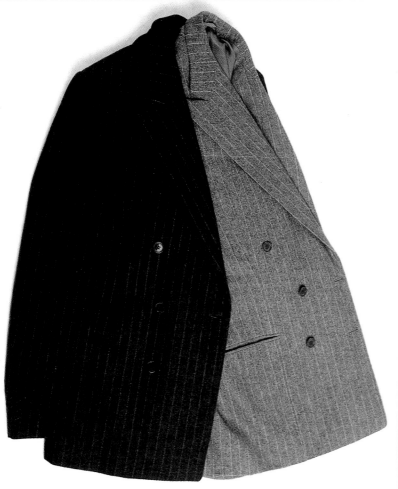

• Two-striped double-breasted jackets with six-button fronts. Winter stripes are always in flannel, although colors may vary. The most popular shades are navy, bright or dark gray.

• *Side:* Dark shoes with a toe-cap are highly recommended with a striped suit, forming a combination that is appropriate for any situation.

• A modern interpretation of a striped suit. The cut is single-breasted with a two-button front. The material is characterized by an imaginative violet-colored line. A single-breasted stripe is less formal than its double-breasted counterpart. It is, however, the preferred suit of Wall Street raiders and Manhattan businessmen. As a result, it has been imitated by virtually everyone who works in a bank. A solid-colored shirt is advisable with a striped suit.

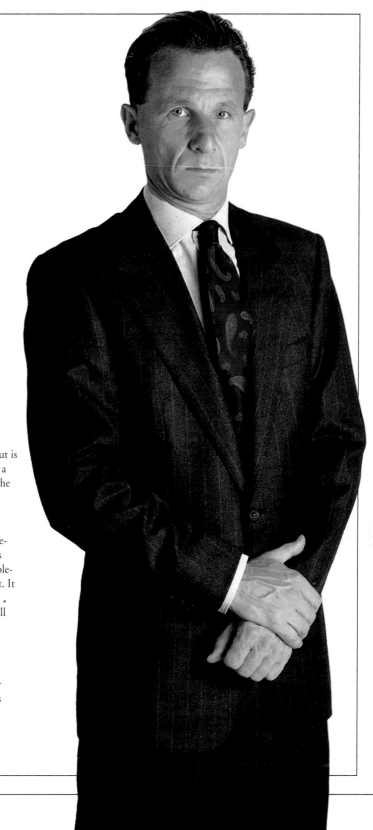

## THREE-PIECE SUITS

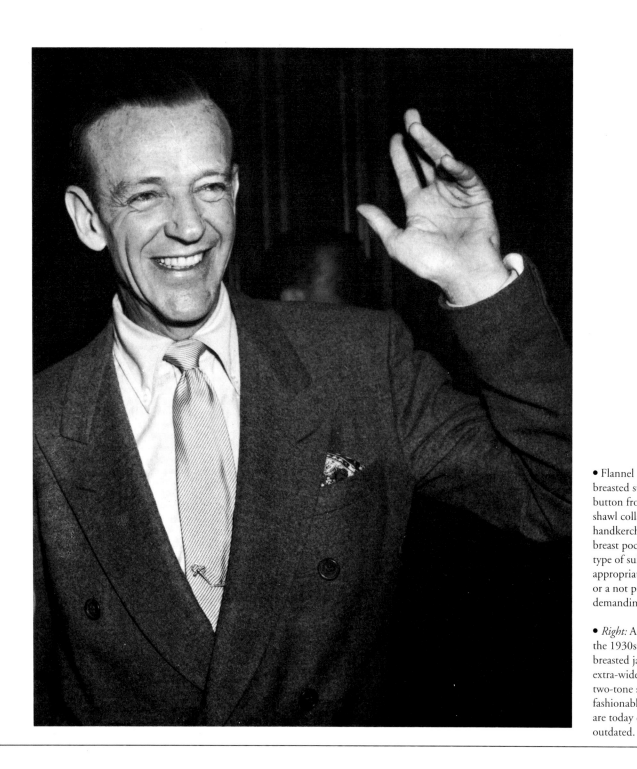

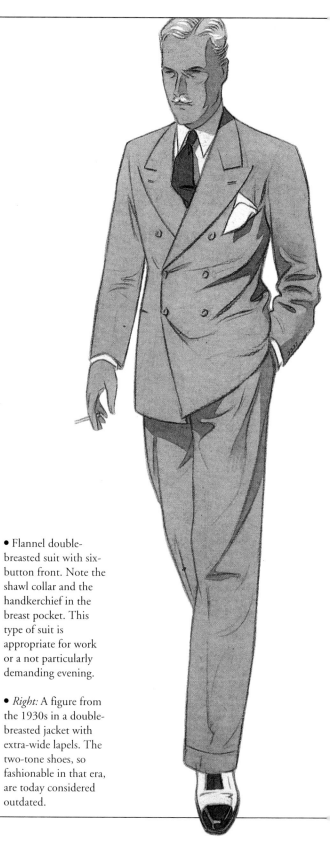

• Flannel double-breasted suit with six-button front. Note the shawl collar and the handkerchief in the breast pocket. This type of suit is appropriate for work or a not particularly demanding evening.

• *Right:* A figure from the 1930s in a double-breasted jacket with extra-wide lapels. The two-tone shoes, so fashionable in that era, are today considered outdated.

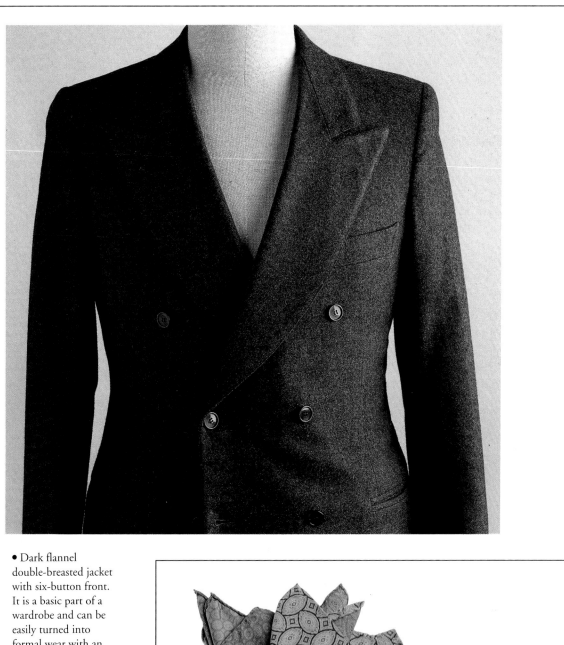

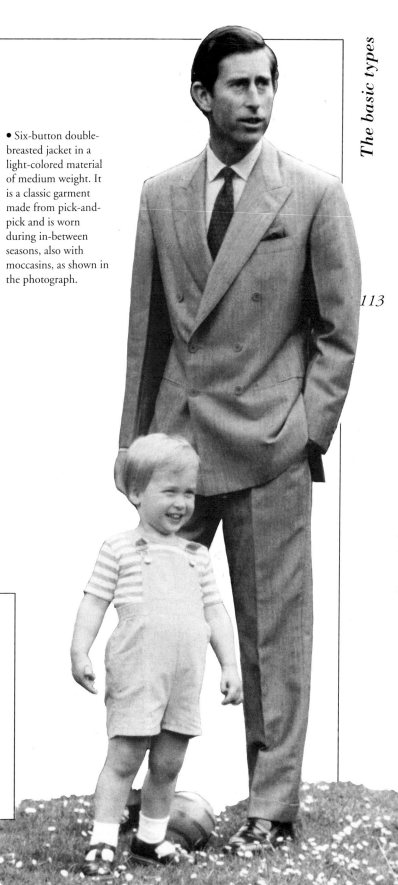

• Six-button double-breasted jacket in a light-colored material of medium weight. It is a classic garment made from pick-and-pick and is worn during in-between seasons, also with moccasins, as shown in the photograph.

113

• Dark flannel double-breasted jacket with six-button front. It is a basic part of a wardrobe and can be easily turned into formal wear with an elegant white shirt and a silk polka-dot tie. It can even be sporty, as shown in the photograph on the opposite page.

• Silk handkerchiefs with lively motifs can brighten up a somber-colored double-breasted jacket.

## THREE-PIECE SUITS

A three-piece suit refers to an ensemble that, in addition to a jacket and pants, includes a vest. The vest, of Persian origin, is relatively ancient. It has been worn by men in a form similar to the existing one since before the 18th century.

It reached its greatest popularity in the 18th century, when, under the long jackets of that period, silk vests with from 12 to 20 buttons were beautifully displayed. In the austere Victorian era, when fabrics of somber colors dominated, vests and ties provided creativity in men's clothing.

The obvious utility of a vest is that it provides protection from the cold, a task it fulfilled excellently until the relatively recent popularity of sweaters.

Today the choice of a three-piece suit, and thus a vest, is more of an aesthetic rather than a practical decision. Actually, a well-cut vest looks better than a cardigan worn under a jacket and is an ideal addition to a single-breasted jacket. A vest adds four more pockets to the already large number found on a man's suit. They are useful for holding change, bus tickets, watches, watch chains or other small items. A vest, even one made of sporty material, helps give a suit a more formal and elegant look and has the advantage of holding a tie more firmly in place. There is no agreement on whether a vest can be worn with summer suits and double-breasted jackets. In both cases, however, the presence of a vest does not seem to be unwelcome; in the first case because it offers protection from unexpected drops in temperature or gusts of wind, in the latter because it serves an unquestionable aesthetic function. □

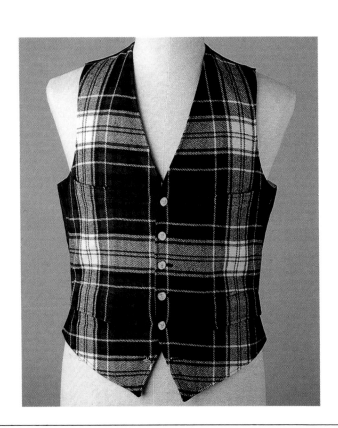

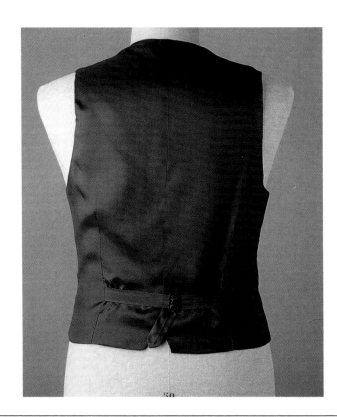

• Scottish vest with six-button front. This waistcoat was cut to be worn with the lowest button unfastened.
At right, the back of the same vest. Note the strap to adjust the width. The back of a vest is usually made of silk or Bemberg.

• *Left:* Three-piece suit with unbuttoned jacket to reveal a six-button vest. The fabric is crossbred, a heavy material created for use in the country, although it can also be worn around town during a particularly cold day.
The ensemble is completed by an umbrella and a derby, which continue to be indispensable accessories for those who work in the city.

• *Above:* Three-piece single-breasted suit complete with accessories in place; waistcoat crossed by a watch chain, carnation in the lapel, handkerchief in the breast pocket, collar pin.

## THREE-PIECE SUITS

### TWEED

Until the 1950s, in cold countries and also in Italy, three-piece suits were made from heavy fabrics, above all tweed, which was much in demand for any occasion that required a warm suit—one that would be practical and resistant. Unfortunately, this suit is now a rarity. It survives in the wardrobe of country gentlemen and of a few enlightened admirers living in the city. It is sporty, perfect for trips and excursions, and can be worn with a vest.
If the material is especially rough, it is a good idea to have the pants lined.  □

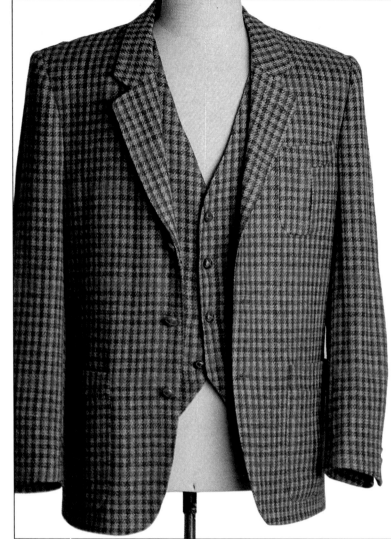

• Tweed three-button jacket with four-button vest; the lowest button remains unfastened. A tweed jacket and vest are rather heavy together, which means that it is better to wear them in cool weather. The accompanying trousers can be the same fabric (as in this case), covercoat, flannel or other heavy solid-color woolen fabrics.

• There are no rules to determine the number of buttons on a tweed jacket. In these two examples of one- and two-button fronts, fake buttonholes are used because the especially prominent configuration of the intertwined leather buttons does not allow for unfastening.

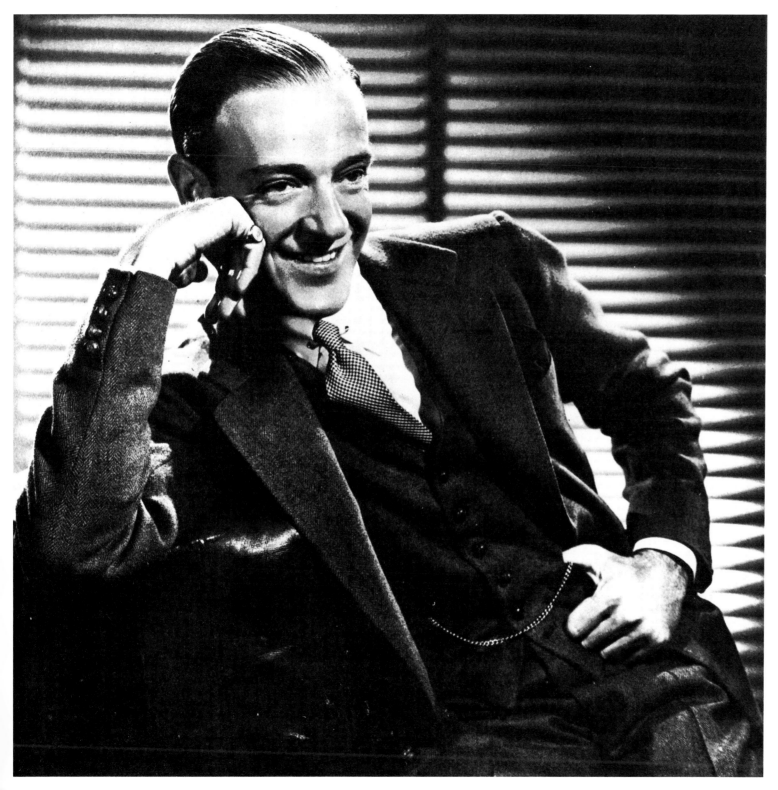

• A splendid single-breasted tweed suit with six-button vest and four-button leather fastening on the sleeve. Due to its heavy weight, a tweed suit has fallen into disfavor; it can be too hot for well-heated houses or apartments. The fabric is quite rough, but an appropriate lining will eliminate any inconvenience. With the introduction of new weaving techniques, it is now possible to create a lighter tweed that can be used to make a complete suit.

THREE-PIECE SUITS

## STRIPES

Under the category of stripes it is possible to include fabrics with continuous lines (chalk stripes) and those with subtle dotted lines (pinstripes). They are mostly used in the making of jackets for the city and were actually created as fabrics for clothes to be worn in the office. They made their first appearance in London, where for generations the pinstriped suit symbolized the division between employees, together with the bowler hat, a furled umbrella and a copy of the *Times*.

It seems as if the design on the fabric of a pinstriped suit was inspired by the lines in accounting books. In reality, continuous or dotted lines can be traced to the lines on the trousers worn with a morning coat, which was very popular in London during the first half of the century. The traditional colors of a pinstriped suit are gray, black and navy, with white or sometimes red dots. If a single- or double-breasted pinstriped suit does not present any particular problems and is appropriate for many situations, including evenings, the same cannot be said for real stripes, which require a certain amount of care in choosing. Chalk stripes, like many other fabrics, owe their popularity to the Duke of Windsor. During a world tour, which included a stop in the United States, the duke dressed almost exclusively in a striped double-breasted jacket. It is advisable to choose stripes that are not too heavily marked in the usual gray or navy tint. □

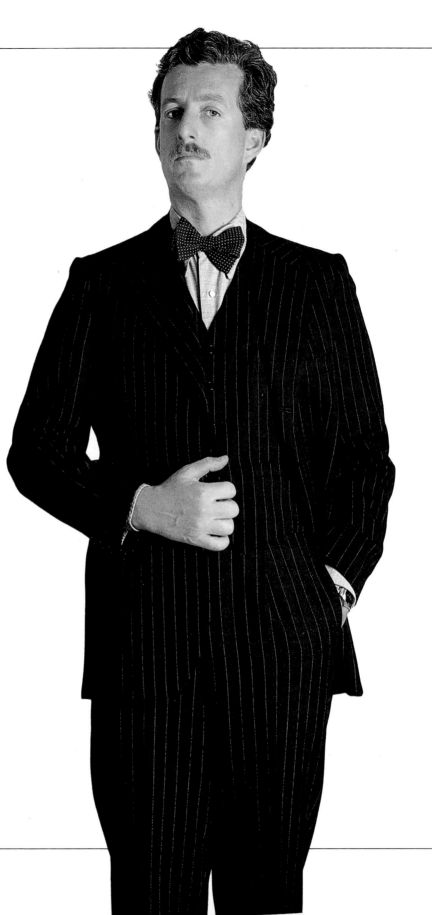

● Pinstriped suit whose lines are formed by a thick succession of dots. The vest under a striped jacket accentuates the demanding and formal tone. In this case, the stateliness of the ensemble is mitigated by the noticeably exuberant bow tie.

● *Opposite page:* Two striped double-breasted jackets with six-button fronts. The jackets are made of nearly identical material and cut in a way that accommodates a vest. Note the very wide lapels and the difference in the size of the tie knots. It is a typical American style to wear a striped buttondown shirt with a striped suit.

## THREE-PIECE SUITS

### VELVET AND CORDUROY

A suit consisting of a velvet jacket and pants is about as rare as that of fustian. Generally, velvet is used to make trousers that go with a jacket of tweed or similar material. It is a particular type of fabric, rather versatile, and deserves mention.

The fabric is divided into velvet and corduroy. It was once made almost entirely of silk and was used for the uniforms worn by the huntsmen of the French king.

At that time corduroy was cut and brushed by hand to raise the fiber. In the second half of the 19th century, cotton was introduced and corduroy lost favor as it was considered a fabric of lower quality, used mostly by the less-affluent classes. It was only after the Second World War that velvet regained its popularity, in part because of its versatility. In fact, this material is adaptable for rugged outdoor use (in the mountains or country), but can also be worn in the city, especially in the narrow corduroy version.

A velvet suit is not too formal for casual situations. Moreover, dark colors will pass the test of use around town.

Velvet is especially suited for between-season wear because the raised fibers of corduroy provide a certain amount of warmth—somewhere between wool and cotton.

A black, green, burgundy or blue velvet jacket with corduroy pants is especially appropriate for early evening situations. It is the in-between season or summer equiv-

alent of heavy cloth jackets. The latter, like velvet jackets, require frequent brushing and are not recommended for those who suffer from dandruff. □

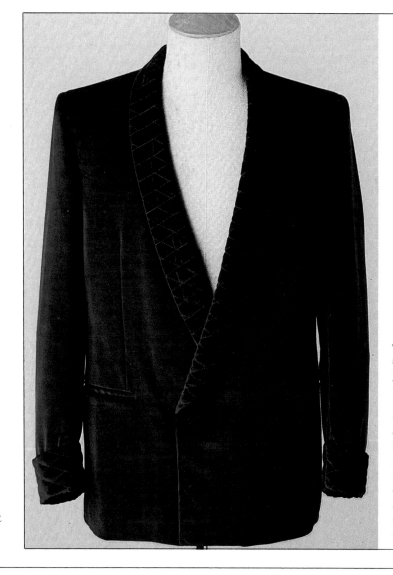

● Velvet is particularly suited for a smoking jacket. In addition to this garment, velvet is also used for other types of jackets; in dark colors—black, bottle green or blue—it is elegant enough for most evening occasions; brown shades give velvet a decidedly sporty character.

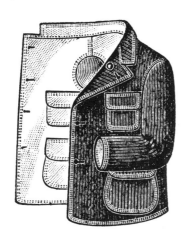

• Models of velvet sports jackets used for hunting clipped from a turn-of-the-century catalogue. Note that the jacket may be completely buttoned on the right, despite having been fashioned with modern lapels.

Velvet was once a very popular fabric for outdoor garments. Unlike wool, however, it does not "hold" water very well and becomes saturated immediately. Although great advances made in developing synthetic fibers have solved these problems, velvet is used almost exclusively for trousers.

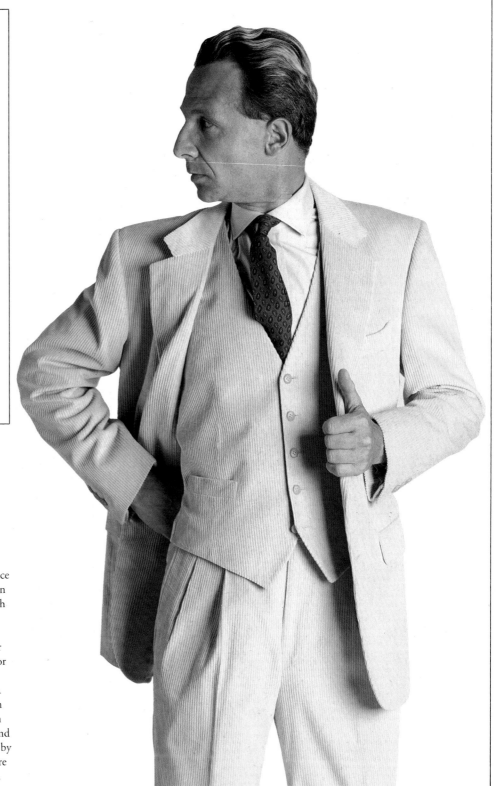

• Corduroy three-piece suit with a five-button vest. Corduroy, which should always be chosen in a single shade, makes it easier to combine a jacket or trousers made of different materials. A corduroy suit is worn almost exclusively on informal occasions and can be accompanied by a scarf. On the left are two classic examples.

## THREE-PIECE SUITS

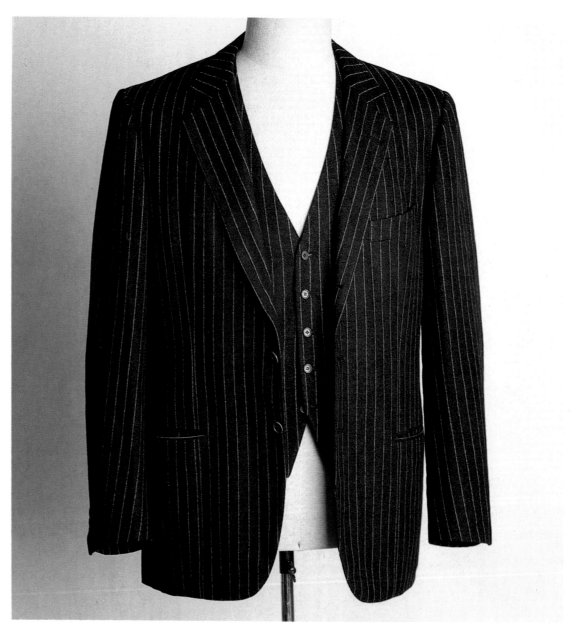

• Black shoes with toe-caps and laces, perfect under a dark suit or as part of a formal ensemble. The black calfskin belt (below) accompanies the shoes.

• Striped single-breasted suit with a five-button vest. It is one of the stripes par excellence, strictly for winter—as much for its dark color as for the weight of its fabric. It lends itself magnificently to the smallest of details because it reaches the height of its elegance when enriched with the right accessories.

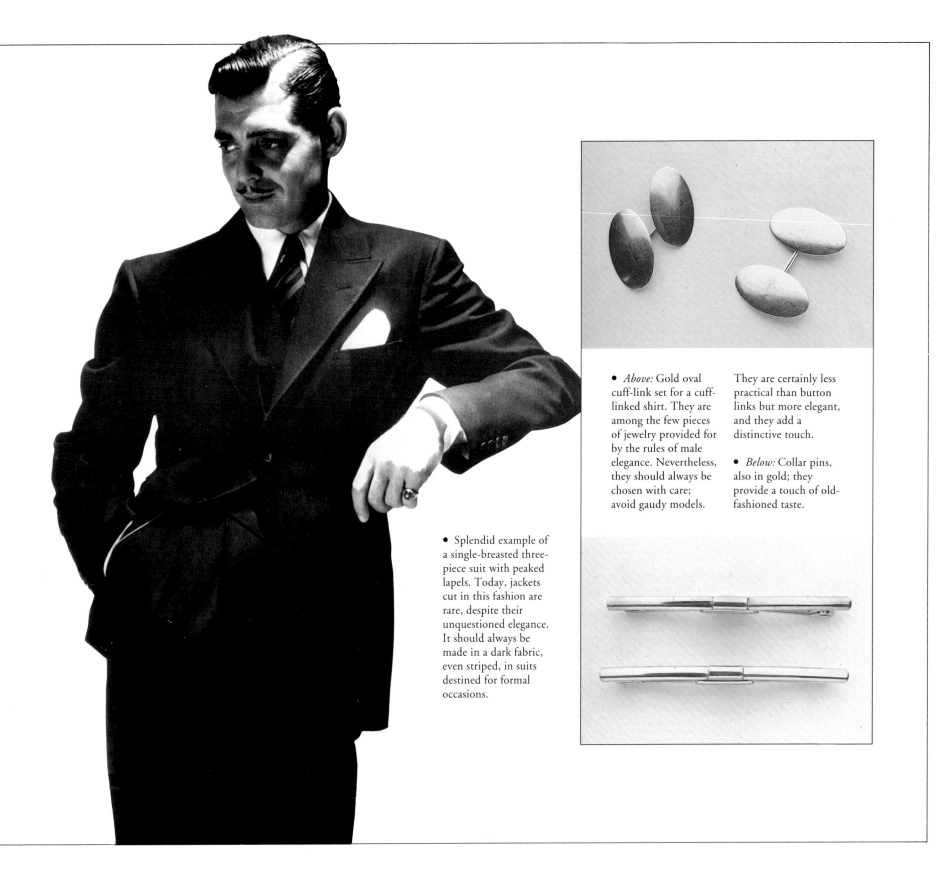

• *Above:* Gold oval cuff-link set for a cuff-linked shirt. They are among the few pieces of jewelry provided for by the rules of male elegance. Nevertheless, they should always be chosen with care; avoid gaudy models.

They are certainly less practical than button links but more elegant, and they add a distinctive touch.

• *Below:* Collar pins, also in gold; they provide a touch of old-fashioned taste.

• Splendid example of a single-breasted three-piece suit with peaked lapels. Today, jackets cut in this fashion are rare, despite their unquestioned elegance. It should always be made in a dark fabric, even striped, in suits destined for formal occasions.

• *Left:* Hound's tooth single-breasted three-piece suit. This fabric has a decidedly informal look; it can be worn with suede shoes and a bow tie, or moccasins during in-between seasons.

• *Above:* Leather and elastic suspenders attached to buttons. This accessory has declined in popularity, along with a three-piece suit, which happens to need suspenders more than other types of cuts.

• *Right:* A series of bow ties in classic designs; polka dots, geometric, and paisley.

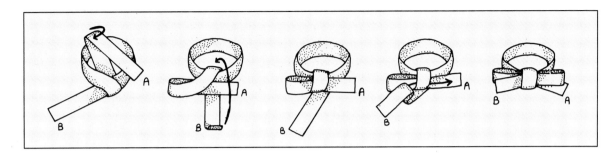

• How to tie a bow tie: After being looped around the inside of end B, end A is folded in half, arranged across and twisted horizontally 180 degrees. End B is looped over the folded loop from the outside to the inside and the folded end of the loop is pulled through the knot thus formed; be sure to keep both loops even.

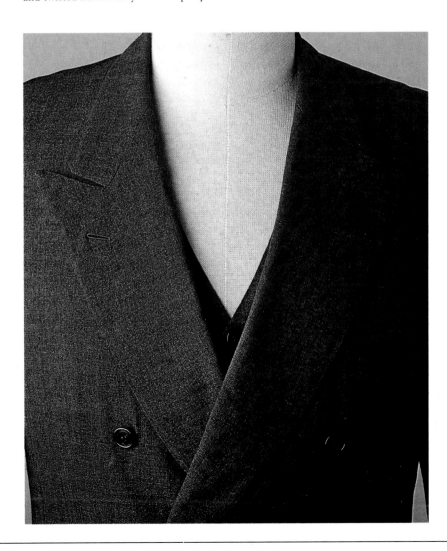

• *Right:* Flannel single-breasted three-piece suit. The six-button vest with lapels, which was once very popular, is limited nowadays to vests worn with morning coats or tail-coats. The eternal polka-dot bow tie, with floppy hat and cane, elegantly complete the ensemble. A bow tie is a good choice in this case because the vest covers most of the buttons on the shirt.

• *Left:* Double-breasted three-piece suit in flannel. Remember that flannel is a material that must be "rested" to allow it to reassume its form. When the jacket is double-breasted, it is worn closed. It is increasingly rare to find it worn with a vest.

## SPORTS JACKETS AND TROUSERS

In addition to the traditional combination of a tweed jacket and pants, or an overcoat for example, there is a combination that can be defined as "urban," in contrast to the above combination, which has a more rural connotation.

The urban combination grew out of a certain necessity. It is known that trousers wear out faster than jackets, which explains why some prudent clients ask their tailors to provide two pairs of pants for every jacket.

Some individuals are not blessed with such foresight. And many buy ready-to-wear suits, which usually come with a single pair of pants. After a few years, these two groups may find themselves with a jacket still in good condition but with trousers that have to be thrown out due to excessive wear.

Since it is practically impossible to find a cut of material whose color corresponds perfectly to that of an older jacket, whoever wants to continue wearing the jacket is forced to wear trousers of a different color. In many cases, the effect is quite pleasing, provided that one is sensible enough to choose solid-colored pants if the jacket is patterned. Naturally, the reverse is also true. Another valid rule is to wear a light jacket with dark pants and light pants with a dark jacket.

Despite its parsimonious origins, a jacket-and-pants combination has also enjoyed wide success because the result is livelier than classical suits for the city. For this reason, many people put together a combination without waiting ▷

• Checkered jacket over dark trousers. The jacket is cashmere, a fabric perfect for high-quality jacket-and-pants combinations for the winter months. The softness of cashmere makes it unsuitable as a fabric for trousers.

• *Opposite page:* Tweed coat and flannel trousers. It is the combination par excellence, one that provides great freedom in selecting the colors of the rest of the ensemble. Note the regimental tie, which indicates membership in a sports club.

- *Top left:* Striped shirt with buttondown collar invented by the Brooks brothers, the first American fashion designers.

- *Above:* The famous Brooks Brothers trademark.

## SPORTS JACKETS AND TROUSERS

for the pants to wear out completely and proceed to buy separate pants and jackets that, together, create a very pleasant effect.

An atypical combination is that formed by a black jacket and striped pants. It is very similar to a morning coat although it is no longer worn very much, because one risks being mistaken for the off-duty concierge of a luxury hotel.

Cotton is the fabric of choice for summer combinations, and the types most recommended are madras and seersucker. The latter is especially popular in the United States, where, during the 1950s, it was also used to make complete suits. Some even joked that if the army needed to mobilize the male population, they wouldn't have to worry about uniforms. It would be sufficient to order everyone to report in their seersuckers. Nevertheless, a seersucker coat is an excellent choice for an informal evening near the seaside or waterfront.

A separate jacket and pants combination can also be created with a jacket and shorts, although they are worn almost exclusively in the tropical climates of many ex-British colonies. Bermuda, for example, is one place whose name has almost become synonymous with shorts. In fact, the local judges and police officers wear shorts while performing their duties. Bermuda shorts became popular between the two world wars. They were produced in a straight-leg version instead of flared, which was characteristic of the so-called empire builders, the short colonial pants worn ▷

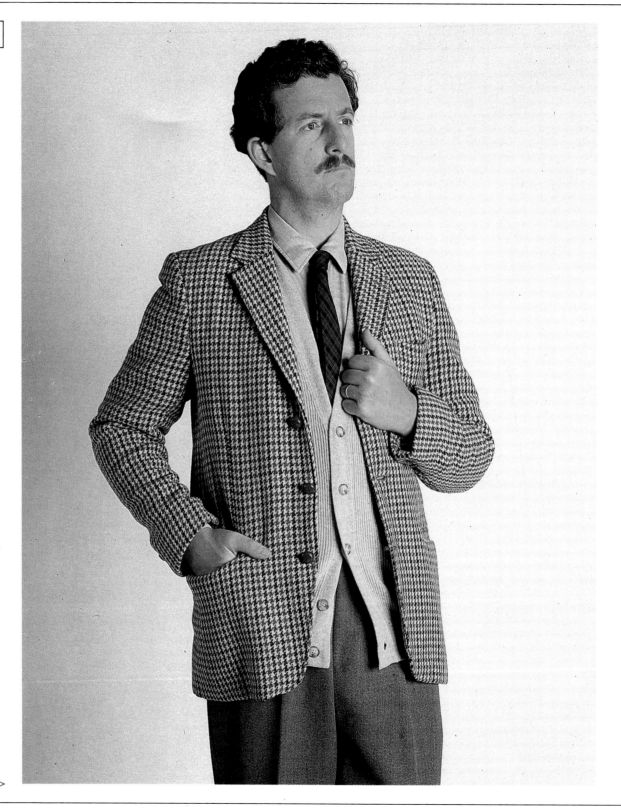

• *Opposite page:* Tweed check jacket enhanced by a cardigan. This type of sweater, which goes so well with a combination that includes a heavy jacket, takes its name from the English lord who "invented" it in the 19th century.

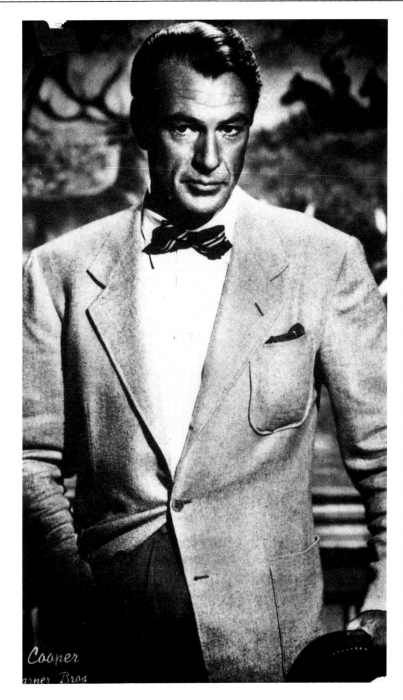

• *Left:* Velvet jacket with four-button front. The four-button version is often found on hunting jackets, which must provide greater protection than normal garments. These jackets usually come with two central or lateral folds to provide greater freedom of movement.

• *Above:* Details of the pockets of the same jacket. The horizontal pocket has a flap and can also be folded.

• A light wool three-button jacket combined with flannel trousers. Note the stitched pockets, which underscore the sportiness of the ensemble. If they are not folded, stitched pockets lose their shape more easily than double besom pockets.

during that historical period.
In European countries and Central America, Bermuda shorts are characterized by their general lack of pleats. They are worn with a jacket, mostly for outdoor cocktail parties.
In such cases, one always wears knee socks. In Australia, Kenya and New Zealand, people often wear a jacket, tie and shorts that are much shorter than Bermudas. Unfortunately, in these cases the length of the socks is often directly proportional to that of the pants. □

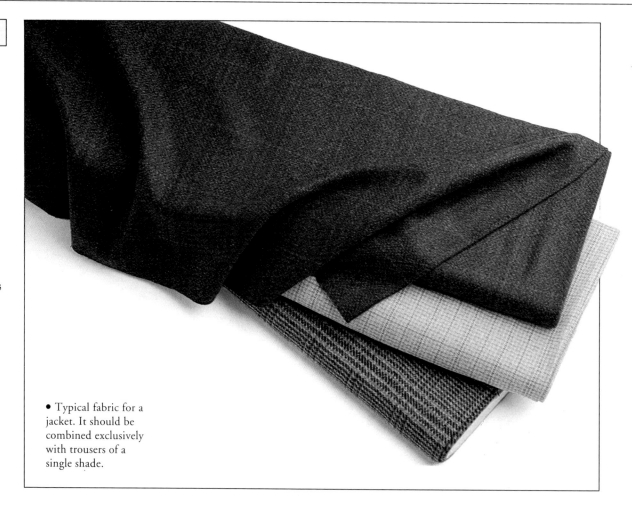

• Typical fabric for a jacket. It should be combined exclusively with trousers of a single shade.

• Two examples of jacket and pants combinations. In both cases, the color of the pants resembles the tint of the jacket. The pants are in cavalry twill, an ideal fabric because it is resistant, warm and does not crease easily.

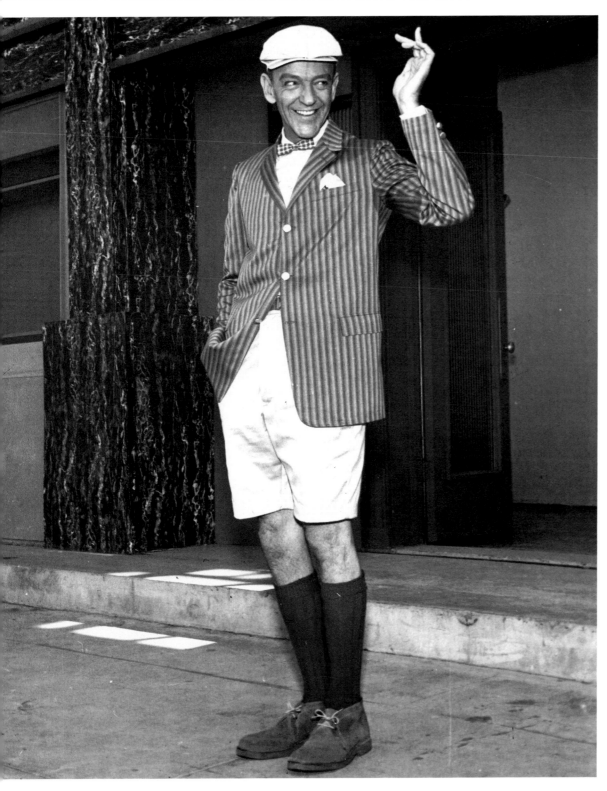

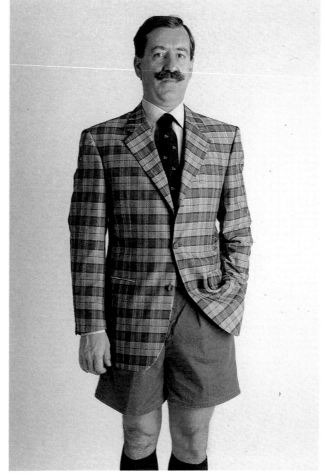

● *Left:* Striped blazer with shorts. The most summer-like of combinations is depicted here with a classic rowing jacket in vogue at English clubs.

● *Above:* A more contemporary combination featuring a madras jacket and Bermuda shorts, whose name derives from the islands of their origin. This clothing is still popular in Australia, Kenya, and South Africa. Knee socks are indispensable.

• *Opposite page:* This elegant ensemble for traveling in the country is still fashionable. The four-button jacket has patch pockets.
It is correct to fasten the first three top buttons.

## TWEED

A tweed coat is one of the cornerstones of a man's wardrobe. The fabric is very resistant and the jacket can last for generations if leather patches are applied to certain strategic points, such as over the elbows. Although considered a noble addition, patches are often applied even when they are not needed. The effect is questionable, especially if the fabric does not appear to be sufficiently worn. Numerous versions of this rather coarse fiber exist, from Donegal and saxony to herringbone. Harris tweed is considered the tweed par excellence. The name is reserved exclusively for pieces of handwoven fabric originating in the Outer Hebrides, specifically from the islands of Lewis and Harris. The islanders began to export their fabrics after 1844, the year in which the count of Dunmore, who owned most of the land on the islands, encouraged the population to weave imaginative motifs into their traditional material. The count was aided by his wife, who convinced the dyers to color the fibers with the natural dyes produced locally. The name tweed is not derived from the valley of the Tweed River, which flows along the border between Scotland and England, but from a spelling error committed by a London employee. In 1826, this man, who was an accountant for a wholesaler of textiles, sent an order for a piece of tweel or twill, but he wrote tweed instead. The designation remained, in part because tweed is also woven in the valley that bears the same name. ▷

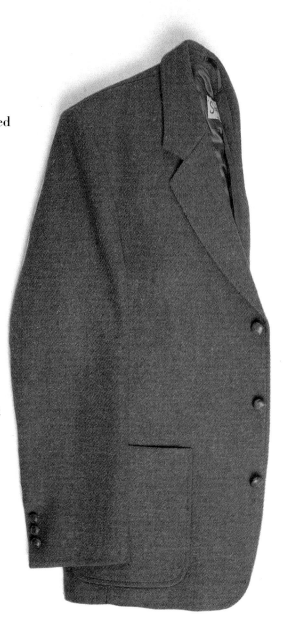

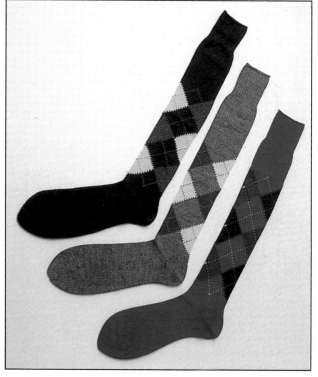

• Harris tweed in the classic burnt-sienna color with a three-button front and stitched pockets. Tweed is an especially long-lasting fabric, but it is not very resistant to abrasion. Consequently, it becomes worn along the edges of the sleeves and at the elbows, where patches are often stitched to prevent further wear.

• Woolen socks with a check pattern, a square design inspired by Scottish tartan. They are rather heavy and go especially well with combinations that include tweed jackets.

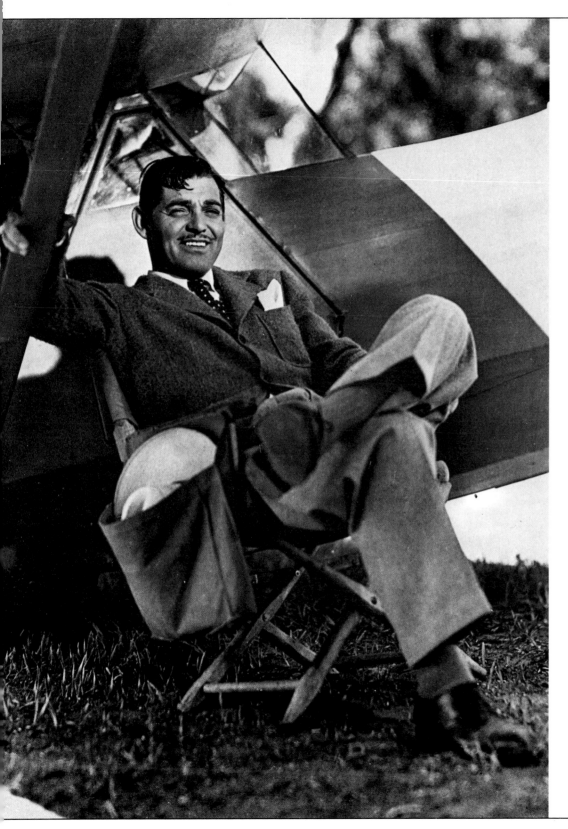

• *Below:* Excellent example of a tweed jacket with a four-button front. The buttonholes are slightly lower than those shown in the photo on the left, which contributes to the narrowing of the lapels.

• *Right:* Both pockets feature retractable flaps. The one above is called a ticket pocket because it often holds bus tickets.

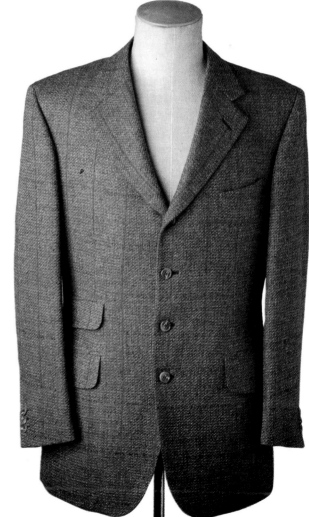

## SPORTS JACKETS AND TROUSERS

A tweed jacket is the country apparel par excellence, even if it is also worn in the city (especially in the United States), with gabardine or flannel pants. Lord Harris did try to make tweed acceptable for formal occasions as well. At the end of the last century, the nobleman appeared in the enclosure of the royal box at Ascot wearing a tweed suit, but he was reprimanded by Edward VII, who said: "Harris, are you going mouse hunting?" Needless to say, this froze Lord Harris, who promptly relegated the tweed jacket to its customary role as a coat to be worn in the country. There is reason to believe, or at least suspect, that following his unhappy experience Lord Harris no longer enjoyed wearing the jacket.

Today, given its coarseness, a complete suit of tweed is seldom made, except when the pants are knickerbockers. □

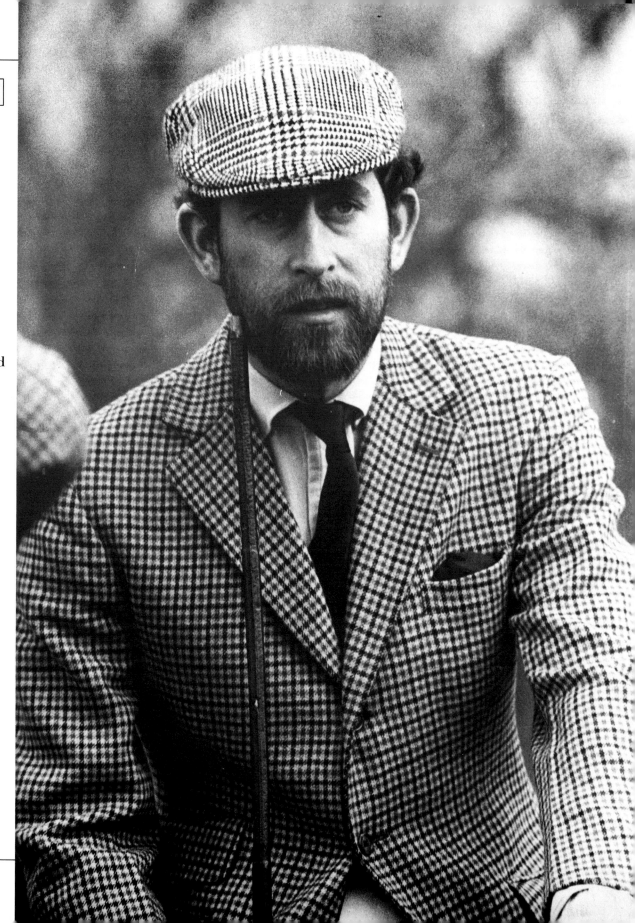

• The splendor of tweed in a sports setting. The three-button jacket is cut in a way that allows it to be worn for riding: the back vent is very high. Although the design on the hat is different, it goes quite well with the ensemble.

• Flannel and covercoat pants of various shades typically worn with a tweed jacket. The name tweed does not derive from the river of the same name along the Scottish-English border, but from a spelling error of an accountant working for a textile wholesaler in London. The accountant wrote tweed instead of tweel in a purchase order.

• The classic tweed jockey cap accompanies a jacket of the same material. Thanks to its water-resistant quality, it offers adequate protection from the rain. Do not, however, dry it with direct heat, such as that coming from a radiator.

• The cap is generally fashioned from the remnants of materials used to make a suit (shown here are samples of tweed). The center of Lewis and Harris tweed is along the western coast of Scotland, where one can still find craftsmen specialized in hand weaving.

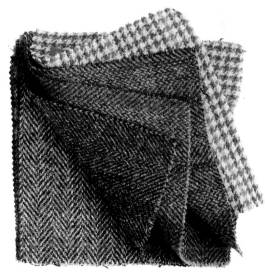

## SPORTS JACKETS AND TROUSERS

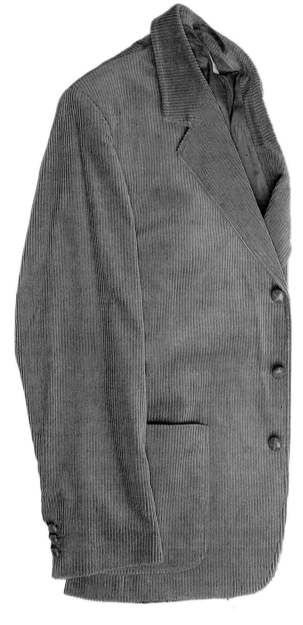

• Corduroy jacket with a three-button front, best worn with flannel or covercoat pants. The jacket can be reinforced with leather inserts on the pockets, collar and elbows. Given its sportiness, it is best accompanied with a shirt and scarf instead of a tie.

• *Below:* To obtain an ascot tie from a normal neckerchief, refold it according to the sequence illustrated below. The result is a sort of large tie that wraps around the neck. It is less "stable" than an artificially knotted ascot tie but the play of the pleats will be livelier.

• A silk scarf is worn under an open shirt. It is an elegant accessory for an informal situation and might be chosen in place of a more banal tie. It can be worn at home, under one's bathrobe or dressing gown, perhaps with a tweed jacket, sweater or shirt, but especially with combination suits, on an evening at the seaside or on other countless occasions. A scarf lends a touch of dignity to a somewhat unkempt appearance and, vice versa, it can lighten a stiff or an overly formal ensemble.

• Check shirts are very appropriate for jacket and pants combinations. These shirts call for jackets of a single shade or with very simple patterns. This is also valid for ties.

• Another scarf to complete an ensemble that consists of a tweed jacket and a shirt tailored so that it can be worn with an open collar. In the breast pocket is a handkerchief that resembles the scarf; usually they are both made of silk.

• One of the many ways to knot an ascot tie is shown above. After having passed end A over end B, insert it in the loop around the neck, thereby causing it to fall in the front and cover end B. A small puff is desirable at the point of exit of the loop around the collar.

## SPORTS JACKETS AND TROUSERS

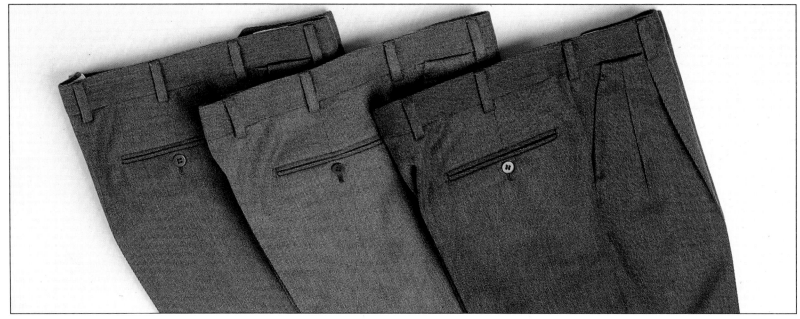

• Another style of pants to combine with tweed jackets. The fabric is heavy covercoat in autumn shades.

• A jacket and trousers combination facilitates the choice of a pullover to wear under the jacket. A sleeveless vest is especially recommended in these cases.

• Briggs umbrella for country outings. The handle of expensive wood, which has contributed to the fame of this umbrella, terminates in a steel point to help traverse soft ground.

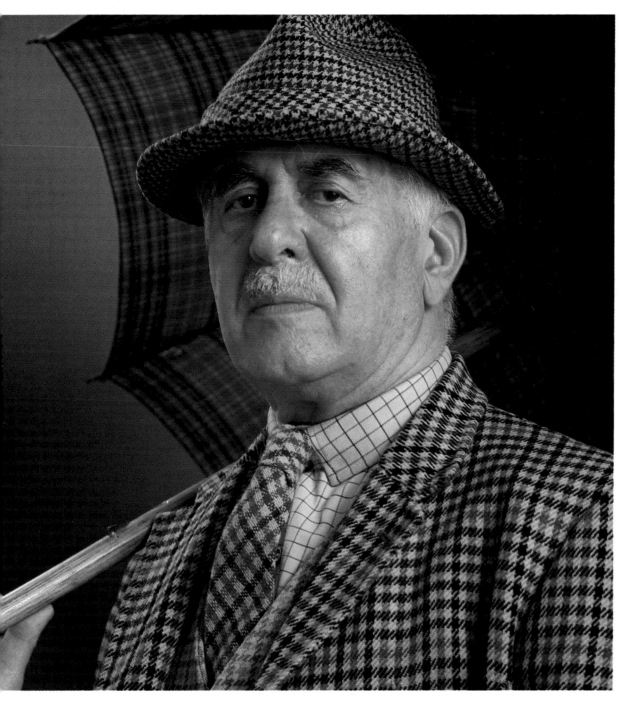

• Suede shoes: In the past they were used only for walks in the country but today are worn in the city and also for work. The model with laces is more traditional and more comfortable than the buckle type.

• Jacket, vest, shirt, tie, hat and umbrella: all checkered, and in different styles. The shirt collar has a tab instead of a collar pin. This will maintain the knot of the tie in a raised position.

## SPORTS JACKETS AND TROUSERS

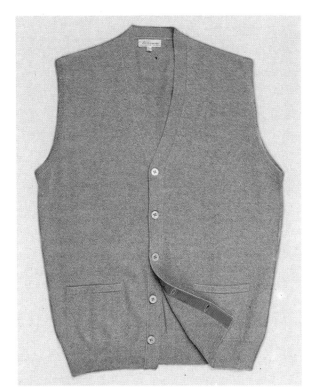

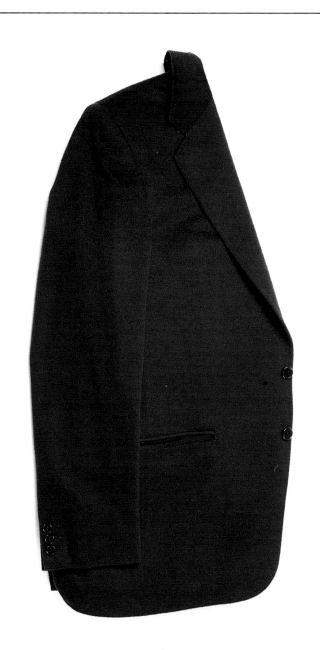

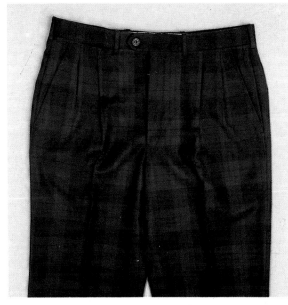

• Sleeveless cardigan. Note the reinforced facing made from a strip of grosgrain. It inhibits the sweater from stretching at the points of major tension, which are under the buttons.

• It was thought that tartans should be worn only by members of a related clan, but due to the beauty of the design, this tenet is so frequently violated that such transgressions have come to be tacitly condoned by fashion purists. Tartan pants are especially popular in the United States, particularly on golf courses, while the jacket is always combined with dark pants of a single shade.

• An expensive green cashmere jacket, which today is incorrectly referred to as a blazer. This jacket has a variety of potential uses, and can be worn in the city with single-color trousers or those of Scottish tartan (photo left) with the same color tone.

# SPECIFIC
# OCCASIONS

## TAILCOAT

The tailcoat was extremely popular in the first half of the 19th century, a kind of uniform that could be worn for any occasion—from a morning ride on horseback to an ornate ball. It was the sartorial expression of the post-Napoleonic Restoration, which, in a single stroke, swept away the imaginative revolutionary clothing, along with 18th-century silk and brocade suits worn with three-cornered hats. Its use was already in decline by the end of the last century and became even rarer in the 1900s.

It remains, however, the only genuine suit for a ball, appropriate for an evening gala, such as the president's inauguration party. It is the waisted coat par excellence, whose tails were once longer but now reach the knee. The tails indicate the coat's equestrian origin and are actually determined by the long rear vent, which helps make long hours spent in the saddle a bit more comfortable.

It goes with a white piqué bow tie. By the way, it is almost impossible to find a normal tie for a tailcoat, even in the best shops; the great majority of white piqué bow ties are pretied and thus should be avoided.

The shirt is characterized by a starched shirtfront and stiff collar; the buttons can be gold or diamond.

The jacket is never buttoned. It should remain open on a vest of heavy silk or white piqué, single- or double-breasted with a shawl collar or without lapels.

The trousers have satin side stripes and the shoes can be patent leather for the theater, or the classic pumps.  ▷

• A white silk scarf completes the ensemble when an overcoat is worn over a tailcoat. The tailcoat is a formal jacket par excellence, which today is worn almost exclusively by ambassadors and musicians.

• Batiste shirt for a tailcoat. The rigid shirtfront is made of starched piqué, like the wing-collar shirt. A shirt with a detachable collar is a bit rare these days. It is fastened with two buttons on each tab, while the single button on the shirtfront is usually made of pearl. The two double cuffs are also made of piqué, lightly starched and closed by cuff links.

• *Right:* Turn-of-the-century tailcoat with wide lapels. In addition to use on official occasions, the Nobel Prize ceremony for example, it is today worn exclusively for society receptions.

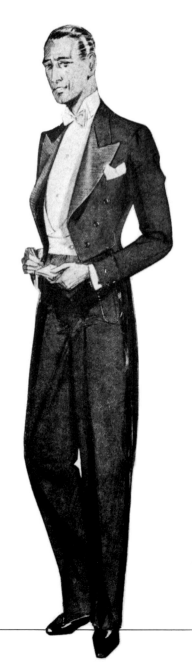

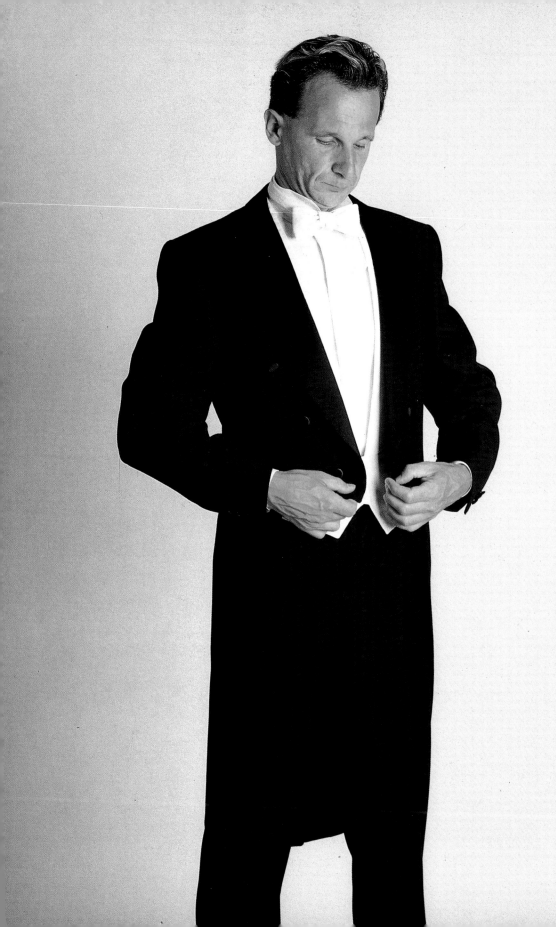

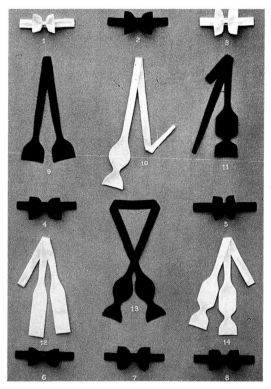

• *Above:* Comparison of bow ties for tailcoats and dinner jackets. Bow ties worn with tailcoats are always in white piqué; as with all bow ties, it is better to tie the knot manually rather than buy one already knotted. When knotting the tie, be sure that your hands are very clean to avoid staining the material.

• *Left:* Classic tailcoat complete with vest in white piqué. The jacket, with three buttons on each side, has satin lapels, and is always left open.

• A cane with an expensive handle is one of the tailcoat's indispensable and elegant accessories.

## TAILCOAT

White gloves always held in the left hand are indispensable.
The top hat is another important accessory. One model, with a retractable spring frame, is especially convenient for packing in a suitcase. □

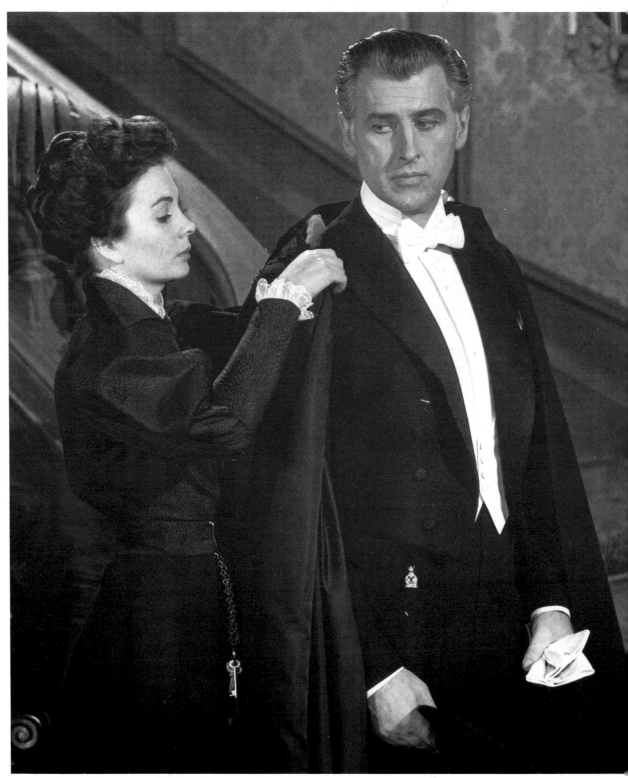

### RULES OF THE TAIL COAT

|  | Fabric or Material | Color | Model |
|---|---|---|---|
| JACKET | drape, mohair or wool barathea silk lining | black | rounded swallow-tailed with silk lapels |
| PANTS | matching the jacket | black | straight with silk satin side stripes |
| SHIRT | batista voile | white | stiff front starched winged-collar double cuffs |
| VEST | honeycomb cotton piqué | white | V- or U-shaped 3-buttoned lapelled |
| TIE | honeycomb cotton piqué | white | bow tie |
| SOCKS | silk | black | long |
| SHOES | patent leather | black | pumps |

• *Opposite page:* A complete tailcoat ensemble with a cloak, top hat and kidskin gloves. The latter are a classic addition to the tailcoat, and were once more common than they are today. One had to wear gloves while dancing in order to avoid touching a lady with the bare hand. The gloves were held in the left hand.

• An orchestra director in action. The tails are a legacy from the time when this suit was also used for horseback riding. The armholes are specially cut for musicians, to provide the arms with greater freedom of movement.

• Top hat. In the last century they were very popular among all the social classes and were also part of the uniform worn by the domestic help.

Today it is rare to see a top hat worn with the nonchalance it requires.

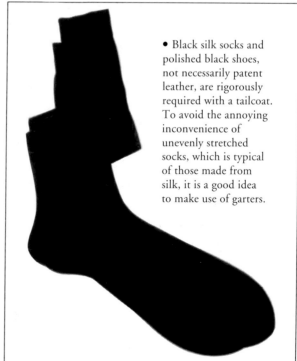

• Black silk socks and polished black shoes, not necessarily patent leather, are rigorously required with a tailcoat. To avoid the annoying inconvenience of unevenly stretched socks, which is typical of those made from silk, it is a good idea to make use of garters.

## DINNER JACKET

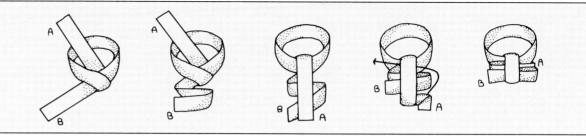

● End A is placed over end B and then passed through the loop

around the neck, thus covering end B, which is folded in half. End

A is also folded; the loop formed is brought through the ring.

I t is the most popular formal evening jacket. The Italians call it a smoking, but in reality, a true smoking jacket is used for having an after-dinner smoke in private. Dinner jacket is actually the English name for what Americans call a tuxedo, which comes from the old New York Club. In fact, there is a longstanding controversy between the Americans and the English over who first created this jacket. Originally, the dinner jacket was only a tailcoat with cut tails, in other words, it was designed to get rid of the tails, which were a source of discomfort for those who had to spend a long time sitting during the course of a friendly gathering. And so this garment first developed as a waisted jacket, traces of which can still be found in the spencer, now used as an evening jacket in summer or in tropical climates, or as the gala uniform for naval officers and members of certain yacht clubs.

To return to the original jacket, the inherent practicality of the invention lends support to an American paternity. It seems that on October 10, 1886, a certain Griswold Lorillard entered the Tuxedo Club wearing this new type of jacket.

For their part the English claim that Edward VII, when he was Prince of Wales, was the first to wear it. Angus Cundey, director of Henry Poole & Co., a Savile Row tailoring house, has confirmed that his company made a dinner jacket for the Prince of Wales in 1885, a year before Lorillard's fateful entrance at the Tuxedo Club.

Fashion experts at London's Victoria ▷

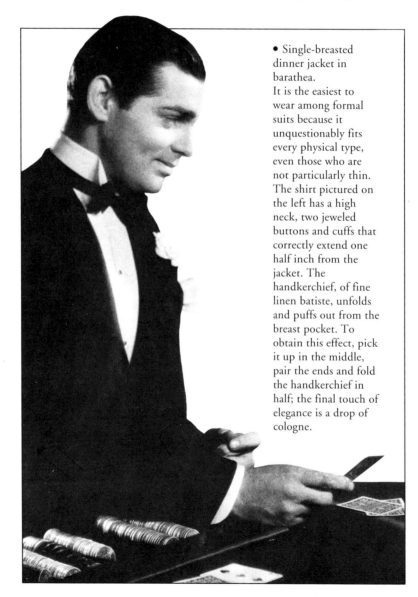

● Single-breasted dinner jacket in barathea.

It is the easiest to wear among formal suits because it unquestionably fits every physical type, even those who are not particularly thin. The shirt pictured on the left has a high neck, two jeweled buttons and cuffs that correctly extend one half inch from the jacket. The handkerchief, of fine linen batiste, unfolds and puffs out from the breast pocket. To obtain this effect, pick it up in the middle, pair the ends and fold the handkerchief in half; the final touch of elegance is a drop of cologne.

● Bow tie for a dinner jacket with a ribbon in the shape of a lens. There are also versions with a straight ribbon or with a more accentuated curve. Bow ties are generally black, although green, navy and burgundy are acceptable. The phrase "black tie" on invitations means that one is required to wear a tuxedo.

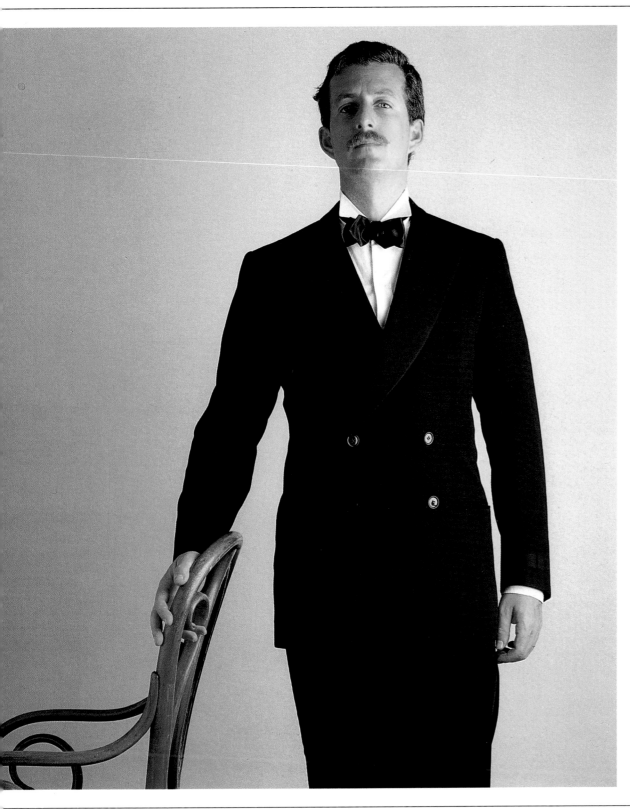

• Double-breasted dinner jacket with a four-button front. Derived from a single-breasted jacket, it began to be cut in a double-breasted version in the 1930s, especially in the United States. The lapels are peaked and the jacket is worn buttoned. Over the years unsuccessful attempts have been made to introduce fabrics in colors other than black. The only variant to gain acceptance is, however, dark blue, which appears to have been launched by show business people.

• Polished black shoes for a tuxedo. A valid alternative would be plain black laced shoes, not necessarily patent leather.
The classic polished pumps are no longer popular. They are characterized by a low cut, no laces and a flat knot of grosgrain.

## DINNER JACKET

and Albert Museum believe in the jacket's American origin, although they are quick to point out that Edward VII probably was among the first in England to wear it. Given the monarch's prestige, it is probable that he was given credit for a modification that was originally conceived by someone else.

The dinner jacket's form is a product of the early 1900s, when it was primarily single-breasted. By the 1930s, a double-breasted version with a shawl collar began to appear in the United States. Certain purists see this version as an abomination, but in reality the shawl-collared evening jacket can be attractive, especially in the white summer version. Be careful about wearing a double-breasted dinner jacket with a shawl collar in exclusive hotels or elegant night clubs because you run the risk of being mistaken for the barman.

One could wear a vest or sash (the English call it a cummerbund) with a spencer or a single-breasted jacket. As with bow ties, it is best to avoid a cummerbund that comes prepared to be fastened to the back with buttons. Satin bands that wrap two or three times around the waist and end at the back are preferable.

The tie must be black, like the satin of the lapels, while the trousers are characterized by a satin band stitched to the outside seam.

The pants must be black, even with a white dinner jacket.

One should wear a plain white shirt with the cuffs fastened by cuff links. The collar can be folded or stiff-winged. ▷

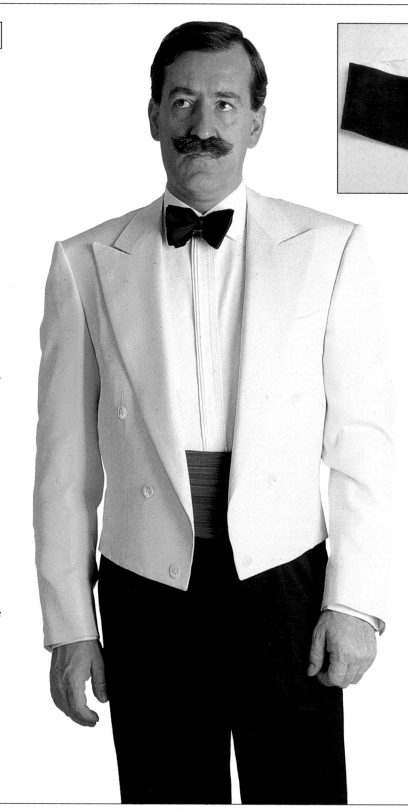

● Cummerbund for a dinner jacket. It is worn at the waist with a single-breasted or spencer jacket. Most of the cummerbunds on sale are the type that close like a belt at the back. A band of satin is more original; the color is optional. It is wrapped two or three times around the waist and fastened in the back.

● Yellow spencer jacket. In effect, a spencer is a tailcoat without the tails, and is generally worn as a gala uniform by naval officers and members of old and traditional yacht clubs. The jacket shown here is the civilian version, especially popular in Central and South America.

## RULES FOR THE DINNER SUIT

| | Fabric or Material | Color | Model |
|---|---|---|---|
| JACKET | drape tasmanian mohair | black | single-or double-breasted with silk satin lapels |
| PANTS | matching the jacket | black | straight widths without cuffs & with silk satin side stripes |
| SHIRT | linen, batiste, self-color fancy cotton, silk | white | pleated shirtfront with starched collar |
| TIE | silk satin, faille, grosgrain | black | bow tie |
| CUMMERBUND | matched with tie or fancy brocade | black | with folds |
| SOCKS | silk, light cotton | black | long |
| SHOES | patent leather | black | plain Oxford pumps |

• Two single-breasted dinner jackets with shawl collars in an unmistakably American cut. This style was born in the United States, where double-breasted dinner jackets with shawl collars were fairly common. Note that the handkerchief extends out an inch or less from the breast pocket.

## DINNER JACKET

Clearly, in this last case, pretied bow ties are noticed immediately.
Black leather shoes without decorations or frills are required, unless one prefers black patent leather pumps with a bow. □

• *Below:* Two figures in summer dinner jackets.
One is double-breasted, the other single-breasted with a shawl collar. The single-breasted jacket has one button.

• White dinner jacket for summer. The trousers must always be black, even if the jacket is a different color. Jackets of varying colors, other than an off-white, have traditionally not been accepted.
The besom pockets are level with the hip and without flaps.

• White single-breasted summer dinner jacket with peaked lapels. The fabric is worked in a white pattern on white and the tie is also a pure white pattern. It is an exception to the black-white combination and one best left to show business people, for whom a tuxedo is a work suit, that is, an outfit to be modified according to personal tastes.

• Particulars of a dinner jacket with a flower on the lapel. In his observations on the subject of men's elegance, De Pisis wrote: "A flower on the lapel can look very good, but one must choose it very carefully." Given his typically European taste, he recommended, among other flowers, a white rose or gardenia. Americans prefer the more flashy carnation.

• Two shirts for a dinner jacket. The model on the right is more formal, with a stiff turned-down collar and a piqué shirtfront and cuffs. The more comfortable shirt is on the left. It has a soft turned-down collar with straight ends.
Jabot embroidery and ornate lace frills that descend along the buttonings are vestiges of a remote past and are wisely left buried.

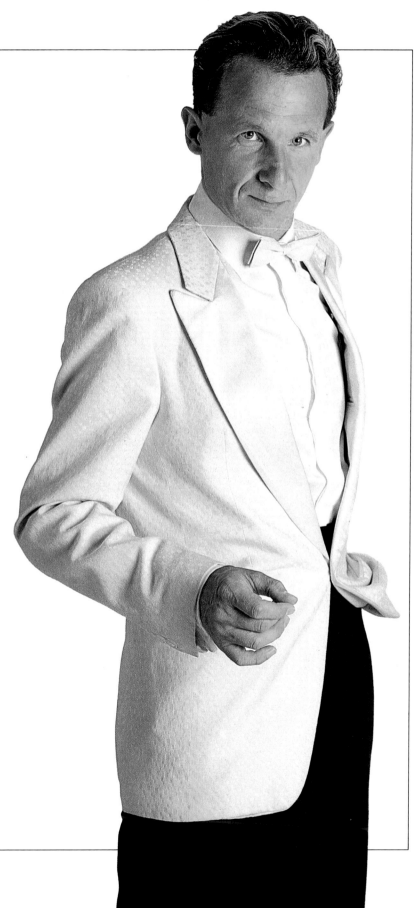

## MORNING COAT

Although it might seem strange, the morning coat is more closely associated with the frock coat than with the tailcoat. The frock coat is actually a double-breasted jacket that extends to the knee. It was worn as an everyday suit from the end of the 18th century until about 1850. It then became a ceremonial suit. Towards the end of the century, this article of clothing—worn by American tycoons, ambassadors and admirals—was replaced by the above-mentioned morning coat, which, though single-breasted, maintains the broadness of the frock coat in the tails. In Italy, this coat is known as a "tight," no doubt in reference to the tightness of the fit around the waist. In England, its country of origin, it is known as a morning coat, while Americans may refer to it as a cutaway.

Gabriele D'Annunzio suggested calling it velada, resurrecting an 18th century Spanish term to define a suit with tails. One cannot say, however, that this name caught on, even if it can sometimes be found in a few manuals. There are two types of morning coats: one completely light gray, top hat included, worn exclusively at Ascot or at horse races of similar importance; the other is usually worn on ceremonial occasions, for more formal wedding ceremonies in a diplomatic environment. In this latter case, the jacket is dark gray flannel, solid color or herringbone, while the trousers, without cuffs, are of striped cheviot. Young people can also wear gray flannel trousers. The normal waistcoat is double-breasted and light-colored with crossed cuffs. Even if a normal tie, possibly of soft satin, goes well with this outfit, it is better to use an ascot, a tie in the form of a scarf which can be knotted, or else use one that is already knotted. Among other things, an ascot makes it possible to display a tiepin mounted with a pearl or elegant stone. A black tie should be avoided, unless you do not mind being mistaken for a butler.

The shirt can have a folded collar, but a starched winged-collar shirt goes better with an ascot.

The shoes must be black, neither patent leather nor toe-capped. The jacket is characterized by lapels separated from the collar by a noticeable V shape or by large peaked lapels, similar to those ▷

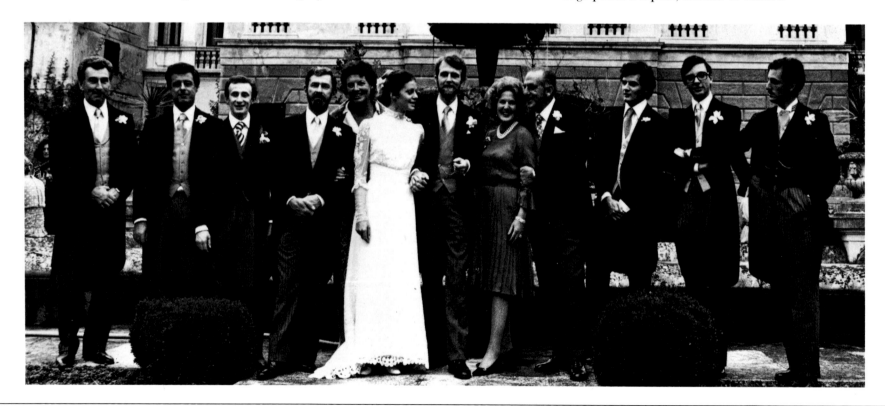

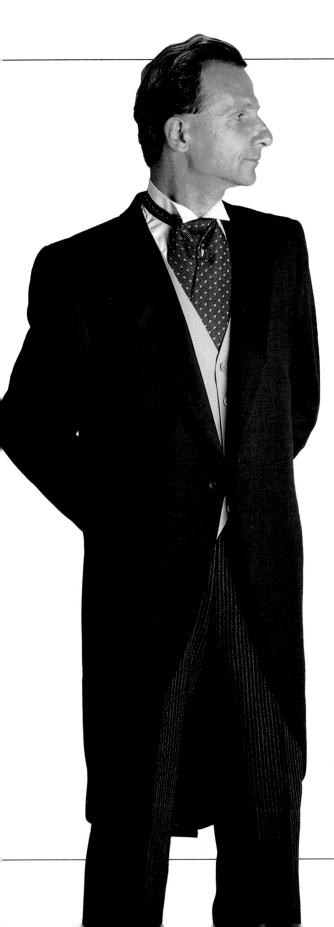

• A tiepin and collar button set. An ascot is worn with a morning coat. If knotted, it is held together with a jeweled tiepin. In the pretied versions, those artificially knotted and stitched, the tiepin would not be necessary but could be added for aesthetic reasons. The suit on the left is accompanied by an ascot tie which requires a starched winged-collar shirt.

## RULES FOR THE MORNING COAT

|  | Fabric or Material | Color | Model |
|---|---|---|---|
| JACKET | worsted flannel, plain or herringbone Super 100's worsted | gray dark gray Oxford gray | rounded swallow-tailed coat |
| PANTS | striped worsted | gray black & white | straight without cuffs |
| VEST | doeskin flannel matched with jacket | pearl gray | five buttons |
| SHIRT | poplin, batiste linen, cotton silk plainweave | white | starched winged collar or regular |
| TIE | solid-color silk jacquard | ivory gray | regular ascot with pin |
| SOCKS | silk light cotton | black | long |
| SHOES | calfskin | gray black | plain Oxford |

• *Opposite page:* A classic wedding photo: the participants have an official role and thus wear morning coats and gardenias pinned to their lapels.

• *Left:* The shape of a plastron tie. The ideal measurements are width 6 1/2 in. max., 1 3/4 in. min.; length 52 in.

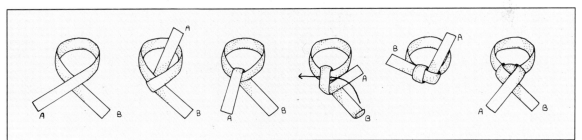

• To obtain an ascot knot, take end A and wrap it around end B. Pass end A through the loop and pull it. At this point end A is folded. Pass the extremity of end B through the ring just formed. The knot is tightened and the ends are crossed one above the other and closed by a tiepin. Ties for a morning coat are always made of silk.

## MORNING COAT

found on double-breasted jackets. It has only one button and the only outside pocket permitted is one for handker-chiefs. If worn on diplomatic occasions, it must be accompanied by a vest of the same fabric and a gray tie.

The morning coat is worn during the day; if one marries in the evening, a tail-coat is required.

Naturally, people are free to make their own decisions on these matters, but it is hard to understand why ever-increasing legions of grooms stand before the altar or in front of the judge dressed in tails, as if they have to go out for dinner. They could easily rent a morning coat, or if they can't stand the smell of mothballs from theatrical costumes, they could satisfy themselves with a dignified blue suit. The accessories that were once required with the morning coat included gray or bright-colored suede gloves, a top hat, gaiters and, for fanatics, a monocle. Technically, a walking stick should be obligatory; a rolled umbrella would be even better. A flower in the lapel is not out of place. □

• A knotted silk tie for morning coats.

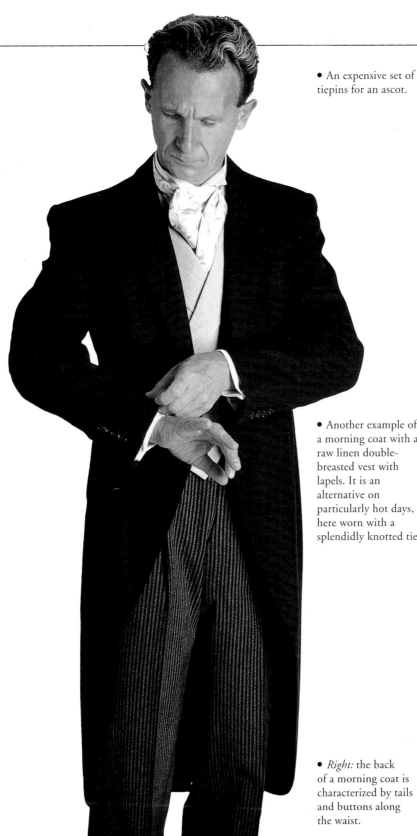

• *Opposite page:* An excellent representation of a morning coat with a normal tie, characterized by a hound's tooth pattern. Until a few decades ago, the morning coat was the working suit of bank officials and managers, who invariably wore top hats or derbies and carried a tightly rolled umbrella.

• An expensive set of tiepins for an ascot.

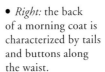

• Another example of a morning coat with a raw linen double-breasted vest with lapels. It is an alternative on particularly hot days, here worn with a splendidly knotted tie.

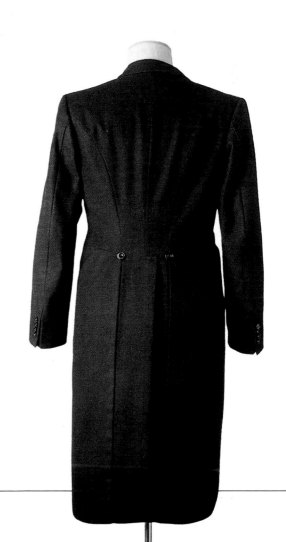

• *Right:* the back of a morning coat is characterized by tails and buttons along the waist.

## BLAZER

**W**hite pants and a blue double-breasted jacket are virtually the evening uniform at the yacht club, or at least in a nautical situation that requires a certain formality. The trousers may be a rust or blue color, especially in winter or in Northern European countries. Completing the ensemble is a club membership tie. If one does not belong to any club, it is best to wear a solid-color tie to be safe. Should a double-breasted jacket, also known as a blazer, have vents? This question has been endlessly debated. If one considers the blazer a derivative of a navy officer's jacket, which has always been without vents, then one could be opposed to the cuts in the back. Originally, the blazer did not quite mean a double-breasted jacket but a striped jacket, more or less single-breasted. The name derives from a warship, the H.M.S. *Blazer*, whose commander in 1840 dressed the crew in blue and white vertical-striped jackets. Since then, jackets used on sporting occasions and characterized by stripes (jackets of rowing associations or for cricket, for example) have been known as blazers.

This leads to an important consideration: Remember that a solid blue double-breasted jacket with trousers of a different color is called a blazer because it is meant to be worn on sporting occasions, particularly those involving yachting. Many people, Italians and French in particular, tend to forget this and sometimes wear blazers for business appointments in the city. ▷

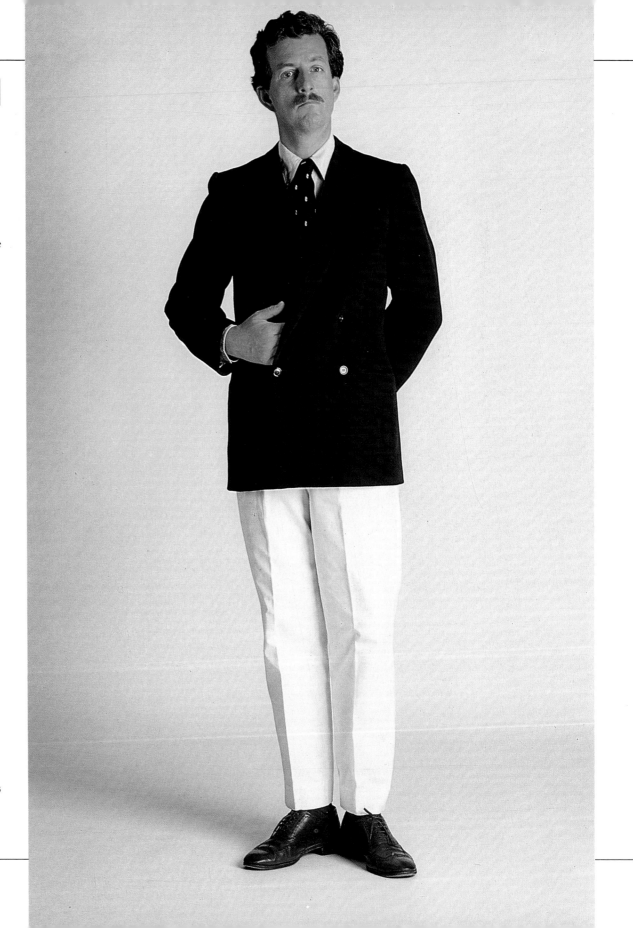

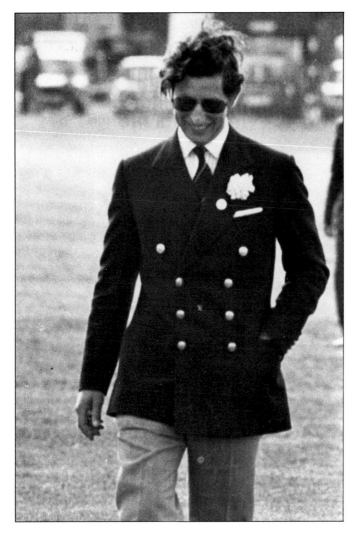

• Regimental tie traditionally associated with sporting clubs, which also include blazers as a part of their uniforms. The tie, therefore, constitutes an integral part of the same uniform, while simultaneously making it easier to identify members of the club.

• The English royal family in uniforms of the Royal Navy. The cut of the eight-button jacket with high lapels is reminiscent of a pea coat, which is used by the American navy.

• *Opposite page:* Navy blue double-breasted blazer with white cotton pants and brown shoes. Under the terms of an old rule, members of the Royal Yacht Squadron of Cowes in England were obliged always to wear brown shoes with a blazer. Blazers were considered sporty and therefore appropriate with shoes of this color.

• *Above:* An unusual example of a six-button double-breasted blazer with two high buttons. This version was unmistakably inspired by military uniforms. It is debatable whether or not a blazer should have a back vent. Given the jacket's sportiness, a vent is permitted.

• Gold and enamel stickpin with the colors of a yacht club. It is worn on a blazer or on other jackets in place of a club tie.

## BLAZER

The Americans and the English pay close attention to these things and never fail to ask whether anyone else is going to wear a blazer if they are about to leave for the sea. Members of the Royal Yacht Squadron, the most exclusive yacht club in the world, normally wear brown shoes and white trousers with a blazer because brown shoes are more suitable than black for sporting occasions.

Some navy officers had the habit of stitching the gilded buttons of the uniform to the blazer. If one is not an ex–navy officer or a member of the yacht club represented by the uniform, it is best to forget about gilded buttons decorated with kedge anchors or other naval motifs; simple black buttons will do. We also do not advise heraldic coats of arms or fancy stitching on the breast pocket.

One could even wear a scarf and a peaked cap, but only if one is a member of the yacht-racing jury or of the race's organizing committee. □

• Members of the jury officiating a New York Yacht Club race. They are in perfect club form: Navy blazer and a striped tie that matches the stripe on the straw hat.

• *Below:* Set of buttons for a blazer, including those for sleeves. It appears that buttons on sleeves were sewn on British naval uniforms to discourage sailors from wiping their mouths on the sleeves of their jackets.

• *Left:* Coat of arms embroidered on fabric. Among the ways of identifying members of a yacht club, in addition to a tie or button, there is the group's coat of arms, which is usually stitched on the breast pocket of the jacket. It is best to be suspicious of those who wear coats of arms on their blazers that do not indicate membership in any existing club or association.

• *Above:* Sperry topsiders, with extra traction in the soles, are the boating shoes par excellence and are worn on informal occasions in place of the usual brown shoes that go with a blazer.

• Sailing pants made from an especially resistant cotton weave. They have become a standard-bearer of classic clothing and, like sailing shoes with extra traction on the soles, they can now be worn with blazers, even if they visibly fade in salt water.

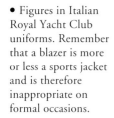

• Figures in Italian Royal Yacht Club uniforms. Remember that a blazer is more or less a sports jacket and is therefore inappropriate on formal occasions.

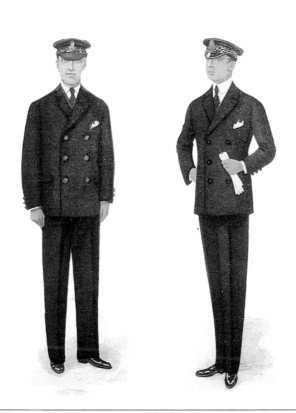

• Striped single-breasted blazer. A blazer can be either single- or double-breasted. A striped single-breasted version was very popular at the end of the 19th century, especially among the members of English cricket and canoeing clubs.

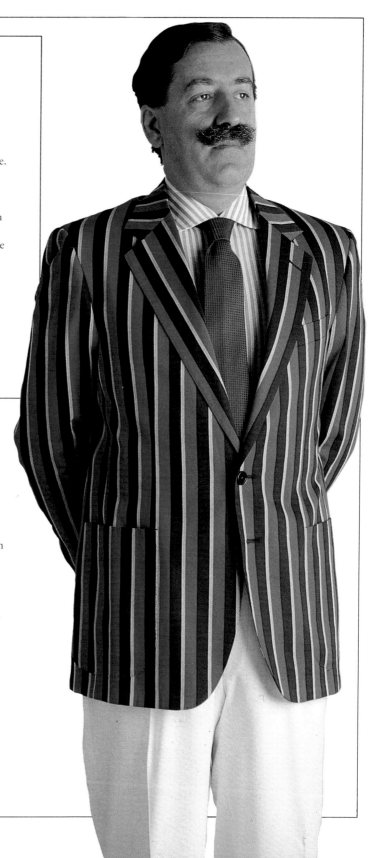

## KNICKERBOCKERS

Knickerbockers are an indispensable accessory to a suit or sports jacket and trousers. This complete ensemble is worn in the country, either for hiking or hunting. Knee breeches are especially practical for the mountains, whether in summer or winter, and for playing golf. Actually, these trousers were very popular in the Twenties and Thirties thanks to this equally popular sport. Knickerbockers are the direct descendants of culottes, whose use is now limited to ceremonial suits. It was only around 1860 that knee pants, along with thick woolen socks, began to appear, especially for sporting occasions. Up to the First World War, they remained relatively tight, but then ▷

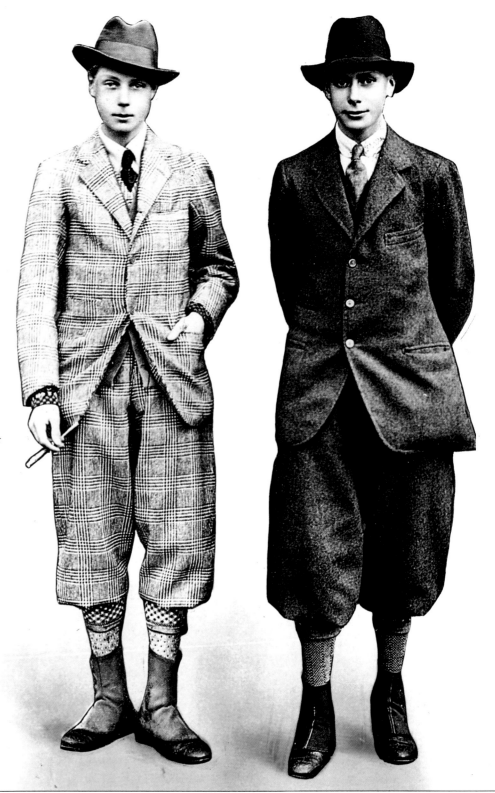

• *Left:* Tyrolian Sarner jacket is acceptable with hunting pants or knickerbockers. These trousers provide the legs with great freedom of movement and are therefore recommended for informal sporty occasions or outings.

• *Right:* Two city ensembles with knickerbockers. For a time, in the 1930s, this suit was worn in town or in situations not strictly related to sports.

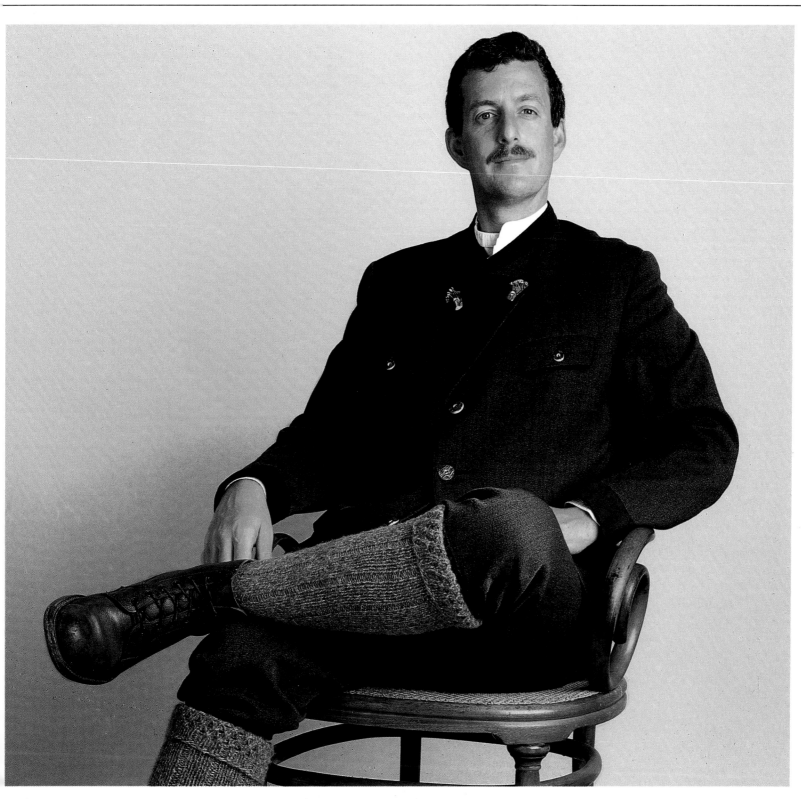

• Hunting outfit with a single-breasted jacket and horn buttons. This type of pants, which has virtually disappeared from golf courses, still survives as an accessory to hunting outfits.

## KNICKERBOCKERS

gradually widened and lengthened over time. The name plus-fours is a reference to the length of this type of pants, which extend four inches below the knee. Actually, in some instances, the length reached as far as the ankle, just above the shoe.

The name has literary origins. Knickerbocker is a Dutch surname that was once rather common in the state of New York, at least since Harmen Jansen Knickerbocker of Friesland arrived there in 1674. In short, the name became synonymous with individuals of Dutch descent, and when Washington Irving wrote an ironic tale set in New York that was published in 1806, he used the pseudonym of Diedrich Knickerbocker. The 1859 edition was illustrated with drawings of Dutch colonists dressed in their traditional 17th century knee pants. From then on the term became synonomous with this style of pants.

In Italy they are known as Zouave. The name derives from a French infantry corps which made them a part of their uniforms. They have become less popular in recent years, even though they are extremely practical, especially if one must hike through muddy or wet fields. They also provide the knee with great freedom of movement, and are still used in the mountains. □

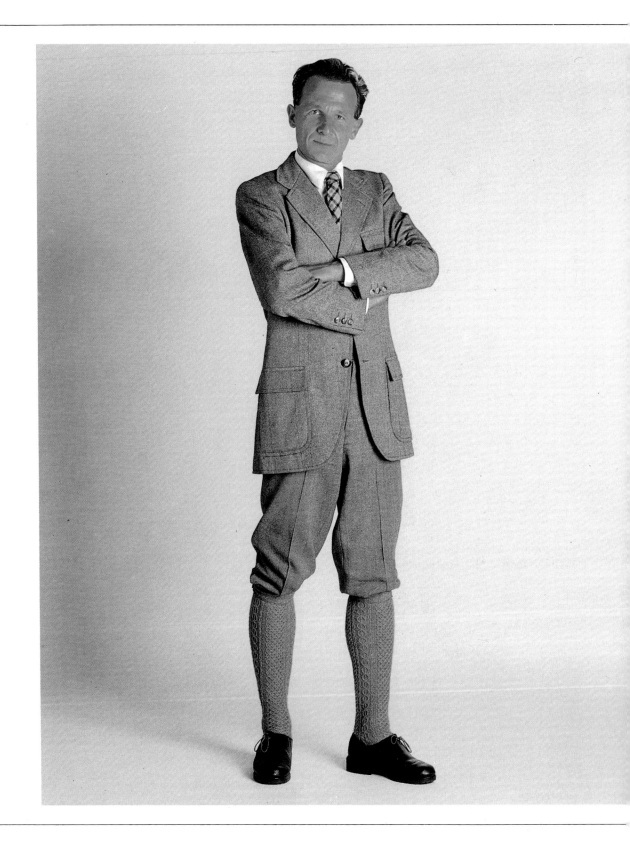

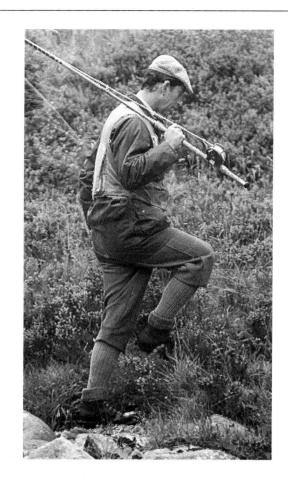

- *Left:* Different types of knickerbockers of various widths and lengths.
In the 1930s, there were trousers, "knickerbockers," that extended to the shoes. One version is called plus-two, another plus-four, depending upon the length.

- *Right:* A perfect outfit for a day of fishing. The knickerbockers are paired with a comfortably equipped vest and a tweed cap, which is extremely useful as protection from the sun and rain and goes very well with the ensemble.

- *Opposite page:* Modern version of the knickerbocker, to be worn in the country. The jacket, which is made from the same fabric as the pants, has intertwined leather buttons and deep folded pockets.

- *Below:* Two different ways of tying the knickerbockers at the knee. The fastening should not be too tight, otherwise it will inhibit circulation. The band is hidden by the excess material of the trouser's fold.

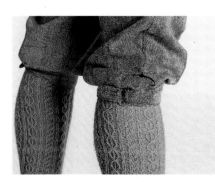

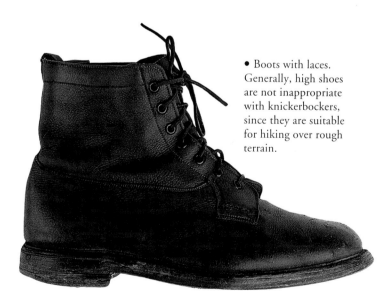

- Boots with laces. Generally, high shoes are not inappropriate with knickerbockers, since they are suitable for hiking over rough terrain.

## NORFOLK

A Norfolk hunting jacket was one of the first garments created especially for sporting activities. It has four buttons, a half-belt, wide and deep folded pockets, stitched suspenders designed to support the weight of cartridges in the pockets, a belt that buttons at the waist and lateral folds on the back to provide greater freedom of movement when raising a rifle.

This garment became popular at the turn of the century. It appears as if its name derives from the fact that it was cut for some of the guests at the Duke of Norfolk's hunting party. □

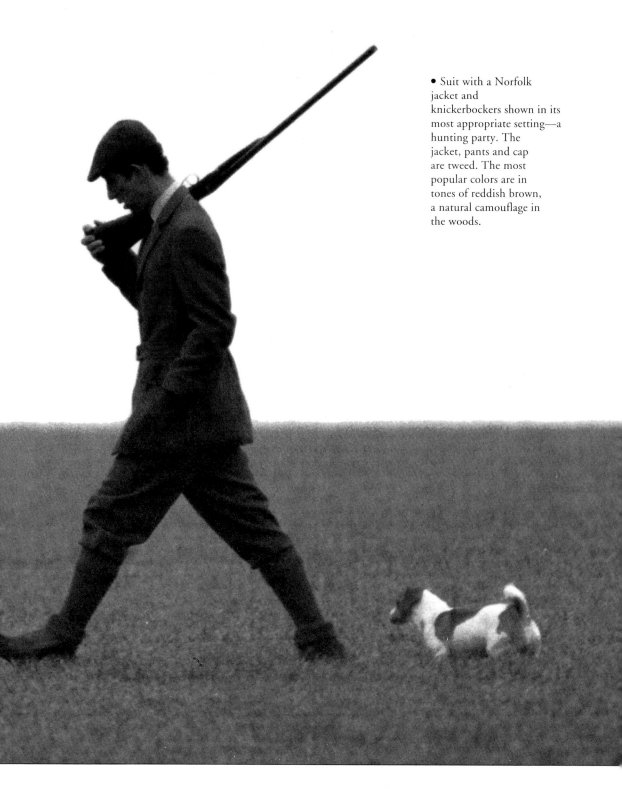

• Suit with a Norfolk jacket and knickerbockers shown in its most appropriate setting—a hunting party. The jacket, pants and cap are tweed. The most popular colors are in tones of reddish brown, a natural camouflage in the woods.

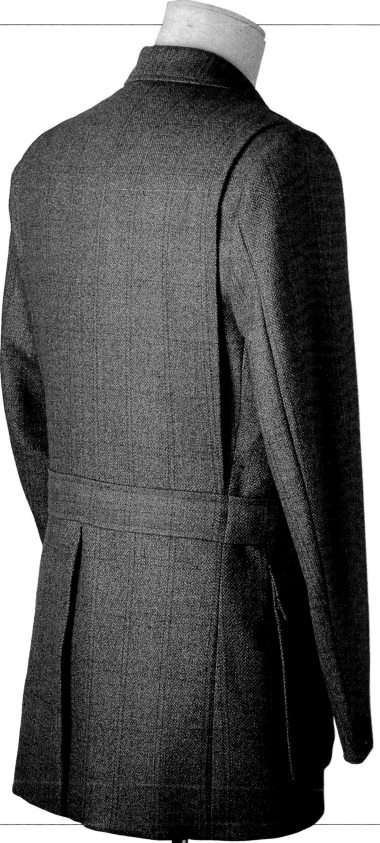

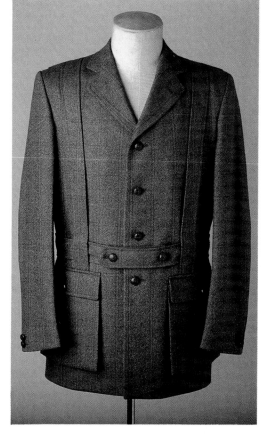

• The front and back of a Norfolk jacket. Note the rather high single vent on the back, a half-belt and deep lateral folds, which provide the shoulders with greater freedom of movement to raise a rifle. The front is closed by four buttons to provide additional protection.

• Folded pockets with closing flaps typical of the Norfolk. The pockets of this jacket are made very deep.

• Details on the waist: the stitched belt crosses with the suspenders and is fastened at the front. The buttons are covered with interlaced leather.

# MAINTENANCE & CARE

— *Carelessness*

*in dressing is moral suicide.*

— *Honoré de Balzac,*
Treatise on the elegant life

# THE WARDROBE

Having a good collection of clothing without an adequate system of organization and maintenance is like having a boat without a place to keep it for the winter.

Clothing will not last long unless one's collection is properly organized. Taking good care of jackets and trousers will prolong their use and provide, one hopes, a certain measure of reciprocal satisfaction.

It might seem an exaggeration to attribute human emotions to clothing, but in fact one can see immediately if a suit is well maintained, meaning that it looks good on the wearer and, as a result, is "satisfied."

This does not imply that a suit must be constantly sent to the cleaners or ironed, brushed and mended. It simply means it should be well cared for, no better or worse than a good manager of personnel who capably assigns people to the tasks for which they are best suited, without expecting extravagant performances from them.

Putting together a balanced wardrobe begins with a tailor, or in the shop where one intends to make a purchase. The garments that one is about to buy should be considered in relation to the clothing one already owns. This is also a good way to dampen an initial enthusiasm that might later turn to disappointment. As in any type of collection, a wardrobe must also conform to certain criteria. For any one reaching a certain age, it is a good idea to maintain a few simple rules that ought to guide one's choice of clothing. It will save time and money, in addition to providing a certain ease in making selections and a certain immunity from the allure of passing fashions.

Unfortunately, there are no absolute rules; each person must create his own style, keeping in mind, however, the need to follow certain rules, such as those involving dinner jackets or navy suits. Apart from these exceptions, each person is free to do as he pleases.

There are those who dress exclusively in navy and have more than fifty ready-to-wear outfits made from a variety of fabrics in this color. Instead of expressing their creativity through colors, they express it through the choice of different cuts or fabrics with particular characteristics.

Then there are the adherents of tweed, who would wear tweed underwear if they could. They are on par with the linen fanatics, meaning those who wear linen suits even in winter. The rule itself is not important; what matters is that there is a rule. Of course, those who do not have the whims of a Michelangelo would do well to follow certain guidelines dictated by time and tradition. There is nothing wrong in deciding that one's model should be Fred Astaire, Humphrey Bogart or one of the many Princes of Wales. Doing so guarantees that no mistake will be made.

It is no accident that in the so-called old days everyone, including those less well-to-do, were better dressed. Until thirty or forty years ago, fashion imposed rather modest variations, which limited themselves, for example, to the widths of trousers. Moreover, choices were much more restricted. In effect, workers and farmers dressed in uniforms, as did office workers. It must have been boring, but it was certainly better than the multicolored sartorial deformities worn today by a majority of people.

In conclusion, it is a good idea to remember that a collector's rigorous philosophy also applies to someone who owns no more than three suits. One does not have to be a millionaire to dress well. But it is important to care for a wardrobe as if it had to last for the rest of one's life. Where to store clothing; how to limit wear by using a proper system of rotation; which

methods to adopt for seasonal changes; finally, what to recommend to those who take care of the ironing, mending or dry cleaning of one's clothing: The answers to these questions will help maintain a wardrobe for a long time.

In the following pages we offer some advice based on experience passed from one generation to the next. Explicit and infallible rules do not exist; like everything concerning elegance, common sense must be the guide.

A BASIC WARDROBE

The following list identifies a wardrobe capable of satisfying all the needs arising from different work and social situations.

Flannel three-piece suit in dark linen
Pick-and-pick three-piece suit
Light cotton two-piece suit
Linen navy two-piece suit
Two-piece suit in tropical wool
Tweed jacket
Wool jacket
Wool blazer in navy blue
In-between season unlined jacket
Two pair of wool pants
Two pair of pants in tropic wool
Black dinner jacket

## The new suit

At the time of its purchase a suit undergoes a sort of test in which it begins its "work." A new suit is viewed with suspicion; it is virtually an embarrassing presence, a foreign body. Like a cadet in his first year at the Naval Academy, a new suit endures something of an initiation rite, one that does not exclude a bit of unhappiness. The sooner it loses its "newness" and stiffness, the faster it will be integrated into the rest of the wardrobe. There are various stories of how lords, dandies, connoisseurs of fashion, etc., have treated new suits.

The most widely known recounts how noblemen chose—and in some cases choose even today—assistants or servants with the same size and physical characteristics as they had. These valets would then wear new shoes and suits in order to break them in for their masters.

Other stories tell of more drastic measures: Yacht owners who, if necessary, took suits fresh from the tailor and tied them to the tip of the stern for a day. By the end of the day the suit looked as if it had been handed down by the owner's grandfather. Actually, at one time certain materials were so heavy and stiff that such brutal treatment was probably necessary.

For those who do not have either yachts or servants, the problem of breaking in a suit or shoes can be solved by a walk in a light rain without an umbrella.

*"Beau" Brummel (1778-1840) is perhaps the most famous dandy of the past. He is credited with most of the rules of male elegance. Preceding page:* An 1838 engraving which shows a caricature of a dandy and his valet struggling to tie a knot.

In addition to the advantage of giving a touch of wear to a suit, a quick breaking-in period contributes to the process by which a suit "settles" or arranges itself. This helps the suit to conform more closely to the wearer's physical characteristics. After all this effort, it is hoped that one would try to ensure the long life of a suit that has survived its initiation rites. Other than the obvious economic reasons, there is the pleasure of handing down some tried and tested garment to children and grandchildren; clothing that will make a good impression and that will allow the new owner to state proudly and without fear of contradiction: "This suit was made for my grandfather seventy-five years ago by the tailor Jones."

## Proper storage

To ensure a suit's longevity, a good closet organized with Prussian efficiency is essential.

The ideal solution is to have a proper dressing room with the walls lined with closets and a mirror. It should be close to the laundry and ironing room.

Aristocrats and the haute monde used to pass the morning in these rooms getting dressed. Their valets were present to provide help and advice. In short, an entire part of the house (which included the closet, ironing room, laundry room, and the head of the household's dressing room) was utilized for the art of dressing. Dandies of the past, such as Brummel for

example, who changed clothes as many as five times a day, spent a third of their day in this area of the house.

Considering the scarcity of space in most modern urban residences, one is obliged to make certain compromises. Articles of clothing should be divided according to their category and uses. They should have enough space to "breathe" and be arranged in a way that provides easy access. If space is limited, it is a good idea to be very careful when choosing clothes, and to guard against the tendency to accumulate things, which is something that lurks in all of us. An examination of one's wardrobe should be carried out at least once a year. Ask yourself which garments are worn frequently and which are never

## Closet and Walk-in Closet

**Closet**
1. Shelves for boxes, luggage, etc...
2. Shoes in boxes, suitcases
3. Suits, overcoats, robes
4. Overnight bag, tote bag
5. Shoes
6. Light & heavy sweaters
7. Sportswear
8. Jackets, shirts
9. Pants
10. Underwear, T-shirts
11. Socks
12. Gloves, belts
13. Ties

**Walk-in Closet**
1. Suits, overcoats
2. Shirts
3. Shoes
4. Ties
5. Heavy sweaters, light sweaters
6. Suits, pants
7. Belts
8. Mirror

The dotted line indicates high shelves for storing boxes, luggage, etc.

worn. These latter cases, errors of judgment or gifts from relatives, are unfailingly relegated to a trunk or donated to the Salvation Army. There is a risk in stuffing a closet full of clothing; some outfits might not get worn because they are hidden behind a mountain of garments.

In general, it is better to have several closets - one to store garments that are out of season, the other for those in use.

Wooden hangers should be used for suits. Be sure to maintain the form of the shoulders. A high closet means that one can hang trousers without having to fold them in half, which eliminates the problem of a wrinkle on the leg of the pants. (In reality, creases on trousers made from a fairly heavy material should disappear after ten minutes of wear.)

It is a good idea to be sure that jackets and trousers intended for wear the following day have been properly placed on hangers. Certain closets come with a shelf, which is useful for holding wallets, keys or other objects normally kept in pockets.

In addition, a well-organized closet comes with a series of drawers designed to keep separate woolen and cotton socks, underclothing, shirts, sweaters, and handkerchiefs. Shirts should be placed on hangers spaced at least 6 inches apart. Ties can be hung from the tie rack attached to the inside of the closet door, while belts can be arranged on the belt holder or rolled up and placed in a drawer. Shoes must be kept in a separate space in the closet, apart from the clothing. Shoe trees placed inside the shoes will help maintain their shape when not in use. One might also find a place for shoe-care items such as polish and brushes. Regular polishing will noticeably lengthen the life of a pair of shoes.

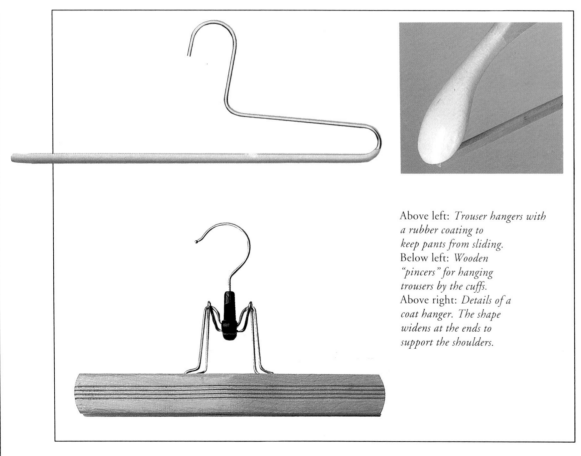

Above left: *Trouser hangers with a rubber coating to keep pants from sliding.*
Below left: *Wooden "pincers" for hanging trousers by the cuffs.*
Above right: *Details of a coat hanger. The shape widens at the ends to support the shoulders.*

# Goodbye to moths

Closets are a good weapon against dust, but unfortunately they do not provide sufficient protection against moths, the voracious eaters of natural fibers. In the darkness and silence of the closet, these insects unleash a treacherous attack against sweaters, jackets and pants, destroying in a few days a painstakingly acquired wardrobe.

One can share the environmentalists' aversion to chemical herbicides and insecticides used in the country. But on the other hand, it is best not to have any scruples when dealing with these winged devourers. In the fight against moths and the deterioration of suits, one can follow a strategy consisting of two different tactics. The first involves placing in the closet perfectly clean suits; those with numerous food and beverage stains attract moths. Suits not meant to be worn for a long time should be stored in tightly closed plastic bags.

The second line of defense is built around natural weapons.

A closet made from camphor wood, for example, will strongly resist the destructive work of these insects. This form of biological warfare can be augmented by hanging gauze bags full of tomato, laurel or tobacco leaves in the closet. They are thought to discourage attacks by moths. These natural methods can be combined with chemical products, including mothballs of naphthalene or camphor. We recommend the latter because they smell somewhat better than the former.

Another enemy is a certain type of dry cleaner who uses metal staples rather than pins to attach laundry tickets. Then there are dry cleaners which use radical cleaning methods more appropriate for suits made of artificial fibers. In addition to removing stains, these methods also erode the fabric, quickly reducing it to the consistency of tissue paper. Prior to becoming a regular client of a dry cleaner, it is a good idea to judge their work by first having them clean an older, less valuable suit. A good dry cleaner is hard to find and it is worth maintaining a good relationship with the owners of a quality establishment. They can be a useful source of information since they can often provide the names of individuals capable of exceptional mending work or ironing of starched collars for dinner jackets and tailcoats, skills that today have virtually disappeared.

Above: *A moth, clothing's great enemy.*
*They should be fought without mercy.*
Right: *Two chemical weapons; camphor and*
*naphthalene mothballs.*

# A fragrant closet

Unless one has a servant in charge of linen who works twenty-four hours a day, there is no way to avoid stale and foul-smelling air in closets. The reason is simple: Fabrics absorb smoke and various room odors, in addition to those produced by the human body. An article of clothing should always be aired, brushed and eventually cleaned before it is returned to the closet. In more serious cases, it should be left out in the air for a few hours. All of this is not sufficient, however, to eliminate odors originating from a particularly crowded restaurant. In this case, the garment should go directly to the cleaners without being returned to the closet. One useful device is to place odor-absorbing products inside closets that will purify the air.

*A potpourri of English perfumes consisting of flowers and fragrant herbs, sometimes soaked in essences that give off a light fragrance. They give a noticeable scent of freshness to underwear and the entire wardrobe.*
*To make more than one bag, simply cut a square piece of gauze, place the necessary quantity of dry flowers inside the bag and seal it with a band.*

# Removing stains at home

It is natural to be a bit afraid when confronting a stain. After all, one slight mistake can permanently ruin a garment or a precious linen. And so you hesitate... You send the garment to the cleaners. It is the more prudent course. Perhaps you will feel calmer after reading these instructions, which are based on two important starting points: the nature of the stain and the type of fabric on which it appears.
Once you have identified the type of stain and the fabric, you must act immediately, before the stain sets in the weave of the fabric and ruins a precious garment.

If the stain can be washed, treat it like a normal washing, giving particular attention to the area of the stain. If it is necessary to work directly on the stain, use a piece of white cloth. It must be absolutely clean. Then take a bottle of stain remover, perhaps gasoline, for example, shake it and pour it on the piece of cloth, which is then used to work on the stain itself. In some cases you should dab the stain with the cloth (in other words, press the cloth directly on the stain but do not rub it, otherwise you risk making it larger); in other cases rub the cloth over the stain until the liquid dries completely. Afterwards the usual course is to sprinkle soap powder over the area to eliminate the ring.

You can also buy stain removers that can be sprayed directly on a stain. The liquid eventually turns into a white powder which is then brushed away. Before using such a product, however, it is a good idea to try it first on a hidden corner of the material in order to avoid unpleasant surprises. Remember always to stay far from heating sources because the liquid used in these products is inflammable. However, those truly concerned about the environment are against the use of such sprays because they come in aerosol containers, which are thought to be responsible for the hole in the ozone layer of the earth's atmosphere. Consequently, it is best not to use such sprays.

*The two photos illustrate a simple and effective system to remove stains caused by substances containing sugar (alcohol, ice creams, fruits...) Dampen a light-colored handkerchief for a garment of the same shade (the same principle holds for dark materials) and heat it well along the edge of an iron. Then rub it on the stain. For other types of stains, consult the next two pages.*

# Stains from A to Z

The following table provides a list of the most common types of stains and how to eliminate them.

•

**Ballpoint pen.** These ink stains are removed easily by rubbing them with a cotton pad soaked in alcohol.

•

**Beer.** Try with soap and water. Use lukewarm water and ordinary table salt on wool; an equal mix of water and alcohol on silk. Wet the stain with a sponge and repeat as necessary.

•

**Blood.** If the stain is fresh, it can be removed with cold water; for an older stain add a few drops of a 3% hydrogen peroxide solution. To prevent the blood from spreading, stretch the material across a basin and pour the solution over it.
If the fabric is washable, place it in a tub with cold water. Wash it in lukewarm water and rinse it well. If the stain is not completely eliminated, use a few drops of ammonia and re-wash the garment in lukewarm water with a bit of detergent.

•

**Burnt Spots.** They can be removed if rubbed with a handkerchief soaked in a 24% hydrogen peroxide solution; or else use cold water and a sprinkling of salt. Repeat the process two or three times, rinse and let dry in the sun.

**Coca-Cola.** Place a clean towel under the stain and rub it with a solution of water and glycerin in equal amounts. Rinse well with a damp and wrung out cloth.

•

**Chocolate.** If it is a wool garment, rub the stain with glycerin and then wash it in lukewarm water.

•

**Coffee.** To remove stains on wool and silk, use a few drops of glycerin and let soak thoroughly. Then wash the garment in warm water a few times. If the stain is very old, add a tablespoon of egg yolk to the glycerin. A word of caution: never use soap. You can use bleach on linens and cottons; use a brush dipped in a bit of water and alcohol for very resistant stains.

•

**Fat.** Rub the stain with a bit of fine salt.

•

**Fruit.** These stains can be removed with a bit of lemon juice.

•

**Grass.** Rub the stain with a solution made from two tablespoons of alcohol, a tablespoon of ammonia and three tablespoons of hot water.

•

**Grease.** Take a cloth and moisten it with trichloro-ethylene or gasoline. Do not rub it on, but dab it lightly, working always on the outside part of the stain if it is large. This action should be carried out quickly. Blow on the stain so that it dries rapidly. Sprinkle with soap powder, let the garment dry completely, then brush it.

If you do not have soap powder or talcum powder within reach, pass over the area with the soft part of a piece of bread.
To prevent the famous "ring" from remaining, it is important to act quickly and allow the garment to dry thoroughly before brushing.
Or else mix soap powder and turpentine. Apply this paste to the stain and remove it with a woolen rag after five or ten minutes. Then brush the area with either a hard or soft brush depending on the fabric.

•

**Ink.** Rub a piece of lemon over the stain. Repeat as necessary. Then lift the stained part, tie it with a rubber band and let it soak a bit in a cup of milk. Remove the rubber band and take a well-wrung cloth moistened with cold water and pass it over the stain.
This is a rather delicate process, which means it is better to try it first on a hidden part of the garment to avoid unpleasant surprises.

•

**Ironing marks.** To remove marks made by an iron, take a damp but wrung out towel and place it folded on the inside part of the fabric, while on the outside part place a white cloth. Leave it overnight. The next day iron it with a moist cloth and a lukewarm iron.

•

**Liquor.** Dampen the stain with the same liquor that caused the stain; then wash it with soap and water.

**Lipstick.** Put a bit of sugar in water and rub this solution over the stain. Remove the water with a damp cloth.

•

**Makeup.** Soak a pad in ether (or else pure alcohol) and apply it to the stain until the pad looks clean.

•

**Mud.** Let the stain dry and then brush it well. Next, pass a cloth moistened with water and vinegar over the spot. Wash everything with soap and water. Or else remove the stain with a piece of raw potato.

•

**Nicotine.** Rub the stain with a solution made of equal amounts of ammonia and glycerin.

•

**Oil paint.** If it is a fresh stain on cotton, apply a damp detergent and then wash using a normal cycle; if the stain has dried, apply a sponge moistened with paint remover and, while the stain is still damp, rub with powdered detergent.

•

**Perfume.** These stains are difficult to remove; rub with soap powder, then soak the stain in alcohol and brush it. To remove those on cotton, apply a slightly wrung out piece of cotton wool soaked in 12% hydrogen peroxide. Rinse immediately with lukewarm water.

•

**House paint.** Clean with turpentine and then pass over it with a sponge soaked in soapy water, then rinse.

•

**Perspiration.** Rub the stain with ammonia diluted by water. Or else wash it with baking soda, making certain to rinse it well afterwards. Older stains can be removed with a light solution of oxalic acid. If the perspiration is fresh and the material is not wool, place the stain under cold running water.

•

**Rain.** Soak the stained part thoroughly. Place a strip of linen above the garment and press it with a hot iron. Or else soak the garment in cold water and let it dry thoroughly.

•

**Shoe polish.** Wet the fabric with turpentine and then rub it with a clean cloth.

**Sugar.** Stretch the garment across a table and place a clean cloth folded into a square under the stain. Soak an old but sheer handkerchief in hot water and rub until the sugar dissolves. Then use the handkerchief to dab the spot with a rapid action until the stain disappears. Let dry and repeat the operation if necessary.

•

**Tobacco.** Rub the stain with 12% hydrogen peroxide.

•

**Vinegar.** Use a cloth moistened with cold water and a few drops of ammonia.

•

**Water.** It can leave traces, especially on silk. Pass the stained area over steam from a pot of boiling water and then iron the area.

•

**Wine.** While the stains are fresh, sprinkle with some table salt and rub at length with lemon juice and soap; then rinse the area thoroughly. Repeat as necessary.

If the stains are on corduroy fabrics, immediately cover the stains with fine salt and leave it until completely dry.

# When traveling

To conserve their "freshness," it is a good idea to change clothes as often as possible, which gives the fibers time to rest, and enables the garment to reassume its shape. One trick when traveling is to hang jackets and pants in a bathroom and leave the hot water running for about half an hour. Over night the steam will put a wrinkled suit back in order. Another expedient, one made famous by Charlie Chaplin, is to fold a pair of trousers properly and lay them out under the mattress. After a good night's sleep, the trousers will look almost as good as a professional ironing.

One way to maintain the form of a suit is to avoid using soft bags when traveling. The traditional rigid suitcases are better; or else use garment bags that provide their own hangers.

When packing a traditional suitcase, place underwear, socks, pajamas, and handkerchiefs on the bottom. They should form a flat layer on which to pack heavier garments: pants, folded in half, and laid in a "staggered" arrangement. Next come the vests, followed by jackets. Place folded shirts on top, and protect them with a plastic bag if possible. Ties should be rolled up to prevent the formation of creases that are not easily removed. It is best to put shoes in the appropriate pouches, and place them in a separate bag.

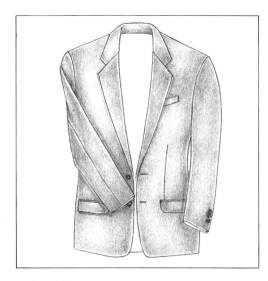

*Place the jacket on a table with the front towards the top and flatten the sleeves lengthwise. Then refold the*

*lower half of the jacket over the front, placing a shirt or a pullover in between the folds in order to avoid dry creases.*

*Another way to fold a jacket is illustrated in the above design. In this case the jacket is carefully stretched over*

*the upper part of the trousers and arranged with the back towards the top, then refolded on the legs of the same trousers.*

# Ironing

Unfortunately, protecting the shape and appearance of your clothing extends beyond a vigilance against moths or a wariness of incompetent dry cleaners; it also involves a careful watch over individuals assigned to wash sweaters and iron jackets. All too often valets who claim to be experts on fabrics return to their clients trousers whose flannel has become as smooth as a sheet after repeated ironings. Or worse: Socks of precious Scottish wool come back felted and shrunk to a size suitable for a newborn baby. Moreover, the widespread use of artificial fibers has contributed to a loss of knowledge that for generations served to maintain suits of wool, linen or cotton.

Since experts in home economics are not always at one's disposal, it is sufficient that the individual involved is capable of reading the instructions on the clothing label and on the washing machine; that he or she is aware that wool is normally washed, preferably by hand, in cold or tepid water, and knows not to wash whites with industrially colored fabrics, whose colors may run.

Regarding the iron itself, it is sufficient to read the manufacturer's instructions concerning the correct temperatures to use with various types of fabrics.

Water, steam and a damp cloth are useful allies in this procedure. A damp cloth is especially handy. It is placed between the iron and the fabric and should always be used when ironing woolen jackets and pants.

A damp cloth is also useful for eliminating any glossy areas on a garment. Instead of a brush with bristles, use one with metal points, which help raise the fibers of the material.

After carefully brushing the area in question, cover it with a damp cloth and press it with a hot iron.

Right: *A worn out slipper widely used by professional cleaners. Although not common in households it is an extremely useful accessory which is used instead of the damp cloth that is placed between the iron and the fabric. The second photo illustrates the way in which the slipper is fastened to the iron.*

## IRONING JACKETS

Before ironing, jackets should be examined for any stains or areas that need mending. Normally, pockets, buttonholes and the internal linings are the areas subject to the most wear. In particular, the parts around the sleeve can easily become unstitched.

**3** *With a steam iron fitted with a slipper, iron both sleeves at once.*

**1** *The procedure begins with the sleeves. Slip the "arm," a rectangle of padded material, into the sleeve.*

**4** *Arrange the pocket linings evenly, pull them by the ends, and pair them.*

**2** *The "arm" is forced through the sleeve.*

**5** *Iron the front of the jacket.*

**6** *Place the jacket with its back up. If there are vents, make sure they are spread evenly.*

**7** *Iron the back of the jacket.*

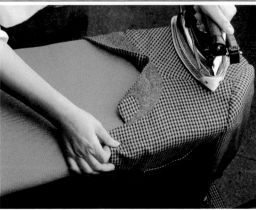

**8** *Iron the shoulders, arranging the garment along the ironing board as shown.*

**9** *Iron the lapels and the collar only from the back.*

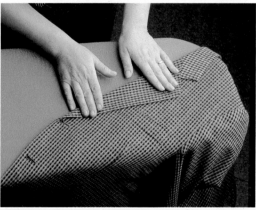

**10** *Shape the lapels with some steam and by hand; do not iron them directly.*

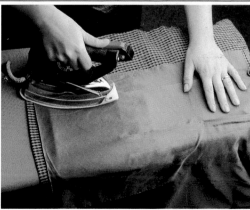

**11** *Iron the inside by following the lining.*

## IRONING TROUSERS

As with jackets and any other type of garment, trousers should be examined for stains before ironing. If a hot iron has been used hastily, stains that could otherwise be quickly removed by following a simple procedure can escalate into problems that must be treated by a dry cleaner.

It is important to remember that trousers periodically require a professional ironing. An impeccably ironed pleat or fold, for example, can be obtained only by a combination of a steam-heated ironing board and the steam from an iron itself, equipment normally found only in dry cleaners.

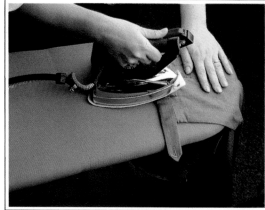

**2** *Turn the pockets inside out and iron the top part of the leg.*

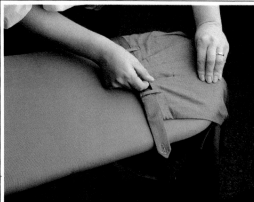

**3** *Prepare the top part for ironing by reinserting the pockets and reforming the folds.*

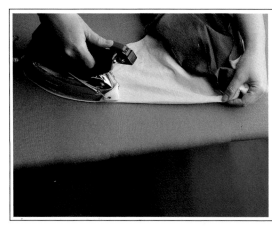

**1** *First iron the pocket linings, front and back.*

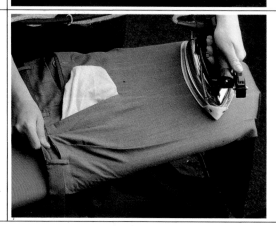

**4** *Iron the waist and the higher part of the trousers.*

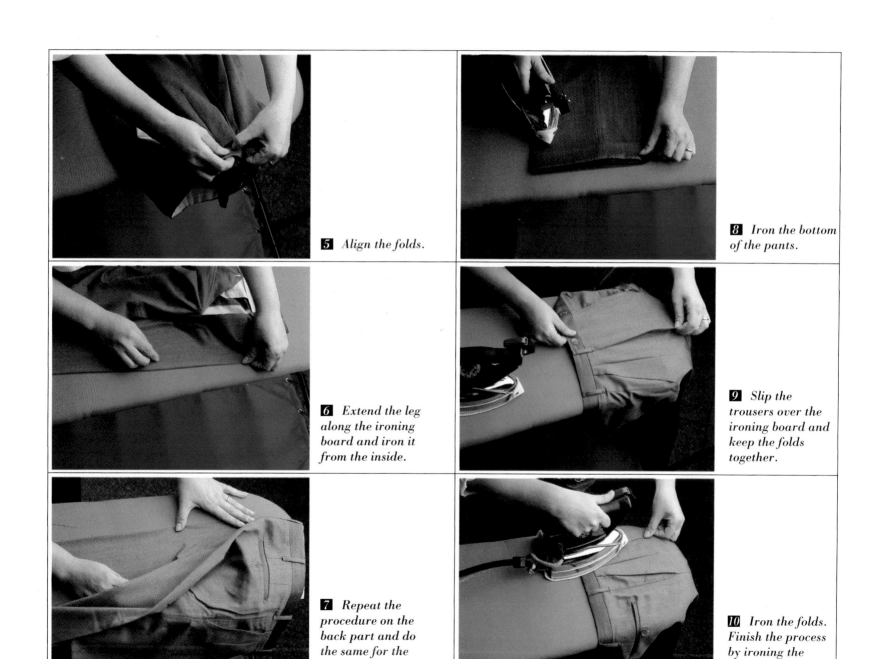

**5** *Align the folds.*

**8** *Iron the bottom of the pants.*

**6** *Extend the leg along the ironing board and iron it from the inside.*

**9** *Slip the trousers over the ironing board and keep the folds together.*

**7** *Repeat the procedure on the back part and do the same for the other leg.*

**10** *Iron the folds. Finish the process by ironing the outside of the leg.*

## IRONING SHIRTS

Few things are more pleasing than putting on a freshly-washed and ironed shirt. The cuffs and collar are without doubt the most delicate parts of the shirt to iron; their borders must not be too "glossy" and there should not be any unsightly wrinkles.

There are two theories concerning the folding of a shirt: The first, which is probably supported by those not lacking space, holds that shirts should be hung without being folded or buttoned; the second calls for rigorously folding a shirt after ironing it.

**2** *Follow the same procedure with the cuffs.*

**3** *Hold the shirt by its cuffs and iron the sleeves.*

**1** *Extend the neck on the ironing board and iron its front and back.*

**4** *Place the shirt on the edge of the ironing board and iron the shoulders.*

**5** *Properly extend and iron the front.*

## IRONING SWEATERS

The procedure for sweaters is the same as that followed for shirts. The bottom part, the collar and the cuffs (especially elastic ones) are the most delicate areas. When ironing pullovers and sweaters it is important to stretch the garment over the ironing board carefully and press down lightly with the iron to avoid damaging the fibers.

**6** *Iron the back, taking care that the resulting folds will be even.*

**1** *Begin ironing at the top and work progressively downward.*

**7** *Do not iron the folded shirt; use only a jet of steam on the front.*

**2** *Iron the back, always beginning at the top. Iron the sleeves last, if there are any.*

# APPENDIX

# Bibliography

## BOOKS

The following list of titles is a representative selection, particularly of those works relating to the history of apparel and clothing and the volumes on etiquette and advice concerning how to dress properly. The list is necessarily incomplete regarding the strictly technical area of a suit's construction and its materials. This is because books on the subject do not exist. Until now, texts that have been published belong to a category of manuals on tailoring and weaving and are thus designed more or less for those who work in the field.

Barney, Sydney, *Clothes and the Man*, London, 1951.

Bennett-England, Rodney, *Dress Optional: The Revolution in Menswear*, London, 1967.

Boni, Chiara, and Luigi Settembrini, *Vestiti, Usciamo*, Milan, 1986.

Boyer, G. Bruce, *Elegance: A Guide to Quality in Menswear*, New York, 1985.

Brubach, Holly, "Men will be Men," *The Atlantic Monthly*, April 1983.

Byrde, Penelope, *The Male Image: Men's Fashion in Britain, 1300-1970*, London, 1979.

Carlsen, Peter, and William Wilson, *Manstyle: The GQ Guide to Fashion, Fitness, and Grooming*, New York, 1977.

Carlyle, Thomas, *Sartor Resartus*, London, 1908.

Cohn, N., *Today There are No Gentlemen*, London, 1961.

Coleman, Elizabeth Ann, *Of Men Only: A Review of Men's and Boy's Fashion, 1750-1975*, Brooklyn, New York, 1975.

Corbin, Harry A., *The Men's Clothing Industry: Colonial Through Modern Times*, New York, 1970.

*Conformismo e Trasgressione: Il Guardaroba di Gabriele d'Annunzio*, Florence, 1988.

Cunnington, C.W. and Phillis, *A Handbook of English Costume in the Nineteenth Century*, Boston, 1970.

Cunnington, Phillis, and Ann Mansfield, *A Handbook of English Costume in the Twentieth Century*, Boston, 1973.

Dolce, Donald, with Jean-Paul de Verlard, *The Consumer's Guide to Menswear*, New York, 1983.

Flusser, Alan, *Clothes and the Man*, New York, 1988.
——, *Making the Man*, New York, 1981.

Furstenberg, Egon von, with Camille Duhe, *The Power Look*, New York, 1978.

Gale, William, and the editors of *Esquire*, *Esquire's Fashions for Today*, New York, 1973.

Hawes, Elizabeth, *Men Can Take It*, New York, 1939.

"History of Men's Wear Industry, 1890-1950," *Men's Wear*, February 10, 1950 [special issue].

Hix, Charles, *Dressing Right*, New York, 1978.
——, *How to Dress Your Man*, New York, 1981.
——, *Looking Good*, New York, 1977.
——, *Man Alive!* New York, 1984.

Jonas, Susan, and Marilyn Nissenson, *Cuff Links*, New York, 1991.

Keers, Paul, *A Gentleman's Wardrobe*, New York, 1987

Kidwell, Claudia Brush, and Valerie Steele, *Men and Women: Dressing the Part*, Washington, D.C. 1989.

Levitt, Mortimer, *The Executive Look*, New York, 1983.

Lurie, Alison, *The Language of Clothes*, New York, 1981.

de Marley, Diana, *Fashion for Men*, New York, 1985.

Martin, Richard, and Harold Koda, *Jocks and Nerds: Men's Style in the Twentieth Century*, New York, 1989.

——, *Giorgio Armani: Images of Man*, New York, 1990.

McGill, Leonard, *Stylewise*, New York, 1983.

Molloy, John T., *Dress for Success*, New York, 1975.

Mosconi, D., and L. Villarosa, *188 nodi da collo*, Milan, 1984.

"One Hundred Years of Fashion, 1892-1992," *DNR* Centennial Issue, May 22, 1992.

Post, Henry, *The Ultimate Man*, New York, 1978.

Price, H.P. *When Men Wore Muffs*, London, 1936.

Schoeffler, O.E., and William Gale, *Esquire's Encyclopedia of 20th Century Men's Fashion*, New York, 1973.

"Seventy-five Years of Fashion: A Pictorial Review of Men's Fashion and Fashion Influences," *Men's Wear*, June 25, 1965 [special issue].

Shaw, William Harlan, *American Men's Wear, 1861-1982*, Baton Rouge, Louisiana, 1982.

Stote, Dorothy, *Men Too Wear Clothes*, New York, 1939.

Tecnicus, *Enciclopedia la moda maschile*, Editrice La Mode Maschile, Milan, 1946.

Von Eelking, *Lexikon der Herrenmode*, Gottingen, 1960.

Walker, Richard, *Savile Row: An Illustrated History*, New York, 1989.

Weitz, John, *Man in Charge: The Executive's Guide to Grooming, Manners, Travel*, New York, 1974.

Wilson, William, and the editors of *Esquire, Man at His Best: The Esquire Guide to Style*, Reading, Massachusetts, 1985.

"You're So Vain" (special section), *Newsweek*, April 14, 1986.

## PERIODICALS

### Italy

L'UOMO VOGUE (monthly), Edizioni Condé Nast S.p.A., Piazza Castello 27, Milan.

MONDO UOMO (bimonthly), Edimoda S.p.A., Via S. Eusebio 26, Milan.

UOMO COLLEZIONI (seasonal), Zanfi Editori, via Ganaceto, 121, 41100 Modena.

### France

VOGUE HOMMES (monthly), Edition Condé Nast S.p.A., 4 Place du Palais-Bourbon, Paris.

VOGUE HOMMES INTERNATIONAL MODE (seasonal), Edition Condé Nast S.p.A., 4 Place du Palais-Bourbon, Paris.

### Great Britain

ARENA (quarterly), Wagadon, Exmouth House, Pine Street, London EC1.

GQ (monthly), The Condé Nast Publications, Vogue House, Hanover Square, London,

ESQUIRE (monthly), National Magazine Co., Ltd., 72 Broadwick Street, London W1V2BP.

FHM (bimonthly), 9-11 Curtain Road, London EC2A3LT.

### Germany

ESQUIRE (monthly), Esquire Deutschland, Charles De Gaulle-Strasse 8, Munich.

### Japan

MEN'S COLLECTIONS (seasonal), Gap Japan Co., Ltd., Tokyo.

### United States

DETAILS (monthly), Advance Publications/The Condé Nast Publications, 632 Broadway, New York, New York 10012.

ESQUIRE (monthly), Esquire Associates, 1790 Broadway, New York, New York.

GQ (monthly), The Condé Nast Publications, Inc., 350 Madison Avenue, New York, New York 10017.

M (monthly), Fairchild Publications, 7 West 34 Street, New York, New York 10001.

DNR (daily), Fairchild Publications, 7 West 34 Street, New York, New York 10001.

## ACKNOWLEDGMENTS

The Publisher wishes to thank:
Fabio Ratti for his invaluable assistance;
Giangiacomo Attolico, Beppe Franzoni and Helmut C. Kupsch who, in addition to Riccardo Villarosa, posed for the studio photographs;
Sartoria Siciliano of Milan for their technical advice;
Anna Arcobasso of Vivaio Drycleaning for her aid in the preparation of the ironing sequences.
The suits and accessories photographed in this book were obtained from private collections and from:
Ermenegildo Zegna, Milan
Scapa of Scotland, Milan
Vezzani, Milan
Brooks Brothers, New York.

## PHOTOGRAPHY CREDITS

AFE, Rome: pp. 107, 115, 119, 125, 144, 149, 150, 154
Davide Mosconi: pp. 137, 139, 142
Doubleday: pp. 115, 127
Dover Publications: p. 145
Little, Brown & Company: pp. 106, 123, 145
Olympia: p. 98
Overseas: pp. 104, 117, 129, 160
Pavilion Book Limited: p. 112
Riccardo Villarosa: p. 152
Rusconi Archives: pp. 101, 110, 113, 131, 135, 156, 163, 164

# Index

*Page numbers in boldface refer to major subject headings; those in italics refer to illustrations.*

191